EGYPTIAN
WALL
PAINTINGS

To Mom from
Laura and Ali,
with love.

Christmas 1987

EGYPTIAN WALL PAINTINGS

The Metropolitan Museum of Art's Collection of Facsimiles

TEXT BY Charles K. Wilkinson

CATALOGUE COMPILED BY Marsha Hill

The Metropolitan Museum of Art, New York

COVER

Osiris and the Sons of Horus.
Tomb of Nebamun and Ipuky. 30.4.157

Portions of this volume are reprinted from
The Metropolitan Museum of Art Bulletin (Spring 1979)

PUBLISHED BY

The Metropolitan Museum of Art, New York
Bradford D. Kelleher, Publisher
John P. O'Neill, Editor in Chief
Joanna Ekman, Editor
Peter Oldenburg, Designer

COPYISTS

Lancelot Crane, figs. 24, 52; Nina de Garis
Davies, pp. 26–27 and figs. 23, 29, 31, 33, 41,
44, 53–62; Norman de Garis Davies, figs. 25,
32, 39, 40, 43, 45, 50; Nina and Norman de
Garis Davies fig. 19; Hugh R. Hopgood, cover,
fig. 14; Francis S. Unwin, fig. 63; Charles K.
Wilkinson, pp. 6, 7, figs. 1, 3, 4, 6, 9, 16,
18, 26–28, 30, 34, 36–38, 42, 46, 47, 51, 64,
and p. 63

PHOTOGRAPHERS

Harry Burton, figs. 5, 7, 10–12, 17, 20–22, 35,
48, 49; Lindsley F. Hall, fig. 8; Walter Hauser,
p. 7 and fig. 15; Herbert E. Winlock, fig. 2. All
other photography by the Metropolitan
Museum's Photograph Studio (pp. 6–63 by
Lynton Gardiner, Metropolitan Museum
Photograph Studio)

Map and tomb diagram by Joseph P. Ascherl
Composition by York Graphic Services, Inc.
Printing by Eastern Press, Inc.

LIBRARY OF CONGRESS CATALOGING IN PUBLICATION DATA

Wilkinson, Charles Kyrle, 1897–
 Egyptian wall paintings.

 Includes index.
 1. Mural painting and decoration, Egyptian—Cata-
logs. 2. Mural painting and decoration—New York
(N.Y.)—Catalogs. 3. Metropolitan Museum of Art (New
York, N.Y.)—Catalogs. I. Hill, Marsha, 1949–
II. Metropolitan Museum of Art (New York, N.Y.)
III. Title.

ND2863.W5 1983 751.7'3'0932 82-7897
ISBN 0-87099-325-9 (pbk.) AACR2

EGYPTIAN
WALL
PAINTINGS

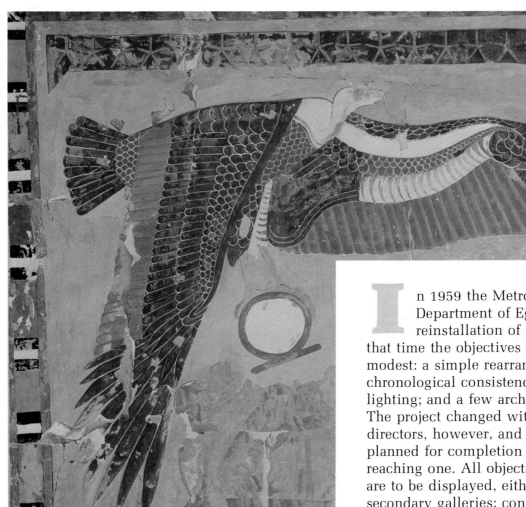

Foreword

In 1959 the Metropolitan Museum's Department of Egyptian Art began a reinstallation of its collection. At that time the objectives envisioned were modest: a simple rearrangement for chronological consistency; additional lighting; and a few architectural changes. The project changed with curators and directors, however, and the effort now planned for completion in 1983 is a far-reaching one. All objects in the collection are to be displayed, either in primary or secondary galleries; consequently a review of the condition of each work and a reassessment of its dating and importance were undertaken.

Under this program the department's extensive collection of facsimiles of wall decoration, principally produced by the Graphic Section of the Museum's Egyptian Expedition between 1907 and 1937 and supported by the Rogers Fund, received new attention. About half of the facsimiles were exhibited in 1930, accompanied by a small catalogue by Ambrose Lansing, then Associate Curator in the Department of Egyptian Art, and selected examples appeared in the old galleries. In 1976, with the opening of Phase I of the complete reinstallation, virtually all the pictures were placed on exhibition.

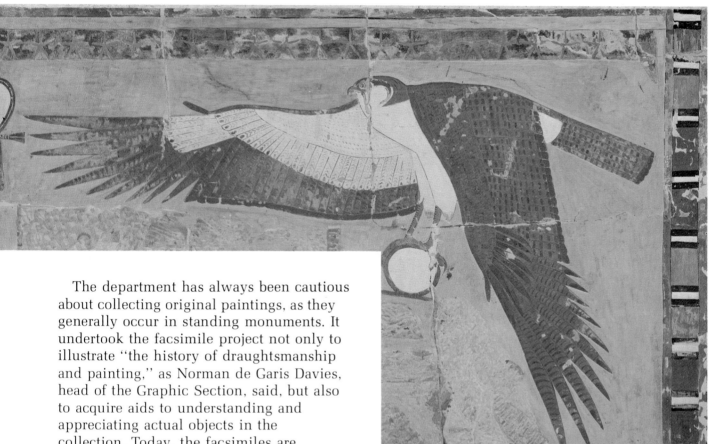

The department has always been cautious about collecting original paintings, as they generally occur in standing monuments. It undertook the facsimile project not only to illustrate "the history of draughtsmanship and painting," as Norman de Garis Davies, head of the Graphic Section, said, but also to acquire aids to understanding and appreciating actual objects in the collection. Today, the facsimiles are valuable records because monuments in Egypt are continually destroyed.

This publication includes a text by Charles K. Wilkinson, Curator Emeritus, Department of Near Eastern Art, who joined the Graphic Section as an artist in 1920, as well as a chronological catalogue, organized by Marsha Hill, formerly Senior Administrative Assistant in the Department of Egyptian Art, of the 369 facsimiles. The works primarily represent Empire tomb decoration, but they also show palace decoration as well as temple blocks and a sarcophagus found by the department's Egyptian Expedition at Lisht and Thebes. Today the department is grateful to have the Graphic Expedition's record and pleased to share it with others through this publication, made possible by the generosity of Lila Acheson Wallace.

CHRISTINE LILYQUIST
Curator, Department of Egyptian Art

Left and above: The patron deities of Upper and Lower Egypt were the vulture goddess Nekhbet of Elkab and the falcon god Horus of Behdet, respectively. Here they appear hovering protectively above (now destroyed) figures of Queen Hatshepsut and holding the *shen*, symbol of infinity, in their talons. The Egyptian artist changed the natural colors of the plumage to brighter hues to heighten the decorative effect. About 1490 B.C. Anubis Chapel, Temple of Hatshepsut, Deir el Bahri. 30.4.138 and 30.4.139

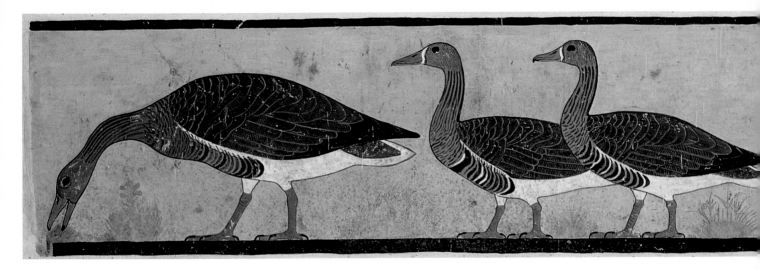

1 Geese from the tomb of Itet at Meidum. This early masterpiece of Egyptian painting, executed on fine plaster covering a brick wall, dates from about 2600 B.C. The original is now in the Cairo Museum. 31.6.8

CHARLES K. WILKINSON

EGYPTIAN WALL PAINTINGS:

The Metropolitan Museum's Collection of Facsimiles

The Metropolitan Museum of Art has on display in its new Egyptian galleries approximately 350 colored facsimiles of ancient wall paintings copied mostly from tombs during the first third of this century by the Graphic Section of its Egyptian Expedition. As the last surviving member of the Expedition and as one who made many of those copies, I have been invited to write about them from the standpoint of my personal knowledge and experience. It is my intention to recount here why and how we copied the original paintings, what we discovered in the process about the Egyptian artist's methods and materials, and what his pictures tell us so vividly and in such detail about everyday life in the civilization that flourished along the Nile 4,000 years ago. I therefore leave to others such matters as the analyzing of stylistic differences in Egyptian art by dynastic periods.

I joined the Egyptian Expedition of The Metropolitan Museum of Art in 1920, working in and among the desert foothills and tomb-riddled cliffs of the Theban necropolis on the west bank of the Nile opposite Luxor (see maps, pages 58–59).

The Museum's Curator of Egyptian art in those days was Albert M. Lythgoe, who, in 1906, had created the department and inaugurated the expedition to Egypt (Figure

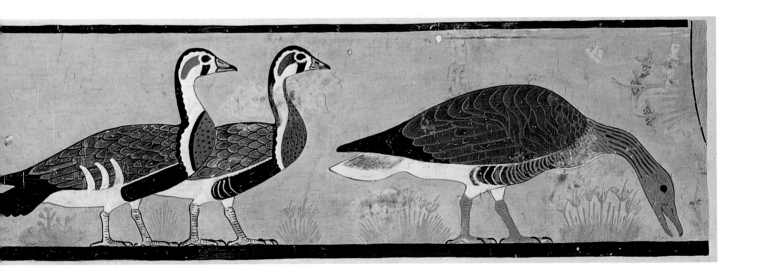

2). Arthur C. Mace, a distinguished English archaeologist, was his senior assistant. After beginning at Lisht and in the Kharga Oasis, Lythgoe sought a third exploration site. In 1910 the Museum was granted a concession at Thebes, and Herbert E. Winlock, once a student of Lythgoe's at Harvard, became the field director. Heading the Graphic Section there was Norman de Garis Davies, the man responsible for my joining the Expedition. It was the task of the Graphic Section to record and copy Egyptian wall paintings, the great majority of which are in tombs of the Theban necropolis.

In 1920, when Davies needed a new assistant skilled in the fine arts, he inquired at the Slade School, University College, London, whence he had previously obtained assistants and where his wife, Nina, had studied. I had just finished my training there, and Henry Tonks, the renowned director of the school at that time, recommended me to Davies. Tonks thought he could help both parties. He knew I needed a job, that active service in World War I had left me none too strong physically, and he felt that the climate of Egypt during the winter seasons, when expeditions are in the field, would benefit my health. Davies, in turn, would be getting a fully qualified assistant experienced in painting in tem-

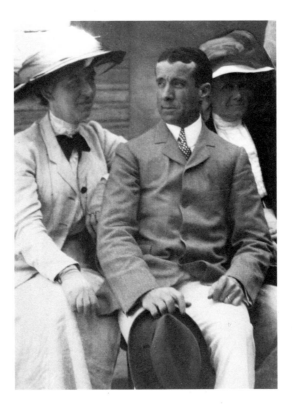

2 Albert M. Lythgoe and his wife, Lucy, photographed at the Kharga Oasis in 1908. Two years earlier, Lythgoe became the Museum's first Curator of Egyptian art, and organized its Egyptian Expedition

9

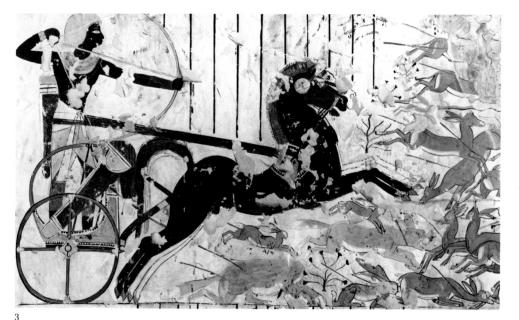

3

3, **4** Userhat, a royal scribe, hunts gazelles, hares, and other desert animals from a chariot drawn by two horses, one red, one white. Chariots and horses were not used in Egypt until about 1700 B.C., when they were probably introduced by invaders known as the Hyksos. This scene dates from about 1450 B.C. At the right is a Coptic monk's version of the red horse, painted some two millennia later on the same wall. Tomb of Userhat (T 56), Sheikh abd el Qurna. 30.4.42, 222

pera, an accomplishment that was essential to the job. It was the beginning of my professional association of twelve years with Davies in Egypt and of a friendship brought to a close only by his death in 1941. The Metropolitan Museum's collection of copies of Egyptian wall paintings by Davies and his associates is unexcelled in size and quality because of his unflagging enthusiasm and high standards, and should be considered in large part his achievement.

One might wonder why the Museum, in its golden age of discovering and acquiring ancient Egyptian objects, was also committed to making copies of wall paintings. The individual responsible for that policy was Lythgoe, a man whose modesty concealed rare administrative ability and a passion for thoroughness. Lythgoe was a staunch advocate of the scientific approach to field archaeology as initiated by Sir Flinders Petrie: a systematic, accurate recording of all finds in excavations, for what might seem at first to be of no intrinsic value could yield information of enormous significance after further examination and study. Lythgoe was also deeply influenced by a perceptive statement by the philologist F. Llewellyn Griffith that, for a fraction of the cost of an excavation, a great deal about Egypt's past could be learned by accurately copying wall inscriptions in

tombs that were already accessible. Lythgoe expanded upon Griffith's idea to include all mural paintings, inscribed or not, and by the winter of 1907/08, during the second season of the Expedition's field work, he had created the Graphic Section under the leadership of Davies to make facsimile copies. Photography was also used to record the tomb interiors, but it is to be remembered that this was still the age of black-and-white prints made from fragile glass plates. Furthermore, even if color film had existed, its transparent, transient qualities would not have met Lythgoe's standards. What Lythgoe wanted were permanent, accurate copies of the originals, exact in line, color, and, when possible, in full scale, for study and exhibition at the Museum and for publication.

Both Lythgoe and Davies were only too well aware that since ancient times wall paintings had been subject to vandalism, some of it perpetrated by the Egyptians themselves. During the reign of Amenhotpe IV, who took the name of Akhenaton and attempted to establish the supremacy of the god Aten, his followers entered the tombs and systematically deleted parts of inscriptions and sometimes even whole figures, such as those of the *setem* priests (see Figure 30). Again, when his successor Tutankhamun ascended the throne, and the god

10

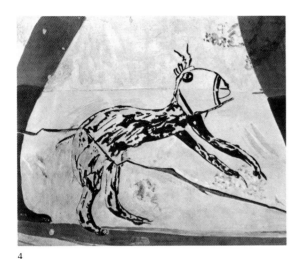

4

Amun was restored to his primary place among Egyptian deities, more deletions were made. Still other disfigurements and effacements were the result of political rivalries, whether royal or not.

With the advent of Christian monasticism in the third century of our era, further damage ensued when the monks took over funerary temples and tombs for monasteries. Deir el Bahri, for example, meaning "the northern monastery," is the Arabic name for Queen Hatshepsut's temple, built against and into the cliffs at the end of the Asasif valley, where in the nineteenth century the ruins of a Coptic structure stood in its uppermost courtyard. The monks used the tombs in the surrounding area for living quarters and for meditation, and when they found things in the wall paintings they considered evil or tempting, such as female figures, they often scratched them out. Sometimes they defaced the walls with little sketches, as happened in the tomb of Userhat. Among the ancient Egyptian paintings in this tomb is one in which a pair of fine horses is depicted with great verve and spirit (Figure 3). Some two millennia later a monk tried his hand at copying the principal horse on the same wall in the chamber (Figure 4), an effort that Davies aptly described as a very triumph of failure.

For centuries, too—even into my time—many tombs were occupied by the local people, who lived in them very cozily with their animals (Figure 5). Their fires, usually made close to the walls, affected the colors of the paintings seriously, the smoke imparting a yellowish cast to cool bluish gray backgrounds, and the heat turning blues and greens to a slaty gray. Only in a few tombs—for example, that of Minnakhte—do the colors appear to have survived undiminished (Figure 6). The people also did some deliberate damage to the paintings, including knocking out eyes to avert evil, but on the whole the abuse they inflicted stemmed from an attitude of indifference.

5 Forecourt of the Theban tomb of Noferhotep (T 49) as it looked in 1920, when the tomb was inhabited by a family with a cow, eight sheep, four goats, a dog, a cat, and poultry. Over the years many of the painted tombs have been protected from intruders by gates installed by the Egyptian Antiquities Service

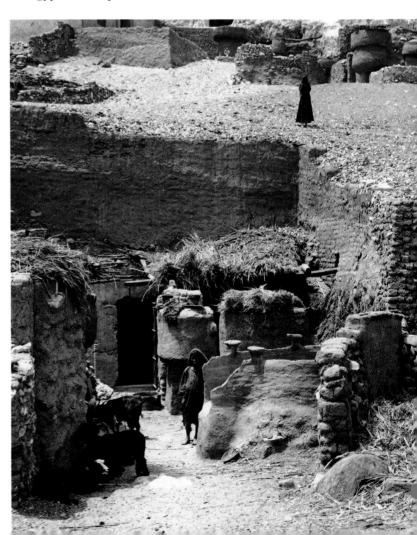

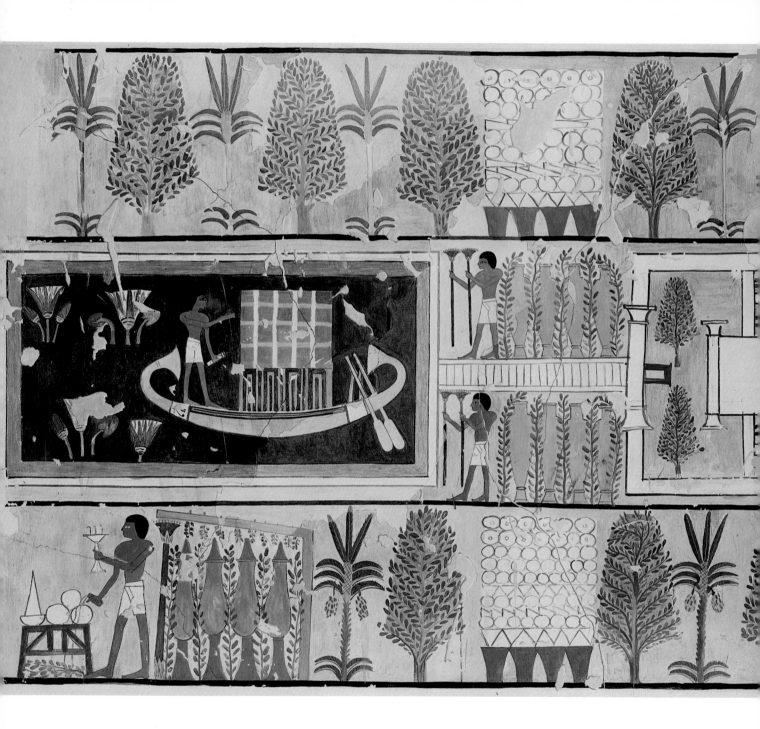

6 Funeral ceremony in a temple garden for Minnakhte, overseer of granaries. His catafalque is being transported across a pool to steps leading up to the temple. The pylons and walls of the temple are seen from above, while the entrances are at right angles to them, as if lying down. Cakes and breads are piled between the trees, and jars of beer and wine are shaded by greenery. The original painting, although damaged when copied and virtually destroyed today, is among the few with exceptionally well preserved colors. About 1475 B.C. Tomb of Minnakhte (T 87), Sheikh abd el Qurna. 30.4.56 (restored)

The most serious damage to the paintings was effected in an entirely different way. After Napoleon's campaign in Egypt in 1798/99, the attention of the Western world was focused on this ancient land, attracting to it throughout most of the nineteenth century both the best and the worst of visitors. In Egypt one could satisfy either an intellectual thirst for knowledge of an older civilization or a lust for material riches.

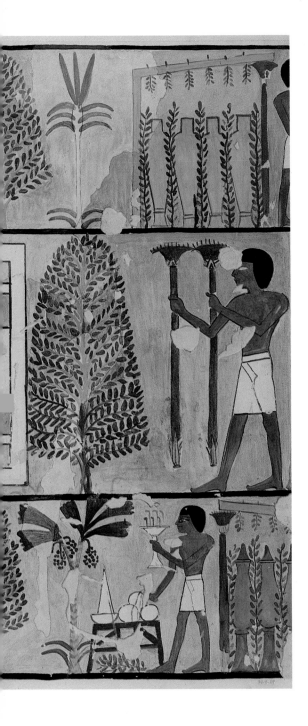

Antiquities Service, Sir Gaston Maspero, authorized Howard Carter, then his chief inspector in Upper Egypt, to install gates with iron bars at Theban tomb entrances and to employ guards. (In addition, wire netting was stretched over the gates to keep bats from living in the tombs.) The project was pursued vigorously by Carter's successor as chief inspector, Arthur Weigall, who sought the assistance of the gifted Egyptologist Alan Gardiner. This security system was a major step in curbing the nefarious trade in pieces of wall paintings, although such trade has never entirely ceased.

Among the commendable travelers attracted to Egypt in the early nineteenth century, two who recorded Egyptian wall paintings before so many were vandalized and whose careful drawings and notes were of value to our endeavors were Sir John Gardner Wilkinson and Robert Hay—and while I am no relation to Sir John, I am honored to have helped in a minor way to further his pioneering efforts. From 1821 to 1833, almost a century before our Expedition arrived, Wilkinson lived in the Theban hillsides, clearing and examining accessible tombs. He was the first to undertake the methodical and accurate copying of tomb paintings with a view to understanding Egyptian life. Hundreds of his line drawings and a few plates in color illustrate his crowning achievement, *The Manners and Customs of the Ancient Egyptians* (1837–1841). Wilkinson's meticulous copies, together with his notebooks, were exhibited in 1978 by the Ashmolean Museum, Oxford University, and although they are too small to be considered facsimiles, their significance as reliable, irreplaceable source material has finally been given due public recognition.

Hay traveled in Egypt and Nubia, sometimes with other artists, between 1828 and

The abundance of antiquities aroused predatory instincts to a very high degree, and a surge of interest in Egyptian paintings gave rise to an unscrupulous traffic in pieces hacked from the walls. Great chunks were carried away, and many paintings were irretrievably ruined in the process. By the beginning of this century thefts had become so numerous and damage so severe that the director general of the Egyptian

1838, and produced an excellent book, *Illustrations in Cairo* (1840). Much of his work, however, including his drawings of Theban tomb paintings, has not been published and is in the manuscript collections of The British Library, London. Although Hay made tracings in a day when artists had to devise their own form of tracing paper, his drawings are of a quality that has never been surpassed. They were used by Davies and at times by myself to restore in our copies missing parts of the original paintings that had been cut out of the walls during the century after Hay recorded them.

When I arrived at Thebes in 1920, the *modus operandi* of the Graphic Section was well established. Davies was assisted by one copyist who worked full time for the Museum, a job I held for the next twelve years. My chief predecessors were Francis Unwin, Norman Hardy, and Hugh Hopgood. Davies's wife, Nina, was also an assistant. A copyist of great facility, she devoted half her time to making facsimiles for the Metropolitan Museum and half to making fac-

similes for private collectors, primarily Alan Gardiner. It was largely through Gardiner's munificence that a selection of her copies may be found today in museums and art institutions other than the Metropolitan.

Of English-Scottish heritage, Nina de Garis Davies (née Cummings) was born in Greece but educated in England, and met her husband-to-be while visiting friends in Alexandria. They were married in 1907, the year Davies was retained by the Metropolitan, and they settled into a house in the Asasif valley on the fringe of the necropolis, a short distance from where the Museum subsequently built its staff house and headquarters (Figure 7). Nina de Garis Davies's professional dedication to the copying of Egyptian paintings began at that time. I worked with her frequently and remember her as a very pleasant associate and an extremely conscientious individual. She was so conscientious that if occasional luncheon guests unwittingly threatened to disrupt her schedule, she would politely excuse herself by saying, "I am sorry, but I must go to my tomb now." And go she did.

Norman de Garis Davies's role was more comprehensive, encompassing both the copying and the interpreting of Egyptian paintings, a task for which he was eminently well suited (Figure 8). The son of a clergyman, he was educated at Glasgow and Marburg universities, and became for a brief period a practicing clergyman himself. But his interest in Egyptology was such that by 1898 he was an assistant to Petrie in the field, and by the turn of this century was fully launched on his life's work of recording and analyzing Egyptian paintings as one means of broadening our knowledge of the civilization that produced them. He was thus the true successor to Sir John Gardner Wilkinson.

Endowed with much intellectual curiosity, Davies considered no project routine. As a result of his vast experience as a copyist, he was able to reconstruct figures in badly damaged scenes with a high probability of accuracy. Although not by nature a patient man, he tackled each project with dogged determination, offset by a droll sense of humor. This last trait he occasion-

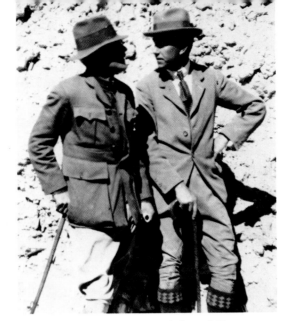

8 Norman de Garis Davies, left, and Harry Burton in 1919 at Thebes. Davies, a scholar, copyist, and interpreter of Egyptian paintings, headed the Graphic Section of the Egyptian Expedition for thirty years. Burton was responsible for all of its photography

7 View from Sheikh abd el Qurna in the Theban necropolis about 1925, looking east to the Nile valley. At the left is the house where the Davieses lived. The domed building in the middle distance is the Metropolitan Museum House. The valley in front of the house, extending along the base of the hills rising to the north, is the Asasif, which continues westward to the temples of Hatshepsut and Mentuhotpe (see map, page 59)

ally found in the work of Egyptian artists, and such discoveries so refreshed him that his commentaries on Egyptian paintings, many of which appeared in the *Bulletin,* are as delightful to read as they are informative. He did not confine his work for the Museum to paintings at Thebes, but labored intermittently for years at the Kharga Oasis, where I often joined him, and he was always willing to make the trek, or else send an assistant, to almost any location in Egypt to copy a painting that he considered essential to the Museum's collection.

Davies had considerable knowledge of the ancient Egyptian language, enabling him to treat picture and hieroglyphic inscription as a whole, in accordance with the original Egyptian practice. Much of the information he so expertly gleaned and analyzed is to be found in the texts of several volumes of facsimile copies to which he and his associates contributed, notably the Metropolitan Museum's splendid Robb de Peyster Tytus Memorial series (1917–1927). While his colored facsimiles are less numerous than those by his wife, he was no mean copyist himself and did well in capturing the appear-

15

ance of solid surface, although in speed and in attaining exact character of line it was she who excelled.

The photographic record of tomb and temple interiors was made by Harry Burton, another English member of the Museum's Expedition (see Figure 8). Best known today as the official photographer of the tomb of Tutankhamun, Burton contributed signifi-

cantly to our work both before and after he was lent to Carter and Carnarvon in their hour of triumph. His black-and-white photographs of wall paintings *in situ* were always detailed, free from distortion, and remarkable for evenness of lighting.

Burton was the most amiable of men and considerate of others even under stress. Once at dinner during a Christmas season when he and two other Expedition members were on a difficult assignment, they were served plum pudding ablaze with kerosene because there was no brandy in the camp; it was Burton who ate the pudding so as not to hurt the feelings of the Egyptian cook.

Although fifty years have brought many changes to Thebes (through excavation and restoration), the general topography and geological conditions remain the same. From the west bank of the Nile one passes

9 This scene may represent twice-widowed Henutnefret mourning before the mummies of her husbands, the sculptors Nebamun and Ipuky, during final rites in front of their tomb. The men died at different times, but the artist, with true economy, shows the rites for both in one picture. Henutnefret as a young girl caresses the feet of Ipuky; as an older woman, casting dust upon her head, she bewails Nebamun. About 1380 B.C.. Tomb of Nebamun and Ipuky (T 181), El Khokha. 30.4.108

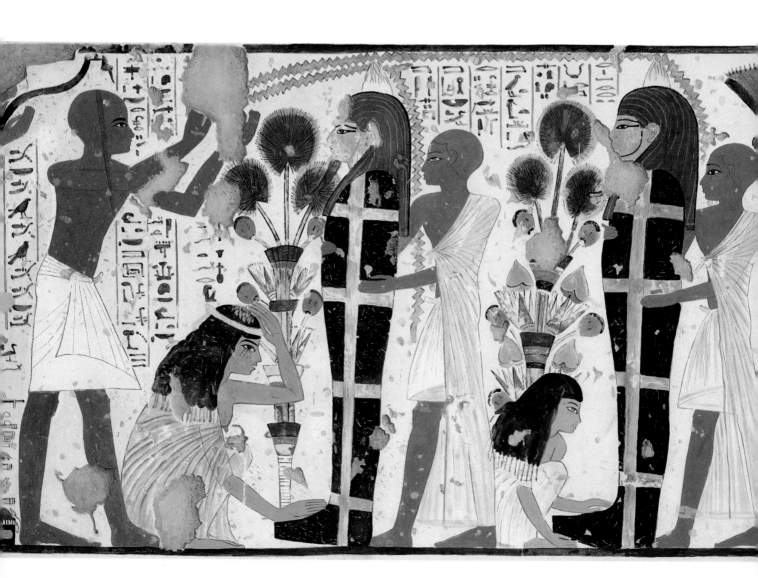

through densely cultivated fields of sugar cane and cotton in the river valley to the desert beyond, where low foothills blend into high cliffs of weathered limestone. The funerary temples are mostly along the edge of the desert near the cultivation or slightly farther back against the cliffs of the Asasif, where they could be reached conveniently for religious ceremonies. The necropolis stretches for some three miles among the foothills and along these cliffs. Its tombs are man-made caves hewn into the limestone or the greenish shale beneath, so that the whole area is honeycombed with holes and depressions between mounds of stone chips excavated by the ancient Egyptians and newer piles made by modern diggers (see Figure 7). By night, half a century ago, the necropolis looked for all the world like the lunar landscapes we have only recently come to know, except for the presence of a myriad of whirling bats, whose wings, when seen against a full moon, gleamed like silver.

The well-to-do Egyptian conceived of the afterworld as a place where he would continue to enjoy the same privileges he had known on earth, and during his lifetime he helped to prepare for this happy state by investing in a private tomb and seeing to its decoration as a reflection of his earthly environment. Egyptian tombs were originally far more imposing than they are today, their entrances now so often in ruins or their limestone fronts turned yellowish brown after thousands of years of exposure to the sun. The tombs—and the temples as well—were once bright with white paint and lively with color, as we know from the wall paintings themselves. The more pretentious tombs were sometimes adorned with

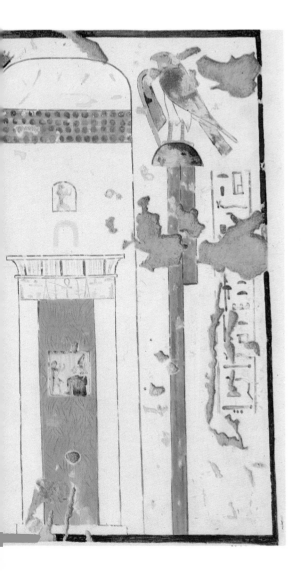

10 Rows of terra-cotta cones set in mortar above the ruined entrance to a Theban tomb, as discovered in an excavation by the Museum. The base ends of the cones are stamped with names of the deceased. In the painting at the left, they are shown as a frieze of pink circles on the white façade of the tomb

17

painted sculptured figures of the deceased (Figure 11), while others, whose original appearance can be determined only from paintings, had a simple frieze of pink circles above the door (Figure 9). Excavations by the Museum confirmed that such circles were the base ends of terra-cotta cones impressed with the names of the deceased, and that the cones were inset in horizontal rows above tomb entrances (Figure 10). By our century there were cones scattered all over the necropolis, and Davies made a sizable collection of them; today the Museum owns 350. They seem to have been peculiar to Thebes and form a veritable "Who's Who" of the perished ancient city.

11 Façade of the tomb of Paser (T 106), dating from about 1300 B.C. Paser was governor of Thebes and vizier. There are nine niches with statues of the deceased, and three with representations of Osiris, god of the afterworld and eternal life. The dry wall above is modern

The tombs vary tremendously in plan and size, depending upon the affluence and status of their respective owners. The standard Theban tomb, however, has an open forecourt made by cutting back the rock slope of a hillside to form a more or less vertical façade (Figure 11). The entrance in the center of the façade was cut straight into the rock to a distance of three or more feet. Directly beyond this, on the same level, the stonecutters hewed out two narrow chambers, the first parallel to the façade (Figure 12), and the second at right angles to it and in line with the main entrance. Often a third chamber was added. A shaft was then sunk from the last chamber, and a burial vault made. The vault and the shaft were left undecorated, while the chambers above were adorned with wall paintings.

Tomb interiors are very dark except near the entrance, and some chambers are in total darkness. Obviously, both the Egyptian artist and the copyist needed some form of

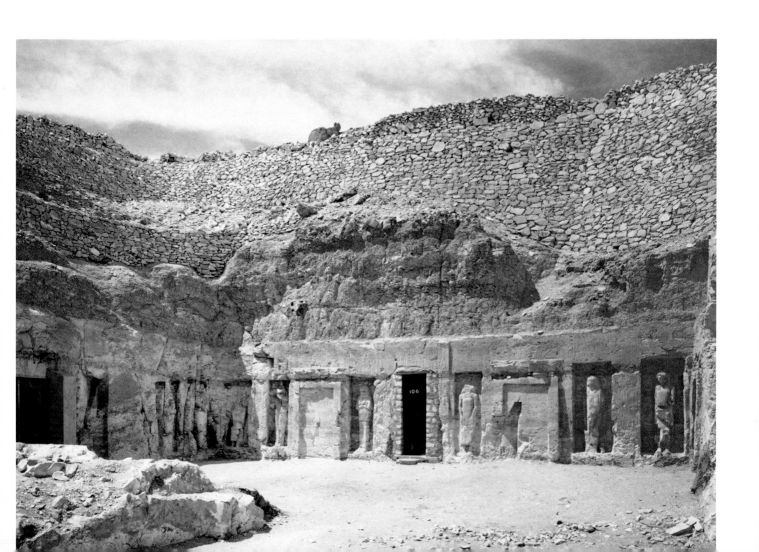

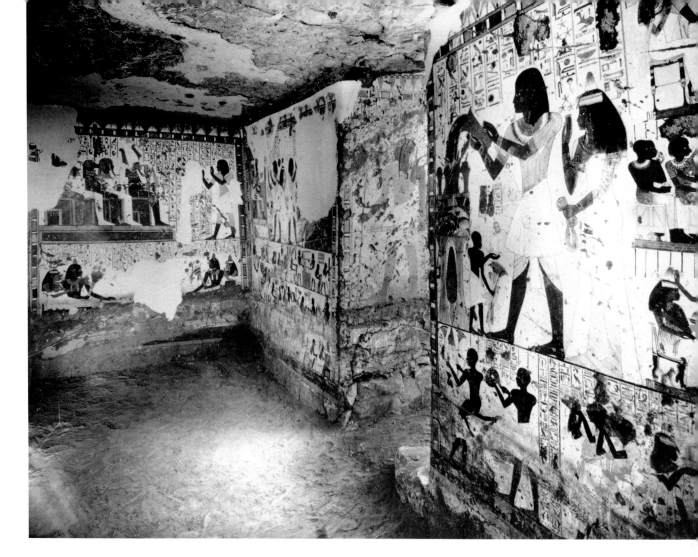

12 First chamber in the tomb of Nebamun and
Ipuky (T 181). In plan and size it is typical of
many Theban tombs. The doorway at right
leads to the forecourt. At the upper left on the
far wall are Osiris and the gods of burial (see
Figure 14)

supplementary light by which to work. The
usual way we succeeded in getting enough
light for copying was by reflecting sunlight
into the tomb with the help of a large mirror
or two. A workman outside the entrance
adjusted the principal mirror in accordance
with the sun's position, throwing a beam of
light into the interior (Figure 15). To reach
out-of-the-way places, the beam would be
directed onto another large mirror within. A
supplementary silver-papered reflector was
sometimes used to diffuse the light. For
very remote places, such as the deepest
chamber in the tomb of Sennedjem, as many

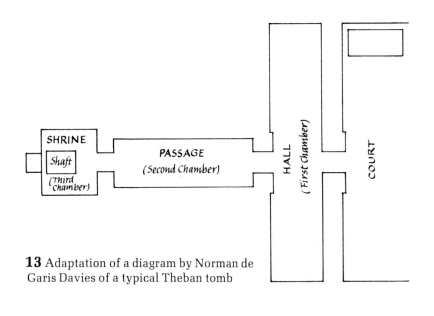

13 Adaptation of a diagram by Norman de
Garis Davies of a typical Theban tomb

19

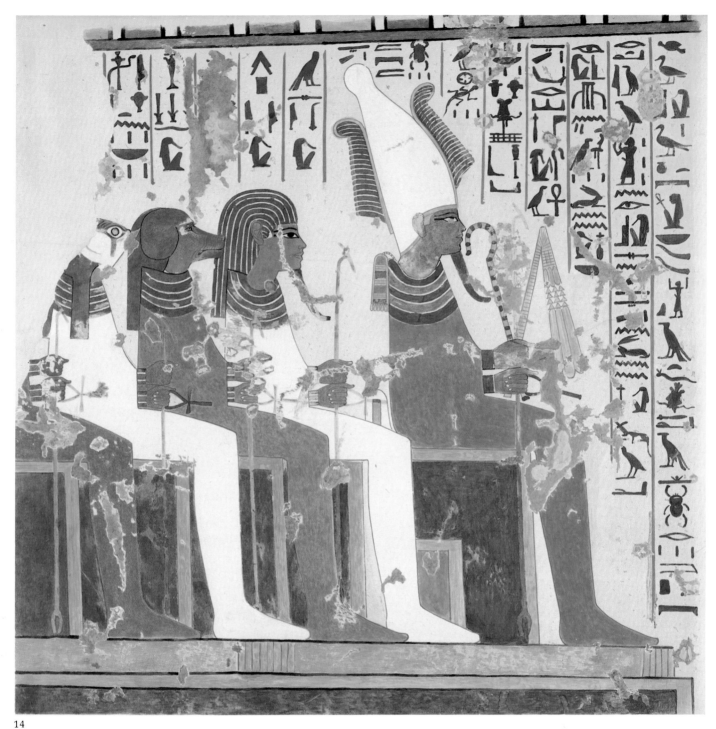

14

as three reflectors were used (Figure 16). So dependent were we upon reflected sunlight that any breakdown in the system, whether caused by man or nature, made for disgruntled copyists. Once, however, on emerging from "my tomb" (we were all, like Nina de Garis Davies, very possessive of the tombs in which we worked) to see what was interfering with the light, I discovered the sun

was almost totally obscured by the wings of hundreds of storks flying in slow circles as they paused on their migration between Europe and the Sudan, and the beauty of the sight more than compensated for my initial annoyance.

The Egyptian artist did not use mirrors. Those of his time were small, made of metal, and were mainly for toilet purposes. Egyp-

14 The god Osiris (right), symbol of eternal life, with three of the four guardian gods of burial: human-headed Imseti, ape-headed Hapi, and hawk-headed Kebehsenuef. The green coloring of Osiris reveals his role as a god of vegetation. About 1380 B.C. Tomb of Nebamun and Ipuky (T 181), El Khokha. 30.4.157

15 Workman reflecting light into a tomb with a mirror. To reach the darkest and most out-of-the-way places, the beam would be directed to another mirror within. Supplementary silver-papered boards were sometimes used to diffuse the light

16 This painting of the cat shown as a deity adorns a doorjamb of the subterranean burial chamber in the tomb of Sennedjem. To obtain enough light to make the facsimile copy, three reflectors were required. About 1300 B.C. Tomb of Sennedjem (T 1), Deir el Medina. 30.4.1

15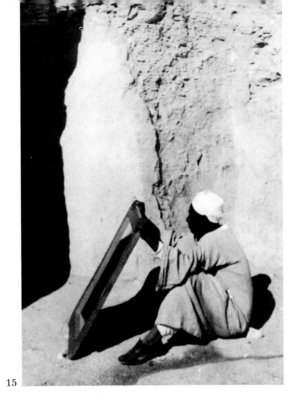

16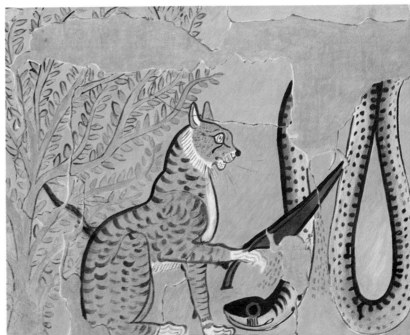

tian oil lamps, on the other hand, although tiny and inefficient by our standards and giving no more light than a candle, were available to him, and I am convinced that these were all he required to illuminate a dark tomb chamber. It must be remembered that only in the last hundred years have we demanded more and more light by which to live and work. Readers familiar solely with strong electric light may find it hard to imagine, but I assure you that one can become used to doing even detailed work with very little light, especially when young, as those of us who recall the oil lamps and candles of our childhood well know. I unintentionally put this theory to a test in the tomb of Khety, where the painting I was assigned to copy was in a badly deteriorating chamber so oriented and constructed that reflected light could not reach it (Figure 17). I tried using a pressure lamp, but it exploded, so, in desperation, I finished the project by candlelight. My colored facsimile stood up to comparison when checked in daylight against a small section of the original painting that had fallen from the wall and been removed for inspection.

Comparison is necessary to determine the accuracy of a facsimile; it also points up the basic differences between the objectives and requirements of the copyist and the Egyptian artist. Under normal circumstances, the copyist needs more light because he is trying to match every tint and tone, and even texture of an existing paint-

ing. The Egyptian artist was not trying to match anything, or to make such fine distinctions as the copyist. He was conveying a message by picture and description, and the objectives of later artists, such as, for example, visual realism, were alien to him. He had a story to tell and knew how to tell it in a simple, direct, and efficient manner.

Interestingly enough, when the paintings were in darkness, we preferred to use candles as our source of illumination for tracing, which was the first step in copying. Yellow candlelight was more penetrating than the white beam of a flashlight and did not reflect off the tracing paper we overlaid on the wall. Once we had completed our outlines, we used graphite paper to transfer them onto watercolor or cotton-backed

paper for painting. When inked, and then usually reduced photographically, the tracings were also made into black-and-white plates for publication.

Egyptian paints have a mat, opaque finish that early copyists failed to duplicate because they worked in pure watercolor, which is essentially transparent. Davies's first assistant, Unwin, who during the season of 1908/09 helped to copy one chamber of the tomb of Nakht in its entirety, made a contribution of the utmost importance: he demonstrated that tempera had the surface quality and delicacy needed for a true facsimile. Thereafter tempera was

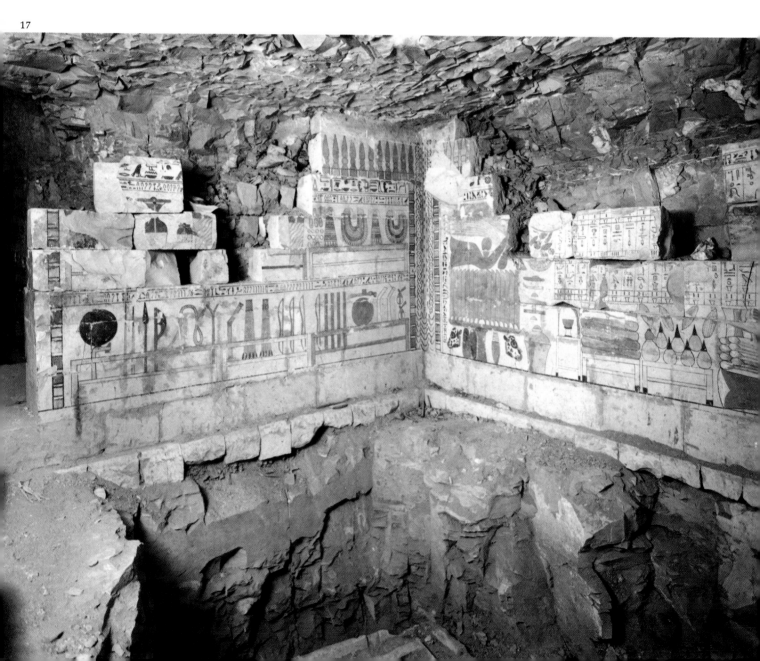

the medium used for the Museum's copies. Indeed, if one took the time and trouble, it was possible to capture with tempera the feel and texture of the original paint, as well as the color and line. All copies were compared with the originals for accuracy by eyes other than those of the copyist.

The Egyptian artist's range of pigments was limited but adequate for his needs. His principal colors were earth colors: red and yellow ochers, both readily available, the red ocher in a variety of tones—that from the Kharga Oasis, for example, being almost purple. Another yellow was derived from orpiment, a sulfide of arsenic. This was applied over intense white and produced a far brighter yellow than ocher. White was primarily gypsum. Carbon, in the form of

soot, served for black, but was not very satisfactory, sometimes disappearing and leaving a pinkish stain. Davies deduced that a very dark brown was sometimes achieved by painting black over dark red, producing a rather patchy effect.

Blue and green were of a different nature altogether, the blue being an artificial frit composed of silica, copper, and calcium that was finely ground. For wall painting green was usually made by adding yellow to the blue frit, although the use of ground malachite was not unknown to the Egyptians. Blue and green frits, because of their glassy, granular characteristics, required more binder than earth pigments to hold them to the wall, and it is mainly for this reason that age has not treated them well. Frits are also

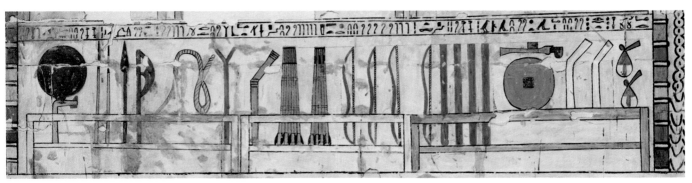

18

17 Photograph of a chamber in the tomb of the chancellor Khety (T 311), taken in 1922. The excavated burial vault is beneath. The walls of the chamber are shale faced with limestone blocks. As no reflected light could reach this area, a pressure lamp was used. When the lamp exploded, the paintings were copied by candlelight

18 Detail depicting some of the possessions Khety considered necessary to his eternal well-being: a mirror; spears, a battle-ax, bows, arrows, and other weapons; an incense burner and a round bowl to hold the incense pellets; two rolls of linen; two bags of eye paint. About 2050 B.C. Tomb of Khety (T 311), Deir el Bahri. 48.105.35

more subject to general and localized changes in tone than earth colors. If exposed to damp, as occasionally happened, both blue and green take on a rusty cast.

Pigments were painted one upon the other after the first had dried. All colors were applied flat with only rare exceptions, such as the heightening of red on a lady's cheek, an innovation that was not introduced until about 1300 B.C.

For wall painting the Egyptian had no need of the conventional palette used by most modern artists, as he kept his colors in separate bowls. His brushes, each reserved for a single color, were made not of animal hair but of rush, the fibers being suitably

23

treated and shaped. But the Egyptian artist was capable of drawing fine, even lines, as the full-scale facsimile copies clearly prove. Some of his brushes were bundles of fibers suitable only for stippling, a technique employed in the occasional dappling of red on the upper part of the white linen garments worn by ladies of high rank. An indispensable item was a cord dipped in red pigment; the artist could make a long straight line by pulling it taut and snapping it against the wall, as we know from the splatters that he did not always bother to clean away.

Where the limestone was of sufficiently good quality, as in the tomb of Puimra,

tivation where the termite (white ant) flourishes, a condition found at, among other places, Tell el Amarna.

In 1925, the Egypt Exploration Society uncovered a small chamber in the north palace of Akhenaton at Tell el Amarna that was exquisitely decorated with a scene of birds flying about in a papyrus swamp (Figure 19). Collapse, rain, and termites had all contributed to the serious deterioration of the wall surface, and the paint remained only as a thin, cracked skin covering cavities made by the termites.

Since the society's architect-artist had sickened and died, immediate assistance

19 Detail (right) of a facsimile copy of a now destroyed mural painting in the north palace of Akhenaton at Tell el Amarna. The scene depicts birds in a papyrus swamp. Here, a kingfisher dives for prey. Floating in the water are lotus blossoms, and flowering plants dot the black-mud edges. The rectangles represent wall niches. About 1360 B.C. 30.4.136 (restored)

In a later painting at the left naturalistic palm trees appear against a yellow background. Detail from a picture in the tomb of Sennedjem (see Figure 64)

flaws were filled with plaster and the wall scenes carved in low relief. The paint was applied onto the stone, presumably after it had been sized. More generally, the limestone was of a less satisfactory quality and the shale even worse, so that a complete plaster surface was prepared and primed. In some tombs the finished plaster was often smoothed over a preliminary layer of mud mixed with chopped straw. At times the priming was only a little thicker than a coat of paint. While this procedure worked well in those areas of the Theban necropolis high in the foothills and cliffs, the use of chopped straw led to disastrous results near the cul-

was needed. I was sent on a rescue mission after promising Lythgoe, whose concern for members of his staff was always paramount, that to avoid infection I would live in a tent and not in the society's house. My work in the chamber, tracing what was left of the scenes, was a perilous task, so fragile was the surface of the walls. It had to be done with the lightest touch I could muster, and took a full week. The tracings were the basis for colored copies made by the Davieses, and although damp had dulled the green color, it is only from the facsimiles that we can get even a faint idea of the beauty of the original paintings. Attempts

24

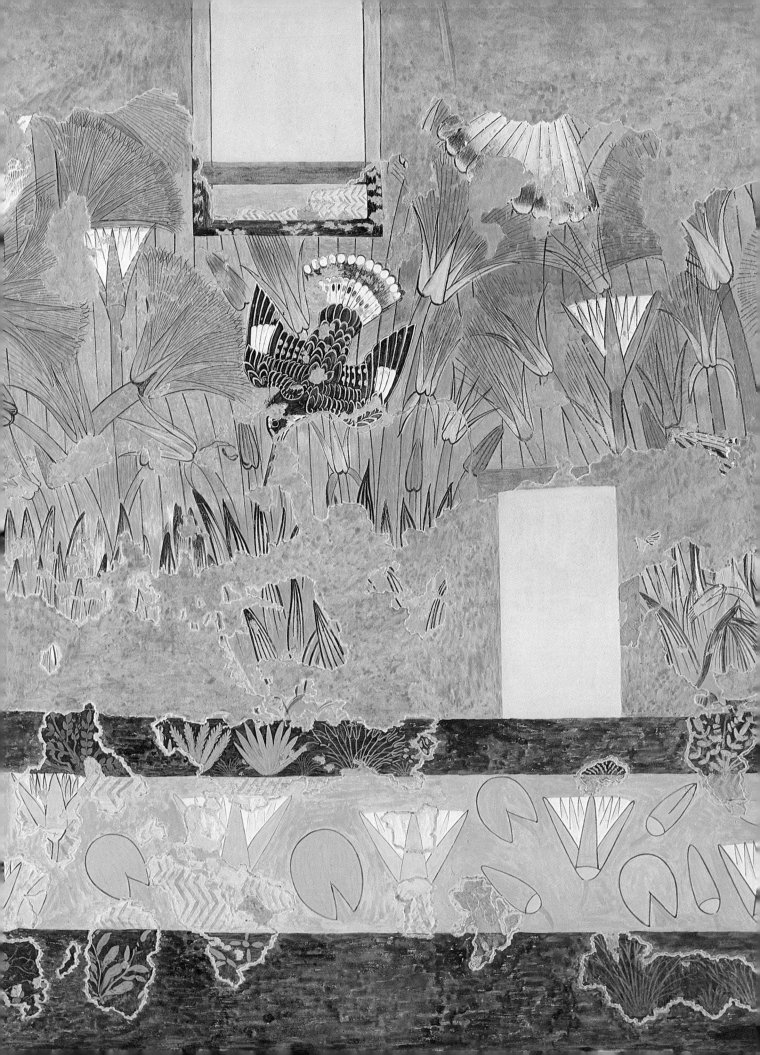

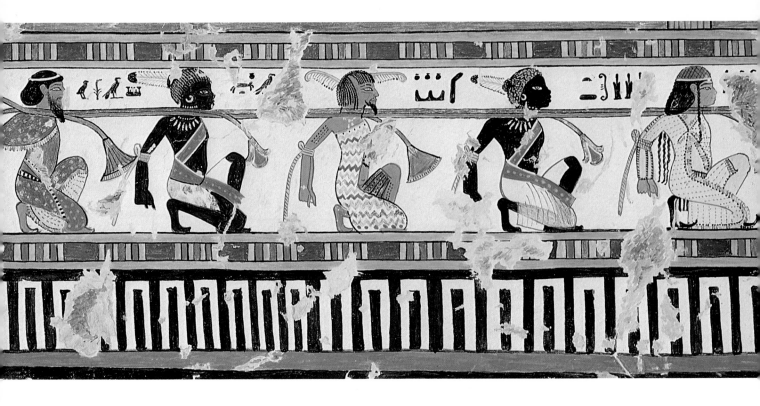

by the society to salvage some small sections might best be described as unfortunate, as the only piece to arrive safely in London was in miserable condition.

Whether the Egyptian artist worked on solid limestone or a plaster surface, he went about his task in an orderly way, planning his overall scheme in advance and executing it in stages. In tombs it was not uncommon for the decoration to be left unfinished (presumably, when owners died, the work ceased), and evidence of various stages are apparent in a number of Theban tombs. Preliminary drawings were occasionally done with great care, as is demonstrated by the figure of the seated king, Tuthmosis III, in the tomb of Amenmose (Figure 20). That the ancient Egyptian could be a sensitive artist is revealed here by the subtle changes of accent in his line—in marked contrast, I might add, to the thin, wirelike lines that have sometimes been in

vogue among Egyptologists whose copies emasculate the virility of the originals.

In laying out his pictures, the artist divided the wall into various registers by horizontal lines. In some scenes he did not extend these lines the full length of the picture, thereby allowing him to use the height of two or more registers for important figures—especially the tomb owner, often with his wife or the gods (Figure 28). Sons and daughters might be shown in smaller scale, not because they were young children but to indicate their less significant station in life. The wall scenes were usually enclosed in ornamental borders consisting of blocks of color, those on top often being more elaborate and surmounted by knot-like forms known as *khekers,* or, in some cases, by designs derived from the lotus. All of the borders, despite repetition, were drawn freehand.

Usually the artist made his preliminary

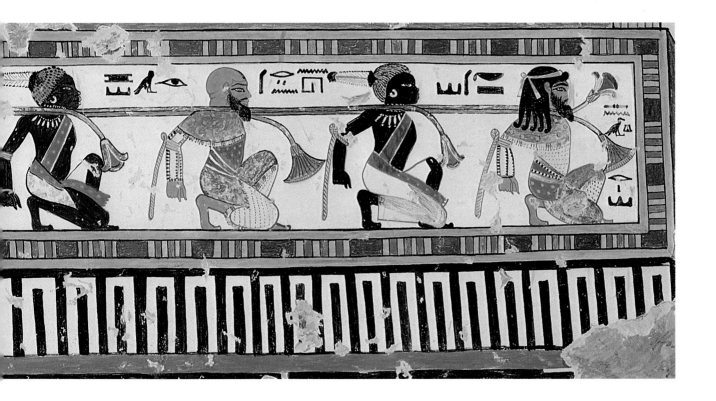

Foreigners (above) representing subject nations. Among them are Bedouins, Nubians, Libyans, Cretans, and Babylonians. The captives, each attired in native costume, kneel in suppliance, and are tied together by a papyrus stem symbolic of Egypt. This frieze adorns the dais of the thrones of Amenhotpe III and Queen Tiye in a much damaged painting in the tomb of the queen's brother. About 1380 B.C. Tomb of Anen (see Figure 31)

20 Preliminary drawing of Tuthmosis III in the Theban tomb of Amenmose (T 89) of about 1380 B.C. The deified king is seated in a shrine. This drawing, made more than fifty years after the king's death, is not a true portrait

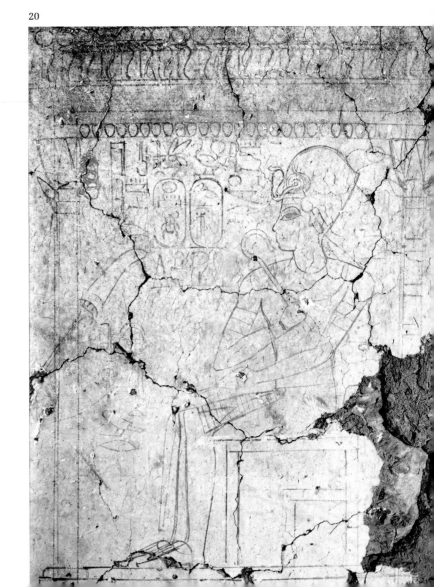

drawings in red sketchlines that were intended to be covered by paint in the later stages of his work. Sometimes the drawings were squared up from sketches, in outline or in full color, done on *ostraca,* or limestone flakes, small enough to be held in the hand (Figures 21, 22). These flakes were abundant in the necropolis, and many were

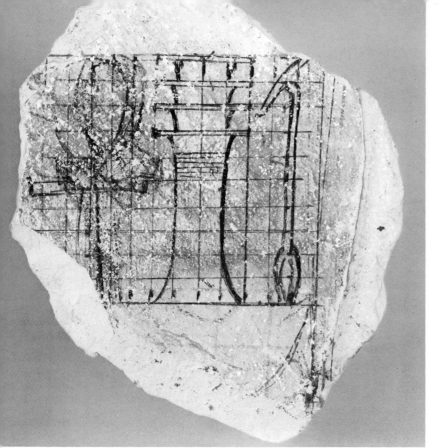

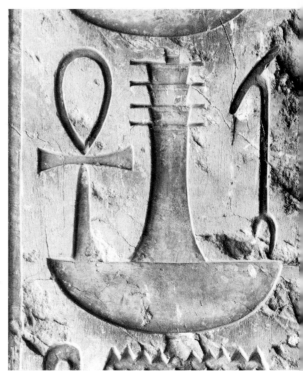

21 22

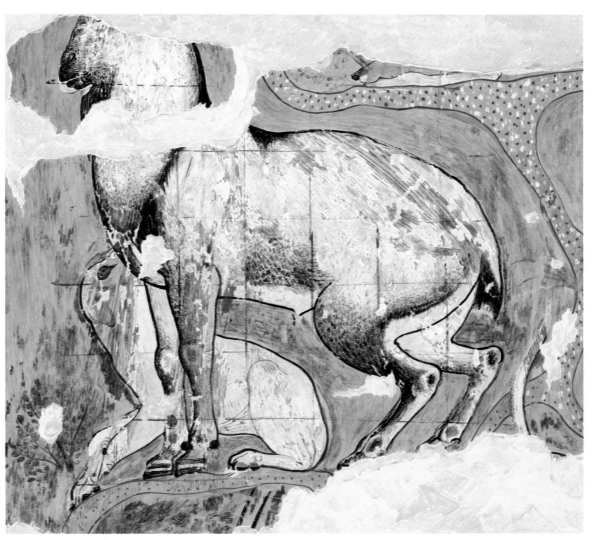

23

21,22 The drawing on the limestone flake at the left was squared up so that the hieroglyphs could be redrawn accurately on a larger scale on a wall. The same carved and painted hieroglyphs (right)—the *neb, ankh, djed,* and *was* signs, meaning "all life, stability, and dominion" —were based on such a sketch. Flake and carving date from the reign of Queen Hatshepsut, 1503–1482 B.C. Deir el Bahri. Flake 23.3.4

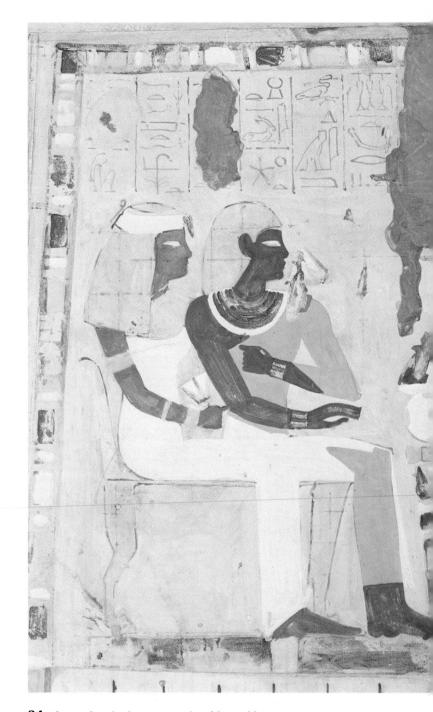

found near Deir el Bahri in the Museum's excavations. The artist's next step was putting in the background, a thin wash of paint carried to the edges of his drawings. Backgrounds were almost always pale bluish gray or near white, until yellow became popular in the late dynasties. After all the colors were applied, the last stage was the addition of precise outlines. The artist's process from squaring up to final outlines is clearly shown in scenes in the tomb of Nakht (Figure 24).

In the course of copying wall paintings, we learned that the ancient Egyptians occasionally copied their own finished work. In a scene in the tomb of Kenamun, clearly visible red squares are drawn on top of some animals for this purpose (Figure 23).

Ceilings were an integral part of tomb decoration, and the Egyptian artist treated them in several ways, usually dividing the surface into panels of colorful geometric patterns with lines of inscription in between. The variety of patterns is extraordinary and well worth studying from both an artistic and an archaeological point of view (Figure 25). The prototype for this arrange-

23 Fragment of a hunting scene in which an ibex is brought to bay by a hound. The picture must have been held in high regard by the Egyptians because it was squared up in red for copying purposes. The speckled areas of the background represent pebble-strewn courses between the desert rises. About 1425 B.C. Tomb of Kenamun (T 93), Sheikh abd el Qurna. 30.4.59

24 This unfinished painting of Nakht and his wife reveals the Egyptian artist's procedure. Some of the red lines used in setting up the picture are visible on the plaster surface, as are parts of the preliminary drawing. The bluish gray background and large areas of other colors have been applied, but fine details have yet to be painted. Only when these were completed were the outlines added. About 1425 B.C. Tomb of Nakht (T 52), Sheikh abd el Qurna. 15.5.19f

ment was probably a wood-framed, textile covering on the ceilings of dwellings of predynastic origin that in very early tombs was imitated in stone. The areas on which the inscriptions were painted represented beams, and the Egyptian artist was most adept at simulating wood grain (Figure 26). In one tomb chamber the artist converted a ceiling into a bower of grapevines. Another unusual ceiling appears in the tomb of Senenmut, a high-ranking official under Queen Hatshepsut; here the design is a

representation of the heavens (Figure 27).

Blemishes appear in a number of the paintings quite apart from the gaps where pieces are missing. When the Egyptian artist had finished, he usually left the painted surface untouched; but in several tombs of the XVIII Dynasty, including those of Kenamun and Nebamun, beeswax was applied to enhance the color, and this has turned into a grayish, almost opaque skin. The wax is easily peeled off and does no harm, but another substance employed for the same purpose has been most harmful. A resin, originally probably colorless and certainly transparent, was used especially to brighten yellow, perhaps to make it look more like gold. The resin also served as a varnish. With time it has often become dark

25 Geometric patterns copied from fragments of a painted ceiling. About 1380 B.C. Tomb of Nebamun and Ipuky (T 181), El Khokha. 30.4.102 (restored)

25

26 Ceiling design with a center strip painted to simulate a wooden beam. About 1525 B.C. Tomb of Tetiky (T 15), Dra abu'l Naga. 30.4.4

27 Astronomical ceiling in the tomb of Senenmut, beneath the lower courtyard of the temple of Queen Hatshepsut. The painting is unfinished, but the composition, based on a star clock, is beautifully drawn. Senenmut was a favorite of the queen and architect of her temple, but he fell from power before plans for this tomb could be realized and was buried elsewhere. About 1500 B.C. Tomb of Senenmut (T 353), Deir el Bahri. 48.105.52

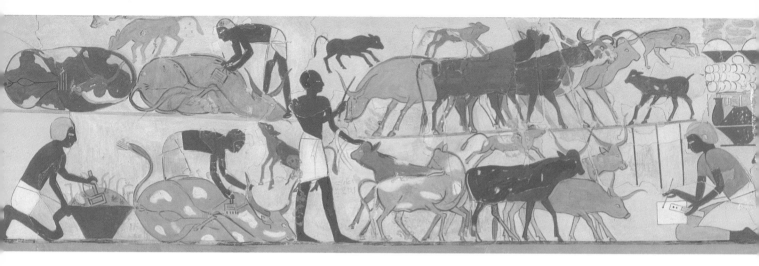

brown and fissured. When the resin flakes off or is removed, it takes the paint with it. Several copies of scenes from the tombs of Kenamun, Huy, and Nakht show the unfortunate effects of these materials.

Other strange markings on Egyptian tomb paintings are due not to man but to the mason wasp, which has a nasty habit of boring into the plaster, covering it with a kind of adhesive, and then building little domelike structures of mud for its offspring. The damage on removal is slight, however, when compared to that of resin varnish.

In the paintings in the Museum's collection, all of these defects can be seen because the facsimiles are usually exact representations of the originals and their condition at the time they were copied. In a few instances where restoration was essential, the restored areas have been indicated in an obvious way, usually by a lighter tone or, occasionally, by a cautionary outline.

Decorated tombs were only for the affluent, and the Egyptian artist painted them for the everlasting benefit of the owner, who expected to live in the afterworld as he had lived on earth. The scenes therefore show him engaged in all the pursuits of his daily life, such as surveying his estate or overseeing the

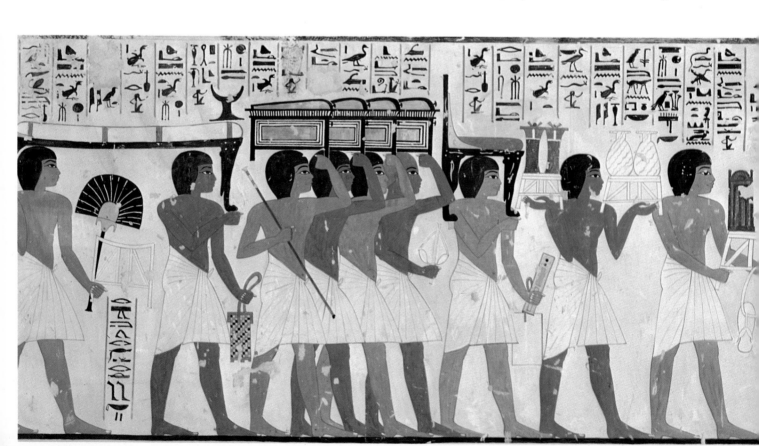

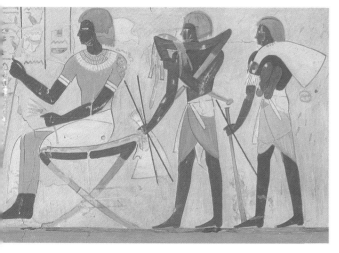

28 Police captain Nebamun, seated on a folding stool, oversees the branding of his cattle and the recording of his herd by a scribe. The scene is from a painting showing many activities on his estate. About 1420 B.C. Tomb of Nebamun (T 90), Sheikh abd el Qurna. 30.4.57 (restored)

29 Funeral procession of the vizier Ramose. In this detail of an elaborate scene, servants carry furnishings to his tomb while female relatives of all ages express their uncontrollable grief. About 1375 B.C. Tomb of Ramose (T 55), Sheikh abd el Qurna. 30.4.37

branding of his cattle (Figure 28), and enjoying with his family all the good things of this world. As would be expected, tomb decorations also include scenes of the funerary rites of the deceased and his journey from this world to the next (Figure 29).

The Egyptian artist recorded these activities in detail, and he did so clearly and economically by employing artistic conventions that are easily understood. He portrayed his subject on a single flat plane without the use of perspective, light and shade, or other visual subtleties that concerned artists of later times. Each object is shown in its most characteristic or easily perceived form and from the most telling

view, and these are assembled in a delightful yet orderly way to convey as much information as possible in the given space. Take, for example, food for the deceased (Figure 30). This was a subject of prime importance, and scenes of such offerings appear in almost every tomb in the necropolis. The table for the provisions is invariably shown in profile, but the items are arranged in vertical tiers above, with every item depicted in the way it is most easily recognized. By this convention the food could be shown clearly, and far more could be displayed than the table itself could bear. To make certain there was enough, the artist usually painted hieroglyphic signs

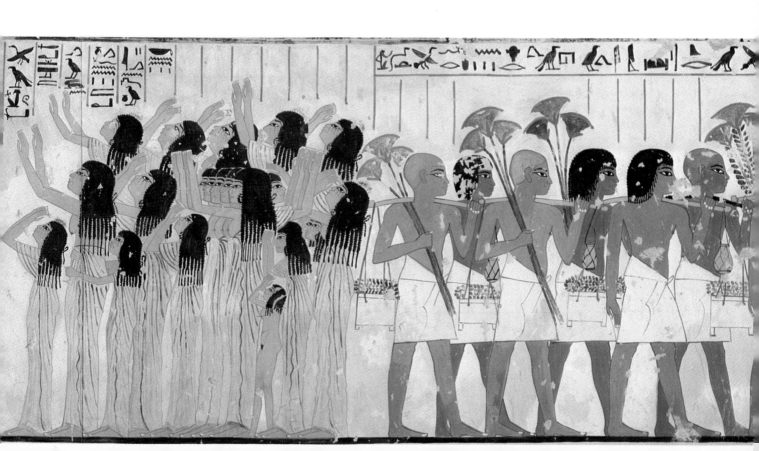

30 The vizier Rekhmira and his mother are seated before offerings of bread, meats, vegetables, and fruit piled in tiers on a table. Beneath it are hieroglyphs (long-stemmed lotus leaves) multiplying the offerings by thousands. The missing figure was a *setem* priest who officiated at the ceremony, and who was, according to custom, a son of the deceased. In Figure 32 another tomb owner's son wears the priest's ceremonial leopard-skin robe. About 1475 B.C. Tomb of Rekhmira (T 100), Sheikh abd el Qurna. 30.4.79

32 As offerings are being made to the sculptor Ipuy and his wife, a pampered cat sporting a collar and a silver earring poses beneath a chair. Her kitten, with the temerity of the young, is playing on Ipuy's lap. This copy, unlike all others in the collection, is a rendition of a badly damaged but very attractive picture and was painted to resemble the work in its original condition. About 1275 B.C. Tomb of Ipuy (T 217), Deir el Medina. 30.4.114

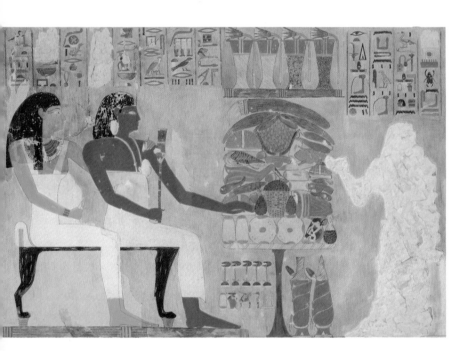

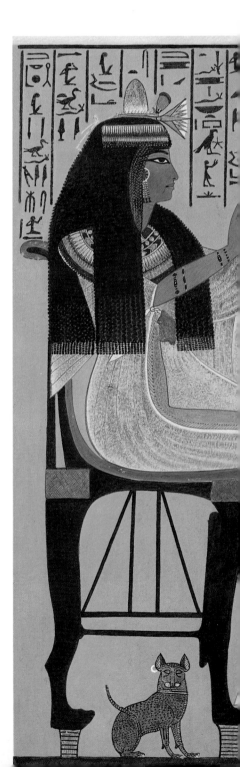

31 Beneath the chair of a queen, a cat holds a goose by the neck, while an excited monkey leaps over them. This detail is from a painting of Amenhotpe III and Queen Tiye enthroned, of which only the lower section survives. About 1380 B.C. Tomb of Anen (T 120), Sheikh abd el Qurna. 33.8.8

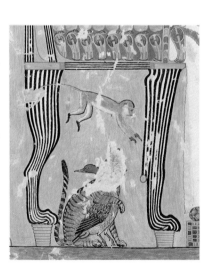

representing "thousands" beneath the table.

Often in these scenes, perhaps to ensure that the deceased would feel at home, the artist placed a favored pet, such as a dog or cat, beneath a chair. In one instance a stolid-looking cat stares out at us from beneath its mistress's chair, while a cheeky kitten plays on its master's knee (Figure 32). In other scenes a household cat might be shown eating a fish, or even "embracing" a

goose, while a monkey leaps over their heads (Figure 31). The artist obviously took delight in including such engaging details, and he did so when decorum permitted, but never in a way that would detract from his main subject or lessen the dignity of his principal figures.

A fine illustration of the practicality and appeal of the Egyptian artist's mode of representation is found in his portrayal of a

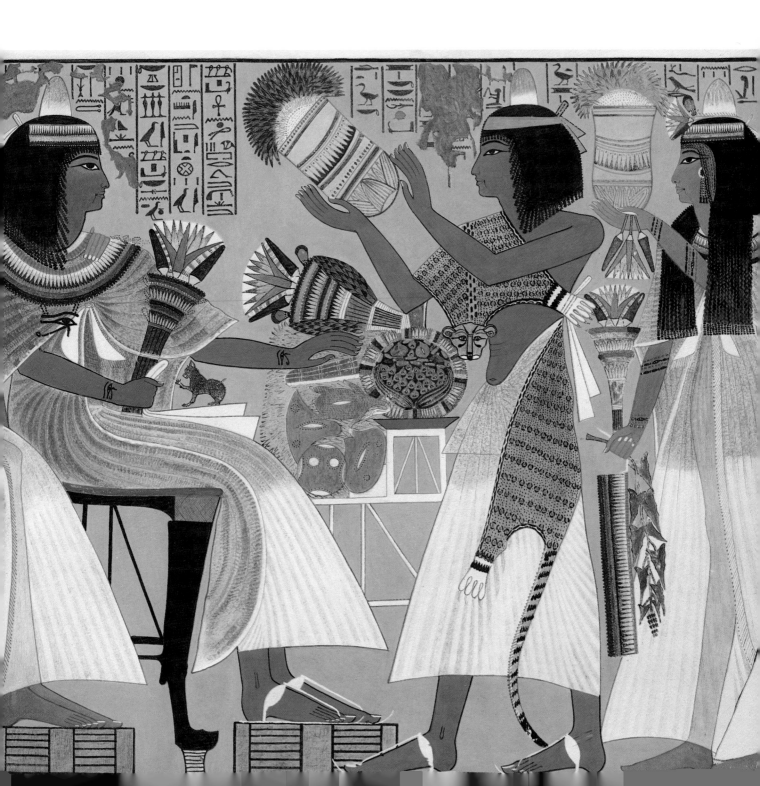

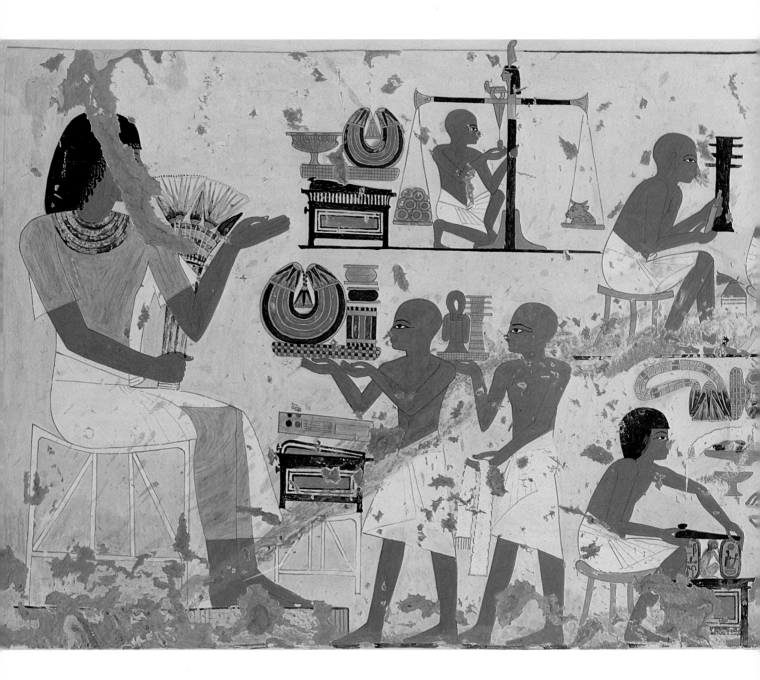

33 In one of the best preserved scenes at Thebes of a royal workshop of artisans and craftsmen, a superintendent, who holds a stylized bouquet, oversees the labors of his staff and inspects the finished articles. In this detail at the upper left, at the superintendent's eye level, thick rings of gold are weighed on a balancing scale. The counterweight, shaped like a bull's head, is equivalent to ten rings of raw gold. Before the weighmaster, wood-carvers shape with adze and chisel the *djed*, symbol of stability, and the *tayt* sign, meaning "protection," for use as decorative elements. These are passed on to the cabinetmakers, where a balding old master has the delicate task of fitting them into the

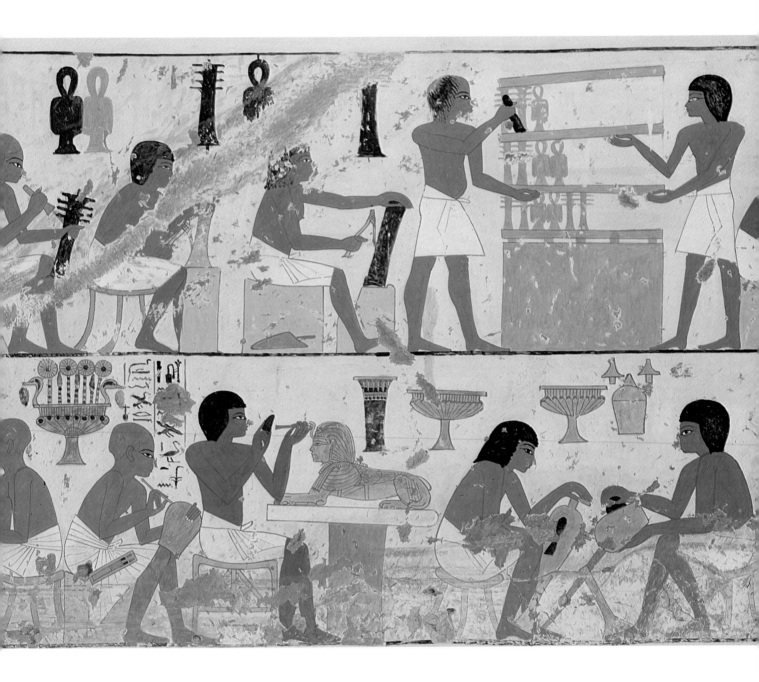

open panels of a catafalque. In the register below a pair hammer out gold and copper vases. Next come the craftsmen entrusted with fine details: one chisels the sacred asp on the head of a sphinx, another paints a vase, and two jewelers (one of whom holds a box) display and discuss their work. The finished products presented for approval include a collar and bracelets of inlay and gold. Because two sculptors, both of supervisory rank, shared the tomb in which this painting appears, the identity of the superintendent has not been determined. About 1380 B.C. Tomb of Nebamun and Ipuky (T 181), El Khokha. 30.4.103

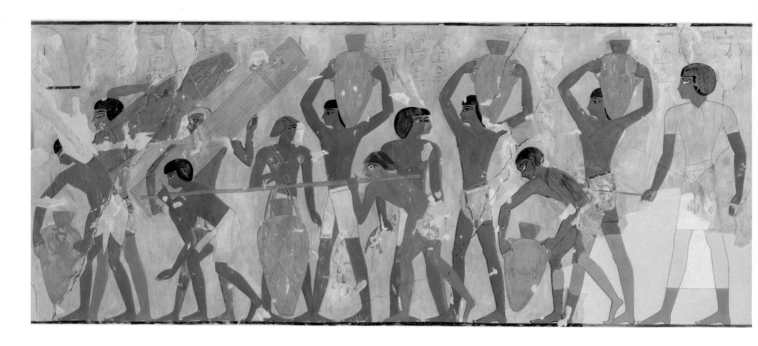

34 Prodded by a foreman, workmen move cargo unloaded from boats. The great jars of wine and oil and bundles of papyrus are destined for warehouses of the temple of Amun at Karnak. The grouping in this scene is excellent, and the movements expressive of the hard labor involved. About 1450 B.C. Tomb of Rekhmira (T 100), Sheikh abd el Qurna. 30.4.151 (restored)

35 This preliminary drawing was sketched in the corridor of Senenmut's unfinished tomb beneath a courtyard of the temple of Hatshepsut (see Figure 27). The squares indicate that the drawing was an enlargement of a preparatory study. Many portraits of Senenmut were found hidden behind folding doors in the temple of his royal mistress. The hieroglyphic inscription identifies him as the "steward of the house of Amun." About 1500 B.C. Tomb of Senenmut (T 353), Deir el Bahri

garden pool and the trees around it. The pool is seen from above, with the water rendered in a zigzag pattern that could be conveniently interrupted to reveal simultaneously and with clarity lotus blossoms and waterfowl on the surface and fish swimming beneath (see Figure 38). The trees project at right angles to the edge of the pool so as not to obscure it, while their trunks and foliage are revealed in full (Figure 6).

Despite the tendency of the Egyptian artist to show people in a flat, friezelike procession, he could on occasion give an excellent impression of a cluster of busy men at work, as he did very successfully in a painting in the tomb of Rekhmira (Figure 34). In his portrayal of human figures he combined two points of view: almost always, heads and legs are in profile, shoulders in full frontal position. While it must be admitted that some of the representations of arms and shoulders of active figures seem awkward, we are rarely in doubt as to what is going on. In a wrestling match, as in Figure 36, it is easy to imagine the actual movements, and in dancing scenes the artist sometimes recorded such nuances as swinging hair. The rendering of the eye frontally when the head is in profile is a convention to which one soon gets accustomed, and it certainly does not prevent paintings and drawings of important officials such as Senenmut from being recognizable (Figure 35).

The rites connected with the owner's interment were always elaborate, and the scenes are made more dramatic by inclusion of the bereaved (see Figure 29). The carrying to the tomb of all the material needs of everyday life considered necessary to a wealthy man's well-being in the next—his household furniture, clothes, jewelry, toilet

36 Singlestick fighting and wrestling in the precincts of the temple of Tuthmosis III. The wrestling match is shown in sequence: the opponents grapple, and the winner emerges with his arms raised in victory. Depicted in the shrine is a sacred barque. About 1300 B.C. Tomb of Amenmose (T 19), Dra abu'l Naga. 32.6.1 (restored)

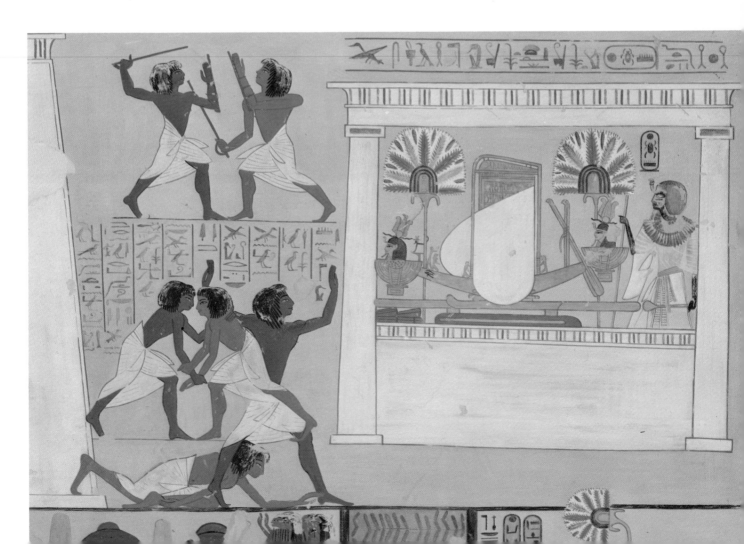

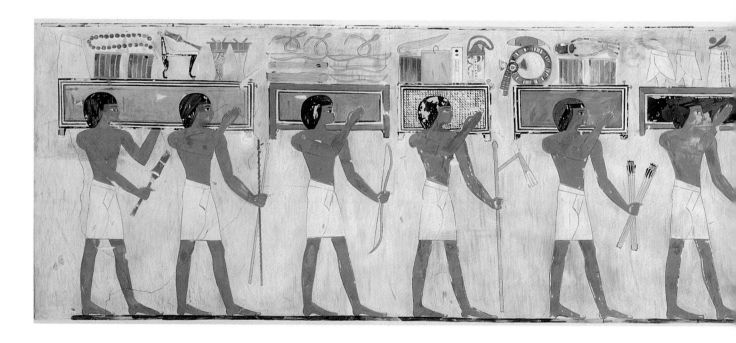

37 Above, the vizier Rekhmira's possessions are carried to his tomb in inlaid wooden boxes, but the objects within are represented as though they were on top. Among them, right to left, are three bags of eye paint; a mace, leather shields, and battle axes; unguents and a mirror; a jeweled collar; linen clothing; inlaid bracelets, and a headband with tassles; a scribal palette, writing tablet, and a copper knife; bows and arrows; a chair, baton, and a necklace. Two statuettes, each wearing the red crown of Lower Egypt, are carried separately. About 1475 B.C. Tomb of Rekhmira (T 100), Sheikh abd el Qurna. 30.4.80

38 In a canal among the marshes, fishermen have made a good catch in a net dragged between their boats. They have begun to draw in the net, and the captains shout directions as the crews manipulate the craft, which are made of short planks owing to the lack of more suitable timber in Egypt. In this lively and colorful scene, the artist has interrupted his zigzag ripples of water with lilies of two varieties, papyrus, fish of various sorts and sizes, and waterfowl. About 1275 B.C. Tomb of Ipuy (T 217), Deir el Medina. 30.4.120

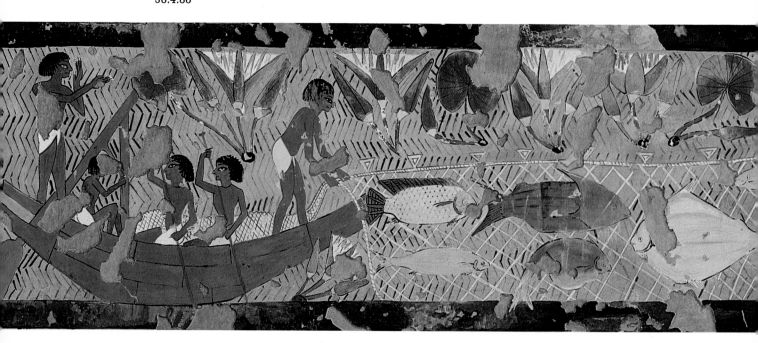

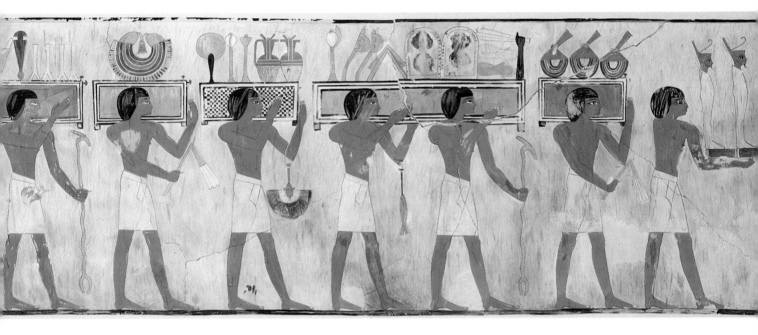

articles, and other possessions—formed a part of the funeral procession (Figure 37). The personal belongings were usually transported in handsome chests, but the artist often displayed the objects within as though they were on top, thus enabling us to see far more in his painting than if we had been watching the actual procession.

In most instances the artist's message was probably strictly truthful, but in matters of color he exercised considerable license.

To cite one of many examples, it was the practice to give Egyptian men a strong reddish complexion and women one of a clear yellowish cast. These tones were probably directly related to the ready availability to the artist of the pigments, and they in themselves were subject to variation. However, he had no qualms about changing the color of a person's skin, sometimes for aesthetic reasons or simply for variety. His love of diversity is particularly striking in a paint-

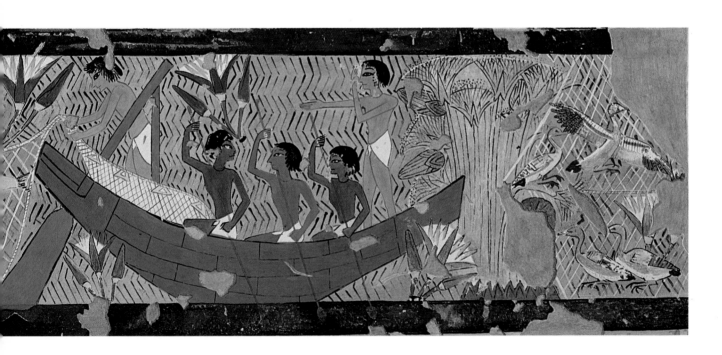

39 The high priest Userhat, his wife, and mother are entertained in a garden by the goddess of the sycamore fig tree. The goddess appears in human form with a diminutive tree on her head. Her guests are shown both as human beings and as small birdlike souls fluttering in the trees and drinking water from the small T-shaped pool. The whole is an exquisite tapestry of color and detail. The goddess wears a slim, beaded dress, and her guests the sheerest of linen with finely rendered pleating. The cones upon their heads are scented unguents. About 1320 B.C. Tomb of Userhat (T 51), Sheikh abd el Qurna. 30.4.33

ing where Nubian princes in a row are depicted with alternating skin tones of black and brown, curls alternately red and black, and sidelocks of bright blue (Figure 42). In this case it must be taken into account that the use of wigs was common in ancient Egypt.

In his treatment of supernatural beings, the Egyptian artist had far more scope than his much later counterpart in Europe, who was usually content to put wings on human beings to create angels. The ancient Egyptian, satisfying a more demanding religion, was adept at combining the heads of animals

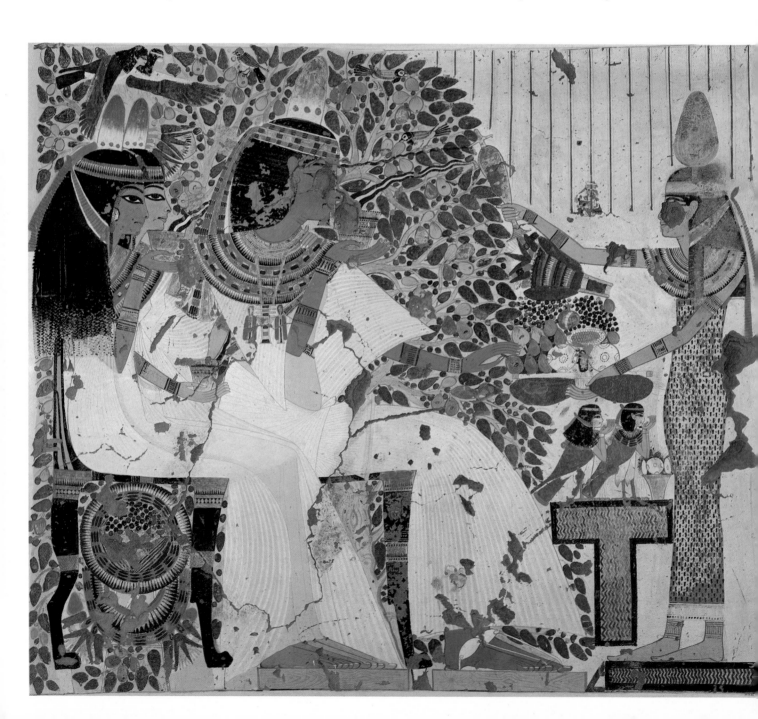

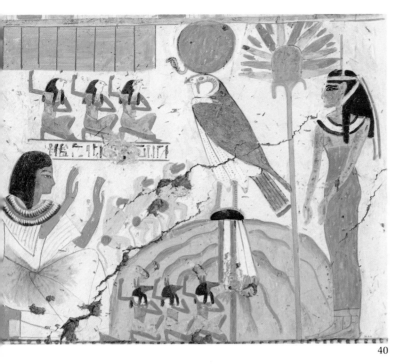

40

40 Userhat kneels before the falcon-god Ra-Harakhty, who here symbolizes the setting sun, and a goddess of the west. Sacred baboons and jackal- and hawk-headed souls of prehistoric dynasties join him in the adoration. The yellowish pink color is typical of the hills in which the tombs are located. About 1320 B.C. Tomb of Userhat (T 51), Sheikh abd el Qurna. 30.4.31

41 Two Cretans, with characteristic hairstyles, carry a copper ingot, conical cup, gold vase, and leather-sheathed dagger. One wears a woven kilt and elaborate shoes. About 1475 B.C. Tomb of Rekhmira (T 100), Sheikh abd el Qurna. 31.6.42

or birds with human bodies to create all sorts of divinities (see Figure 14). Even the meeting of the deceased with the gods and goddesses seldom seems awesome (Figure 40); in fact, it can be charming, as in the scene where Userhat, his wife, and his mother are entertained in a garden by the goddess of the sycamore fig tree (Figure 39).

For many of us, the Egyptian artist's revelations of life in this world are by far the most fascinating. Since the wall paintings depict in detail each tomb owner in his own earthly environment and occupations, the range of subjects is indeed comprehensive, covering almost every phase of ancient Egyptian life and the parts played by its people, from the highest official to the humblest servant.

In the tombs of the most politically powerful, there are scenes of foreigners bearing tribute—Syrians, Libyans, Nubians, Cretans, to name but a few (Figures 41, 42). The artist portrayed faithfully the costumes of each group and the products and crafts of their countries. Even trees are included among the gifts, reminding us that in those times, as now, man was not always content with the flora indigenous to his own country. As to fauna, there is almost no end to the

41

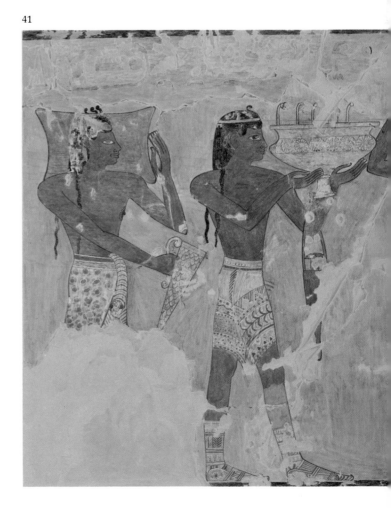

42 Part of a tribute scene in the tomb of Huy, viceroy of Nubia under Tutankhamun. At the upper right are northern Nubians of high rank, and a princess in an ox-drawn chariot. Walking behind are warriors, their submission made certain by the *sheyba* (taming stick) attached to their wrists and

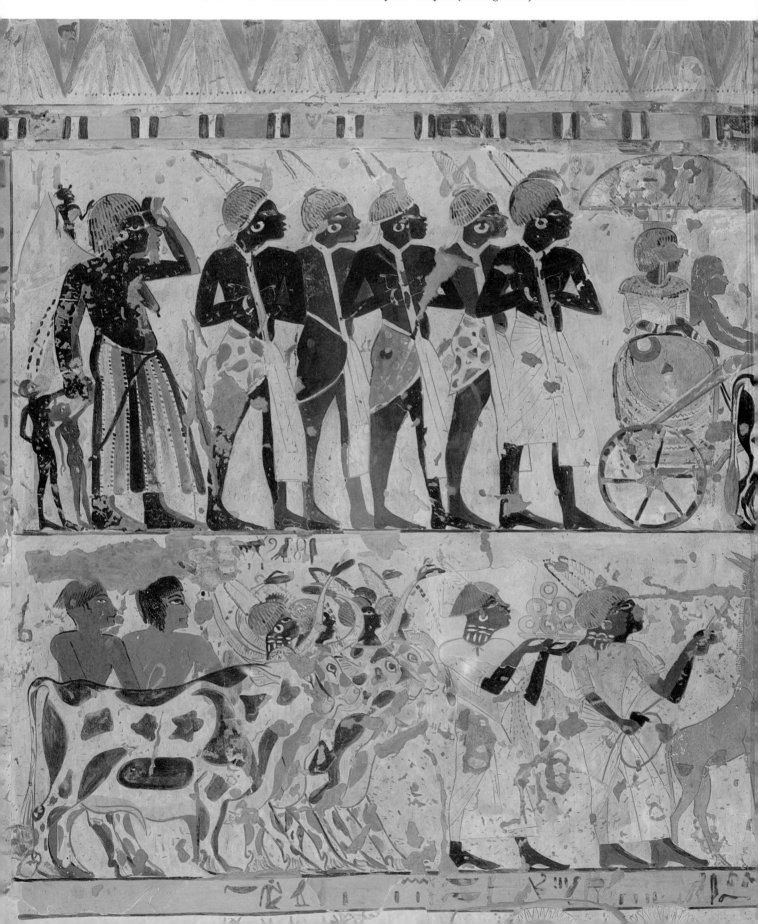

necks. Women and children follow. Below are southern Nubians and their retainers. Among gifts to the king are rings of raw gold, a giraffe, and oxen, the latter with dummy heads of Nubians set between horns ending in hands. About 1360 B.C. Tomb of Huy (T 40), Qurnet Murai. 30.4.21 (restored)

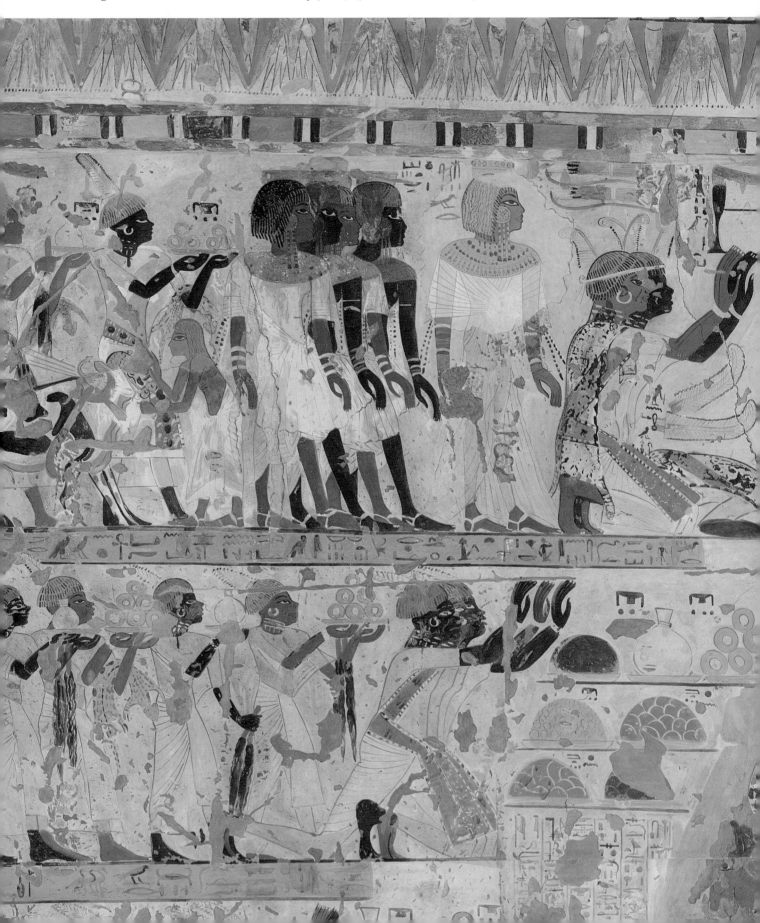

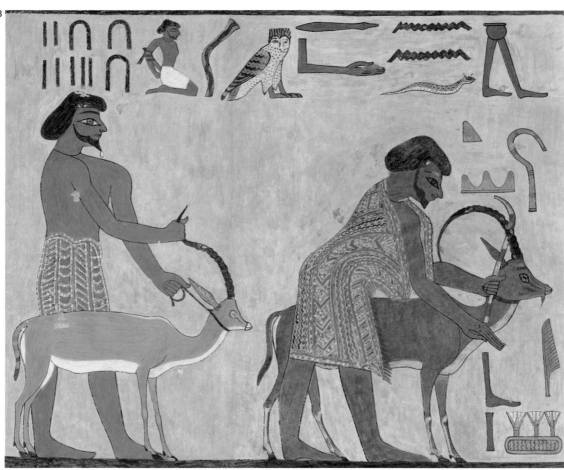

43 Bedouins of western Asia, in typical gaily colored costumes, are shown here with a gazelle and an ibex, possibly tribute to Khnumhotpe, overseer of the eastern desert. About 1890 B.C. Tomb of Khnumhotpe (T 3), Beni Hasan. 33.8.17

exotic creatures one sees, such as bears, elephants, monkeys, baboons, and giraffes. In one tribute scene in the tomb of Rekhmira, who was vizier of Upper Egypt under Tuthmosis III and Amenhotpe II, the artist appears to have indulged his sense of humor by showing a little green monkey climbing the neck of a giraffe (Figure 44). But Nina de Garis Davies learned from a gamekeeper in Africa that monkeys actually do steal rides in this manner to get from one group

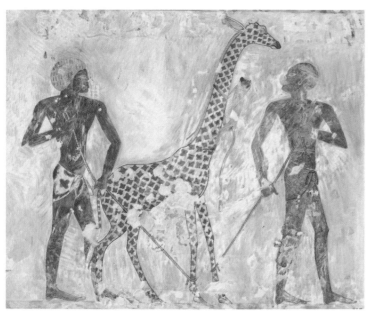

44 In a tribute procession a giraffe, led by two Nubians who hold its forelegs by ropes, has a little green monkey climbing its neck. The monkey's action might be construed as a humorous detail, but the artist has given an accurate portrayal: in Africa monkeys sometimes steal rides in this manner to get from one group of trees to another. About 1475 B.C. Tomb of Rekhmira (T 100), Sheikh abd el Qurna. 31.6.40

of trees to another. Thus the Egyptian artist accurately portrayed not only the animal but its habits as well.

Some scenes can have deeper implications, such as the tribute procession in the tomb of Huy, viceroy of Nubia under Tutankhamun (Figure 42). Here, approaching Huy and Tutankhamun himself, a Nubian princess rides in an elegant chariot of Egyptian design pulled not by fine horses but by oxen. She also lacks a personal servant to hold her parasol, so it has become part of her headdress. This surely emphasizes in a condescending way the provinciality of the Nubian princess. In the register beneath is a group of oxen with human heads between their horns, which terminate in hands. Even though these heads and hands would seem to be dummies, the oxen were being brought, perhaps for sacrifice, in Tutankhamun's honor. Submission as well as adoration are thus vividly expressed.

All of the crafts of ancient Egypt are carefully recorded in the tomb paintings. Since details from the finest examples are to be found in the Metropolitan Museum's facsimiles, we are provided with a veritable guide to the workshops of every trade (Figures 33, 53-62). Artisans of all kinds—sculptors, chariot makers, goldsmiths, carpenters, potters, and leather workers—may be seen at their daily tasks. In the tomb of Ipuy, a sculptor during the reign of Ramesses II, a marvelous scene shows artisans in the process of constructing an elaborate catafalque (Figure 45). Activity is

45 Almost a dozen men are involved in finishing the work on this elaborate catafalque. Inside is a bed for the deceased with a high footboard and curved headrest, steps, a mirror, and a table with some figs; above is a polychrome hanging of cloth or leather panels. At the lower left an artisan is having his eyes made up. (See detail on page 48.) About 1275 B.C. Tomb of Ipuy (T 217), Deir el Medina. 30.4.116

On the roof of a nearly completed catafalque, one artisan has fallen asleep, and is being aroused because the boss has spotted him. This amusing detail is from a painting in the tomb of Ipuy, a sculptor who helped decorate the royal tombs at Thebes. About 1275 B.C. (see Figure 45)

so brisk that it takes a while before one realizes that the artist has introduced some humorous incidents. A bit of skylarking is going on: one workman has taken time off to have his eyes made up; another, exploiting his location high atop the catafalque, has fallen asleep and is being aroused by a fellow worker because he has just been spotted by the boss (see detail above). Such incidents, although always taking place among the lower ranks, indicate that when the Egyptian artist was not inhibited by taboos associated with those of high

46 On an estate supervised by Menna, overseer of government lands, two surveyors measure the standing grain with a rope knotted at regular intervals. Scribes with palettes are on hand to record the results, attended by a helper who holds their equipment in a bag. Tenants on the estate include an old man with a staff, a couple greeting officials with gifts or refreshments, and a small boy carrying a baby goat; a donkey in front of the boy has been badly damaged. In the register below Menna, standing in a papyrus shelter, is offered two jars of wine. Behind him eight scribes record the harvest, as laborers measure the grain by bushels. One scribe, sitting on top of a grain pile, counts on his fingers. Nearby is a wooden box for writing materials. At the left Menna's chariot and horses, held by a groom, await his departure. About 1420 B.C. Tomb of Menna (T 69), Sheikh abd el Qurna. 30.4.44

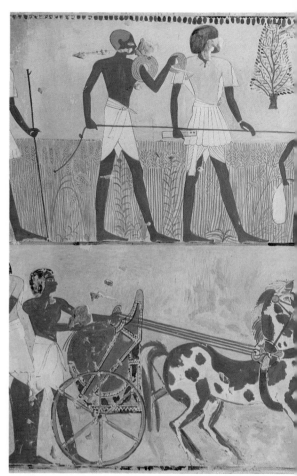

rank, he endeavored to show life as it really was. We, in turn, are reminded that human nature has not changed in 4,000 years.

Scenes of a wealthy Egyptian tending to the affairs of his self-supporting country estate leave no doubt that all procedures were highly organized, as we see the measuring of standing crops and the careful recording of essential facts and figures by scribes (Figure 46). Overseers, farmhands, herdsmen, laborers of all sorts and ages go about their chores, often under the eye of their lord and master. The raising of wheat and barley is shown from plowing and sowing to harvesting and winnowing. Grapes are grown in well-ordered vineyards, picked, trodden, and wine stored in jars (Figure 47). As flax is essential to the making of linen, the standard material for Egyptian clothing, we are shown both the work in the flax fields and the entire process of weaving (Figure 50)—a process, incidentally, at which the ancient Egyptians were

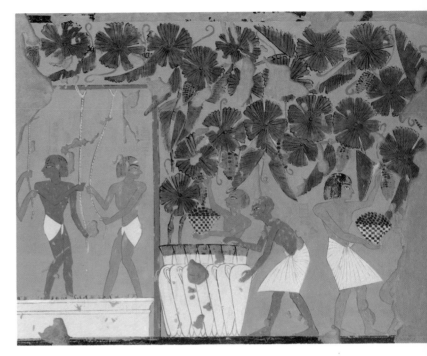

47 Vineyards were usually depicted with grayish backgrounds until the Ramesside period, when yellow was used with pleasing results. This scene shows wine making, from the picking of grapes to the sealing of wine jars. About 1275 B.C. Tomb of Ipuy (T 217), Deir el Medina. 30.4.118

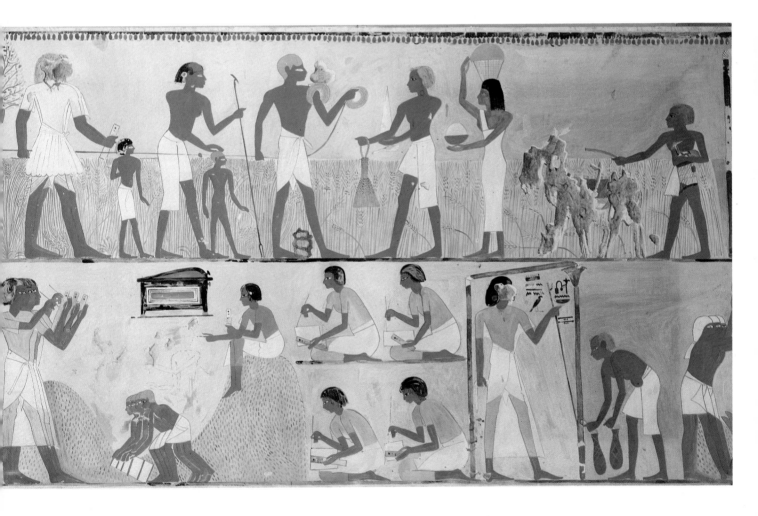

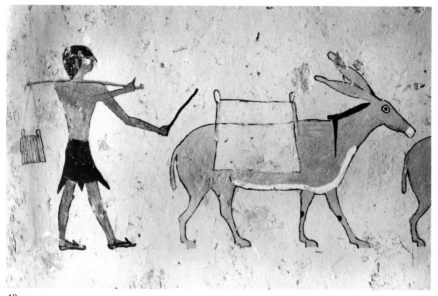

48 At the left a donkey, with saddle packs, is followed by his carefree attendant. The donkey was the patient beast of burden throughout dynastic Egypt and remains so to the present day. (The camel was not used in Egypt until late in the first millennium B.C.) This detail is from a photograph taken by Harry Burton in the tomb of Djar (T 366) in the Asasif. About 2030 B.C.

48

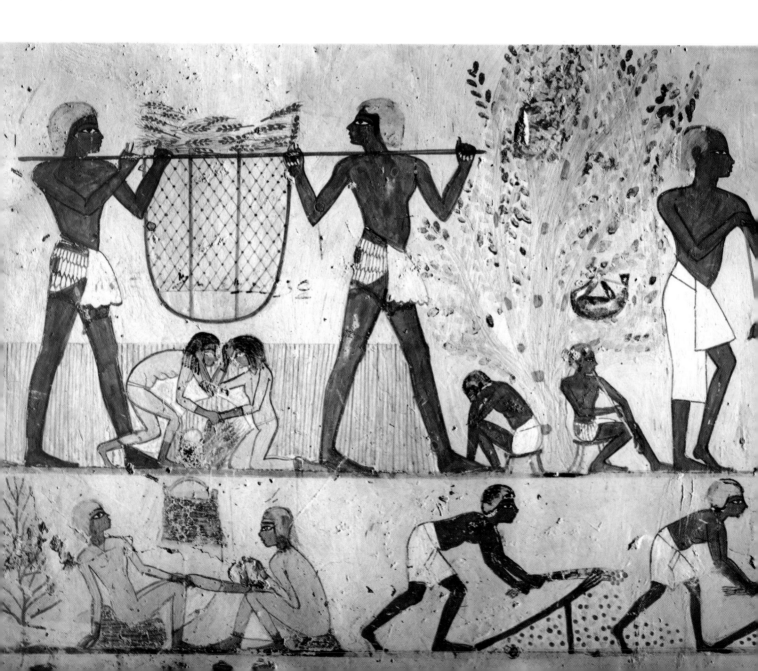

so adept that the finished fabric was semi-transparent. Animal husbandry is accorded the same thorough treatment. These scenes disclose the tending of cattle and their service to man, from birth to their slaughter for food and sacrifice. As would be expected in a country owing its very life to a river, fish were an important item of diet, and we discover they were caught in large numbers in nets dragged between boats (see Figure 38).

These themes recur in many tomb paintings, but just as no two estates were exactly alike, so also were the artist's portrayals of them varied. In the midst of the organized activity, so absorbing in itself, there are always the candid glimpses of his lesser characters, such as a happy-go-lucky lad and his donkey (Figure 48), or two gleaners having a spat in the fields (Figure 49). There are surprises as well. In a scene in the tomb of Sennedjem, the fields of wheat and flax have become the fields of Elysium, where the plowing and reaping are done not by the peasants for their lord and master but by Sennedjem and his wife, possibly for theirs (see below).

By great good fortune, the Museum's expedition at Thebes discovered early in 1920 a tiny chamber beneath the main corridor of the rock-cut tomb of Meketra, a high palace official who died about 2000 B.C.

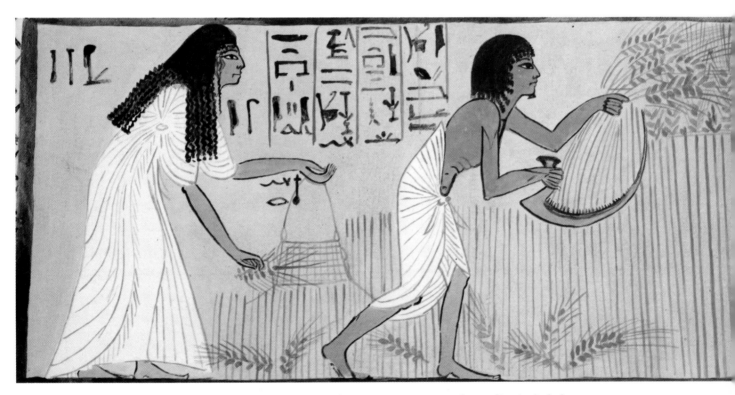

49 During the harvest two gleaners have a spat; one is pulling the other's hair. A basket filled with ears of wheat has fallen on the ground between them. Below, another gleaner removes a thorn from a friend's foot. This detail is from a photograph taken by Harry Burton in the tomb of Menna (T 69), Sheikh abd el Qurna. About 1420 B.C.

The Egyptian concept of paradise included farming a plot on the estate of the god of the afterworld. Above, Sennedjem and his wife, attired in elegant clothing, harvest wheat in the fields of Osiris. This detail is from a well preserved painting in the tomb of Sennedjem, a craftsman who worked on the royal tombs. About 1300 B.C. (see Figure 64)

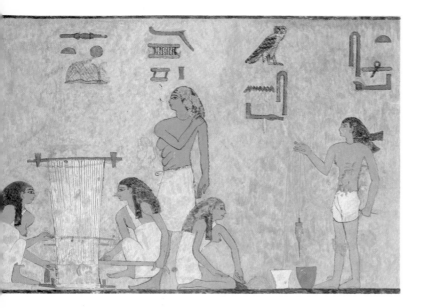

50 Women spinning and weaving linen. The spinner at the right uses two spindles. The weavers employ a horizontal loom (seen from above) typical of the Middle Kingdom. About 1890 B.C. Tomb of Khnumhotpe (T 3), Beni Hasan. 33.8.16

51 As the state ship of viceroy Huy gets ready to sail for Nubia, a pilot sounds the depth of the river at the prow; oarsmen take their posts; and sailors climb in the rigging fore and aft. Huy's horses are in their stall, and the viceroy himself is shown in the forward cabin. About 1360 B.C. Tomb of Huy (T 40), Qurnet Murai. 30.4.19 (restored)

It was crammed with brightly painted models of boats and buildings essential to the operating of a country estate. All were peopled with little wooden servants, some even in linen garments, hard at work at their various jobs. A comparison of this collection with the estate scenes from the wall paintings can be most rewarding, as the models mirror in three dimensions many of the activities the Egyptian artist rendered so faithfully in two.

In their leisure time social entertainment obviously gave the Egyptians much joy. We are shown elegant parties where guests are presented with floral collars and lotus blossoms, served cakes, fruit, and wine, and entertained by musicians and dancing girls (Figure 52). These scenes are so charmingly

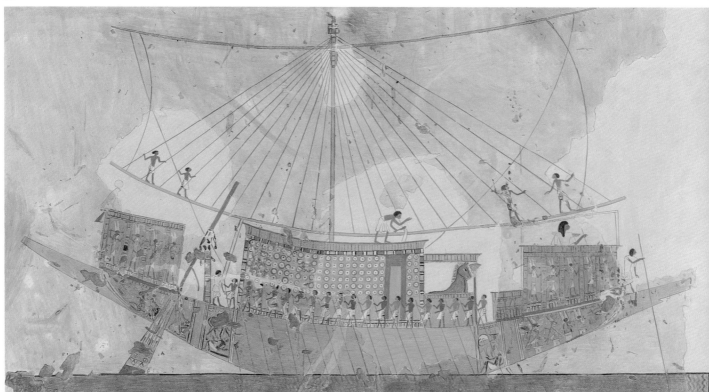

52 These musicians entertain at a feast in the home of the scribe Nakht. One plays a double flute, and another a standing harp with a soundbox covered by a leopard skin. The musician in the center, attired only in a jeweled belt and collar, is playing a long-necked stringed instrument that may be a lute. The facsimile has suffered flaking to a greater extent than the original. About 1425 B.C. Tomb of Nakht (T 52), Sheikh abd el Qurna. 15.5.19d

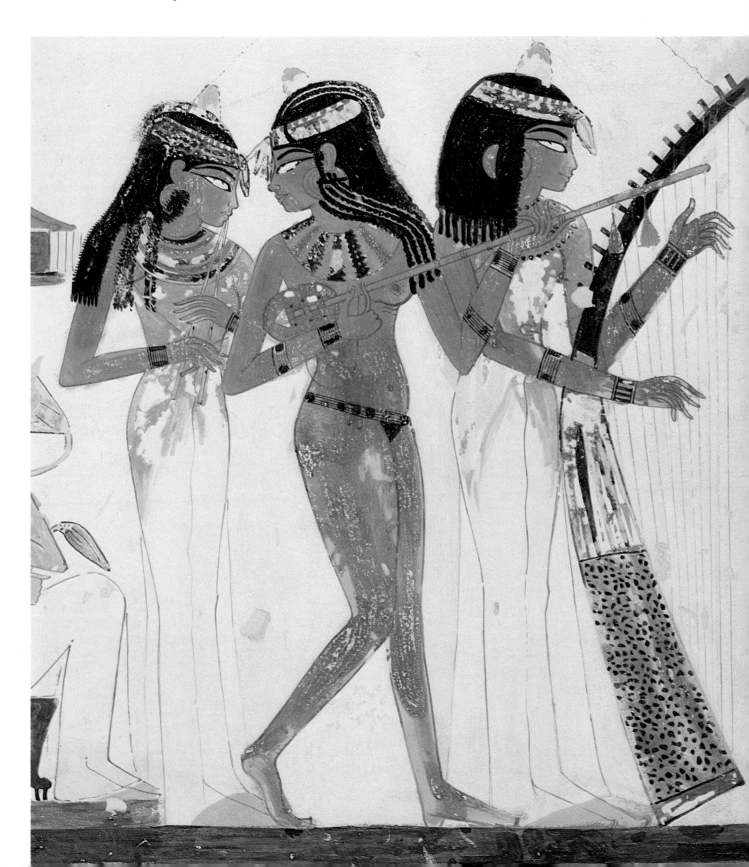

53

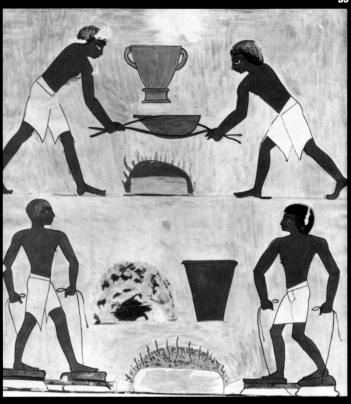

53-62 Craftsmen of Amun in the workshops of the temple at Karnak. These details are from scenes in the tomb of Rekhmira. (53) Smelters lift a crucible of molten metal off a fire. Below them men operate bellows with their feet to fan another fire. (54) A jeweler bores holes in stone beads with a bow drill, and another strings them. (55) A sculptor completes the head of a white limestone sphinx, while two workmen dress the surface of the stone—any flaws would be filled in with plaster. (56) Craftsmen on scaffolding finish a red-granite statue of Tuthmosis III. While three sculptors work on the front, a fourth chisels inscriptions on the back; the painter above him picks out the text in color. (57) Long leather thongs, made by cutting hide in continuous strips, are held fast at one end by a worker as they are twisted into rope to be used on ships. (58) A cabinetmaker fashioning an inlaid chest. Two essential tools, his adze and his carpenter's square, are shown at the right. (59) A smith holding tongs, used when soldering small objects, creates the necessary heat with a blowpipe. (60) A sandalmaker pierces the straps of a sandal. (61) Tanners and cutters prepare leather. One takes a hide from a jar where it has been soaking, another scrapes a hide with a stone, a third stretches a skin over a trestle, and two men cut leather on a sloping board. (62) To cast sections of bronze doors (shown above in plan), workers pour molten metal into a many vented mold. About 1475 B.C. Tomb of Rekhmira (T 100), Sheikh abd el Qurna. 31.6.11; 31.6.25; 31.6.10; 30.4.90; 33.8.2; 31.6.12,22,26; 35.101.2; 33.8.5

54

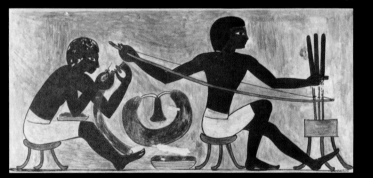

56

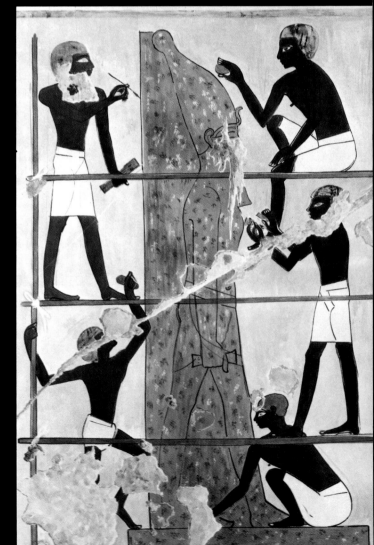

55

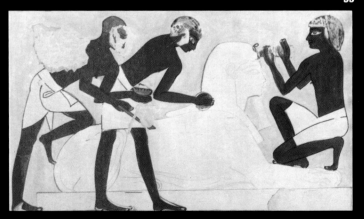

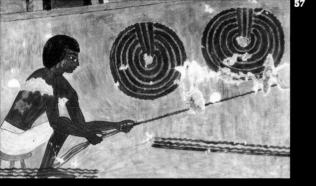

57

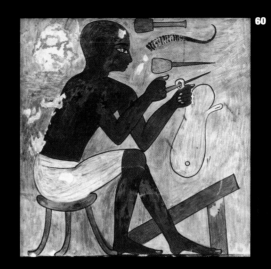

60

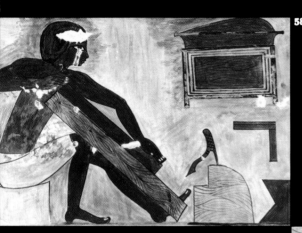

58

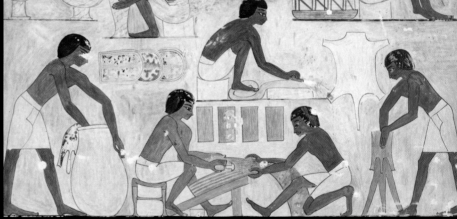

61

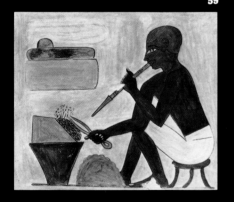

59

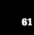

62

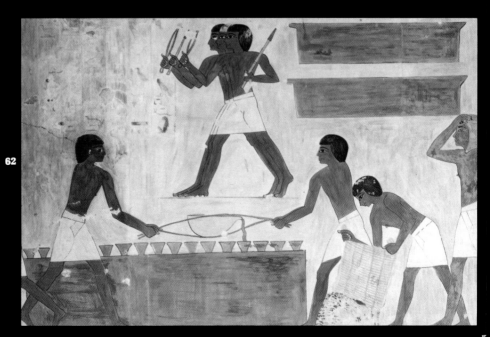

63 Attended by his family, Nakht enjoys sports in the marshes. At the left he hunts ducks with a throwing stick; at the right he spears fish—although the artist failed to include the spear. A goose once appeared on each papyrus skiff and a cat in the rushes, but they have been destroyed. About 1425 B.C. Tomb of Nakht (T 52), Sheikh abd el Qurna. 15.5.19e

depicted that they convey a feeling of pleasure even today. For their outdoor recreation men hunted wild animals, such as hyenas and gazelles, from light horse-drawn chariots, shooting their prey with arrows. Fishing was done with spears, and

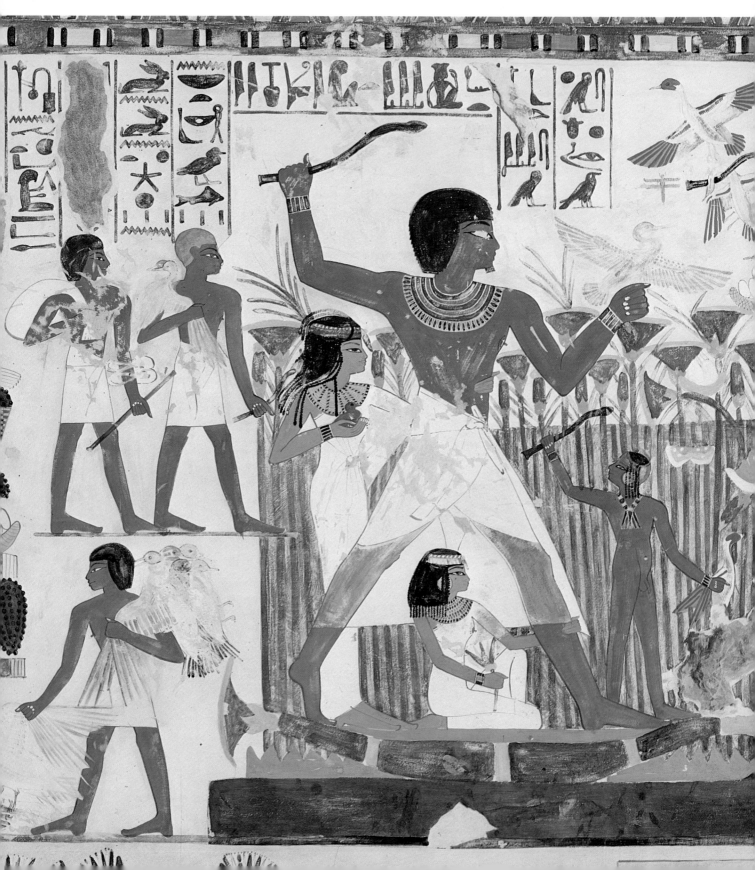

fowling with throwing sticks. Fishing and fowling in the marshes from a light papyrus skiff were often turned into a lively family outing (see below), where pretty young girls might wear nothing but jeweled belts and necklaces, and young boys nothing at all.

The Egyptian artist presented such scenes in a balanced pattern, but the formality of his design is enlivened by birds fluttering above the marshes and occasionally, as in the tomb of Menna, little animals climbing the papyrus stalks to steal birds' eggs.

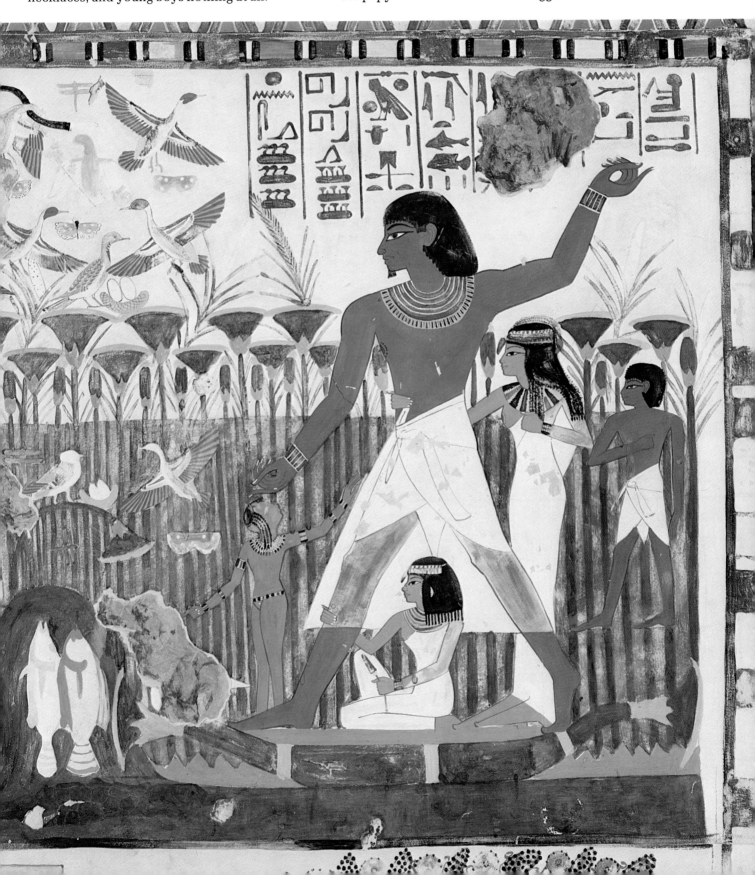

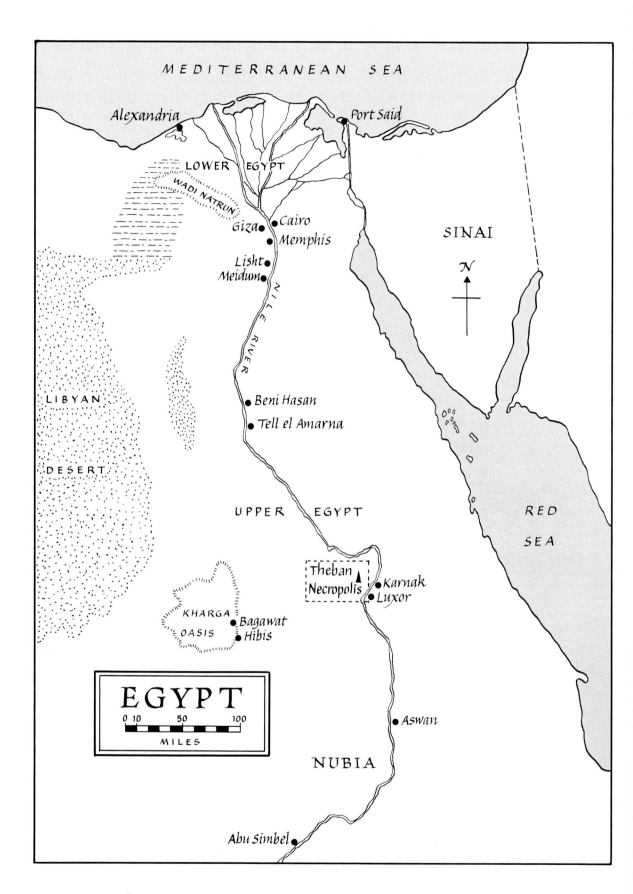

58

The Museum's collection of copies of Egyptian wall paintings is so comprehensive that it gives us the opportunity to appreciate the skill of the Egyptian artist and to make all kinds of fruitful comparisons to an extent impossible in the tombs themselves. As I have endeavored to demonstrate, if given more than a cursory glance, the facsimiles provide a starting point for all kinds of intriguing investigations. One can follow various lines of thought and be rewarded by the pleasures of discovery. Nothing is easier than to get started on such ventures, for despite the remoteness of the time when the original scenes were painted, they disclose much in common between that world and our own. I trust the reader will discover—as did I—that the Egyptian artist who told his story for the happiness of the deceased long ago did it so well that today we can enjoy it, too. Such satisfactions are not restricted to professional Egyptologists; they await all who give this unique collection careful attention.

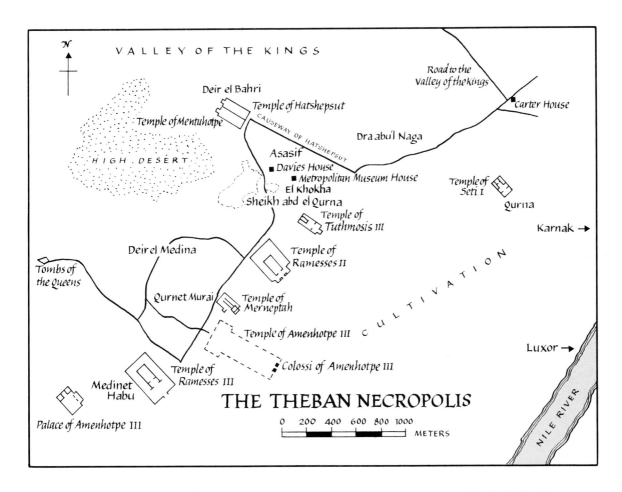

THE THEBAN NECROPOLIS

0 200 400 600 800 1000
METERS

Theban tombs are located in the following areas:

Asasif El Khokha
Deir el Bahri Qurnet Murai
Deir el Medina Sheikh abd el Qurna
Dra abu'l Naga

59

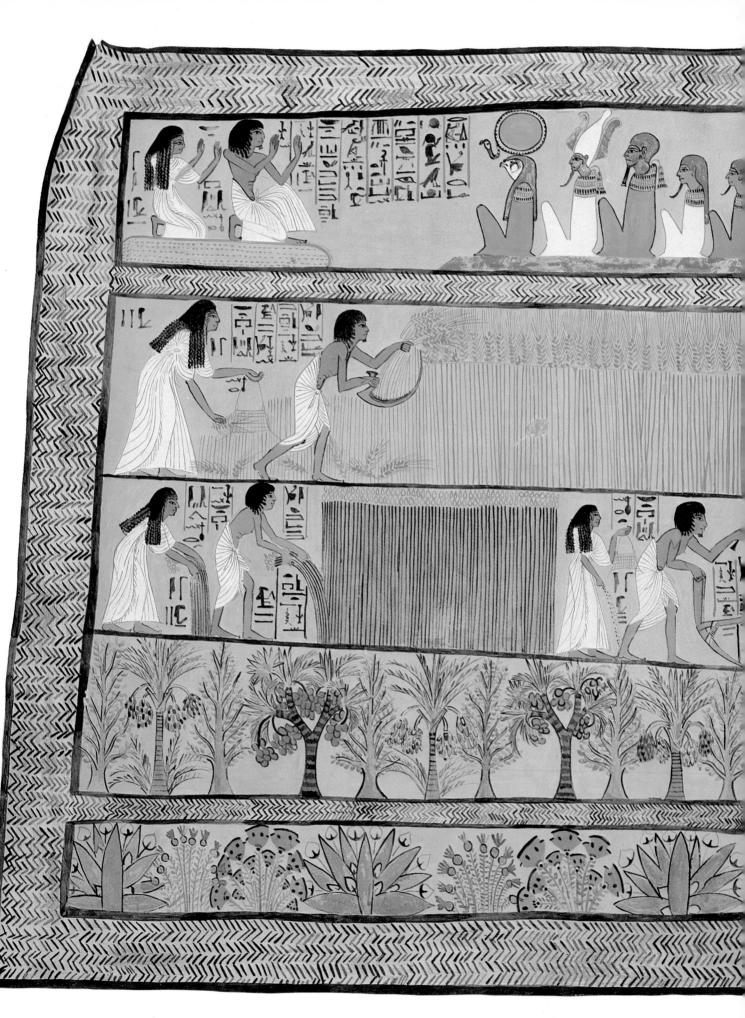

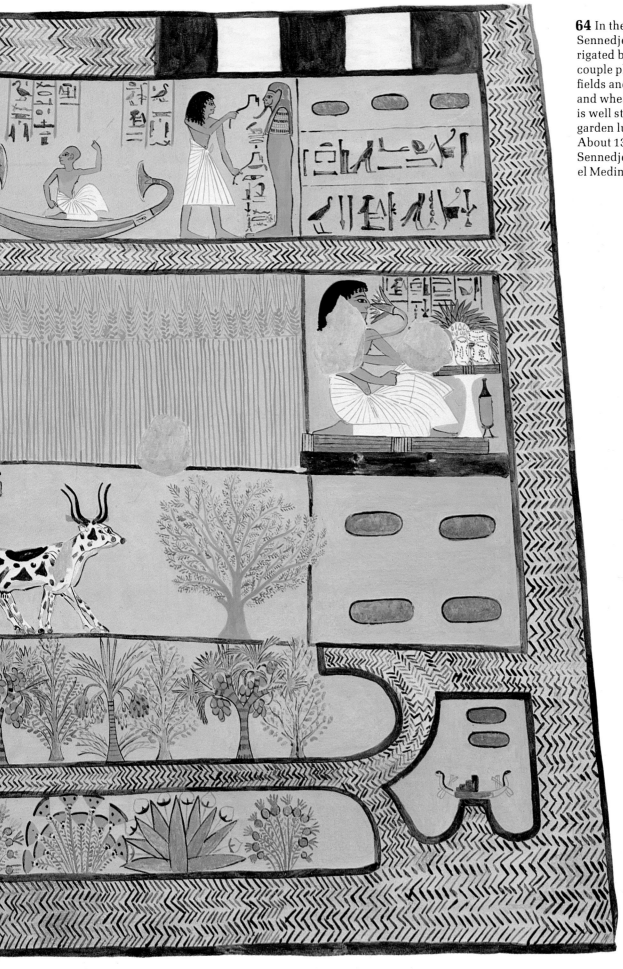

64 In the paradise of Sennedjem, which is irrigated by canals, the couple plow and sow the fields and harvest flax and wheat. The orchard is well stocked, and the garden lush with flowers. About 1300 B.C. Tomb of Sennedjem (T 1), Deir el Medina. 30.4.2

Old Kingdom

(III-VIII Dynasties): 2686-2160 B.C.

 First Intermediate Period

Middle Kingdom

(XI-XIII Dynasties): 2133-1633 B.C.

 Second Intermediate Period,
 including the Hyksos Period

New Kingdom

(XVIII-XX Dynasties): 1570-1085 B.C.

Opposite:

65 The spread of Christianity in Egypt, during the early centuries after Christ, brought with it an art markedly different in character, technique, and subject matter than the art of antiquity. This painting decorates the cupola of a mud-brick Coptic tomb at the Kharga Oasis. The figures, depicted against a background strewn with four-petaled roses, are all fair-haired, and are identified by Greek inscriptions. Both Biblical and allegorical subjects are illustrated, and are treated either as scenes or individual figures. Upon entering the tomb one is confronted with a representation of Daniel in the Lions' Den. He has a halo around his head and stands calmly between two very Persian looking lions that are snarling at his feet. To the left, in clockwise progression, are: Justice holding a cornucopia in one hand and her balancing scales in the other; a large figure in flowing robes, symbolizing Prayer; Jacob; Noah and his family in an ark, its roof supported by three columns, two with spiral fluting and pseudo-Corinthian capitals; two doves, one above the other, the lower dove carrying a twig from an olive branch to Noah, and the upper dove, representing the Holy Spirit, facing the next figure in the circle—Mary, who stands with hands raised in prayer at the moment of the Annunciation; Paul and Thecla, popular early saints in Egypt, seated on stools, as the apostle instructs his student; Adam and Eve with the serpent, who is coiled around a tree between them and is whispering in Eve's ear; Abraham about to sacrifice Isaac on an altar, with Sarah, her arm outstretched, to the left of Abraham, and behind him the Hand of God extending from above and the ram that was sacrificed in Isaac's place. The circle is completed by Irene (Peace), holding a scepter with a spearlike point in one hand and in the other the *ankh* sign of life, the sole symbol surviving from ancient Egyptian art and religion. Probably 5th or 6th century A.D. Tomb 238, Bagawat, Kharga Oasis. 30.4.228

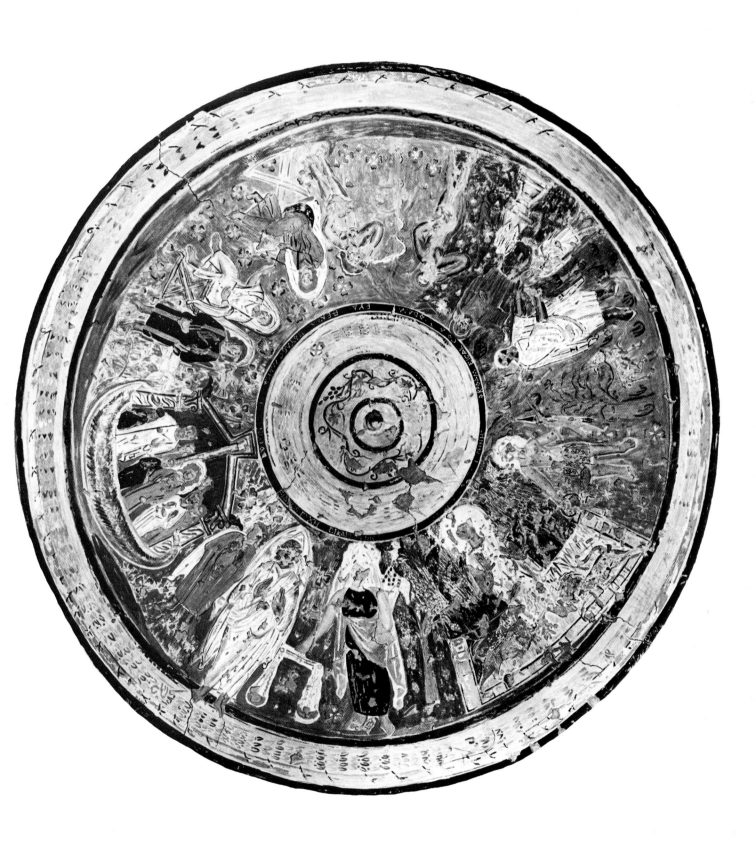

Catalogue of the Facsimiles

The following abbreviations
for copyists' names have been used:

CKW Charles K. Wilkinson

EHJ E. Harold Jones

FU Francis Unwin

HRH Hugh R. Hopgood

LC Lancelot Crane

NdeGD N. de Garis Davies (probably Norman de Garis Davies, but final determination is not possible)

Na.deGD Nina de Garis Davies

No.deGD Norman de Garis Davies

NH Norman Hardy

WJPJ Walter J. Palmer-Jones

The following abbreviations
have been used for original paintings'
present museum numbers:

CG Cairo Museum *Catalogue Général*

J Luxor Museum Journal

JdE Cairo Museum Journal d'entrée

Oxford Ashmolean Museum, Oxford

MMA Metropolitan Museum of Art

RSM Royal Scottish Museum, Edinburgh

If no site is indicated, location is Thebes.

The following information is given
for each facsimile:

Title of monument and its site with, where applicable, identifying Egyptian Organization of Antiquities tomb (T) number or excavator's number

Period

Description of scene and, where applicable and known, its present museum location and number

Location in tomb with PM (B. Porter and R. Moss, *Topographical Bibliography of Ancient Egyptian Hieroglyphic Texts, Reliefs and Paintings*) reference, where known. After the first citation in a tomb group, reference to Porter-Moss is by page. The following volumes have been cited: I²1 (vol. 1, 2nd ed., part 1), Oxford, 1960; I²2 (vol. 1, 2nd ed., part 2), Oxford, 1964; IV (vol. 4), Oxford, 1934; II² (vol. 2, 2nd ed.), Oxford, 1972.

Copyist and date of copying; length and height of facsimile in centimeters; scale with original

Accession number of facsimile in the Metropolitan Museum

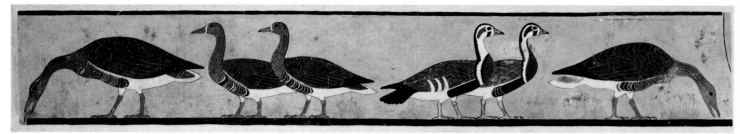

31.6.8

48.105.28

48.105.29

48.105.30

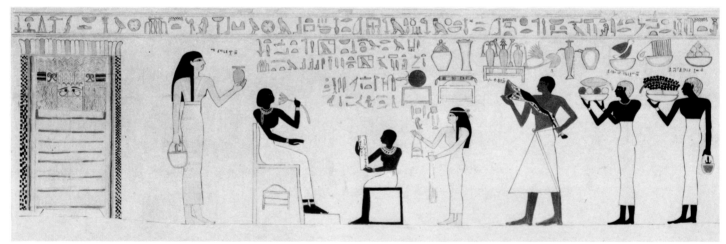

48.105.32

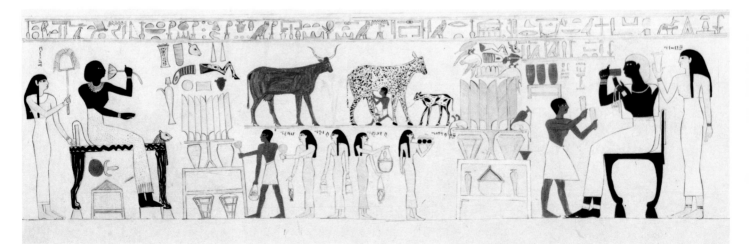

48.105.31

48.105.33

48.105.34

48.105.35

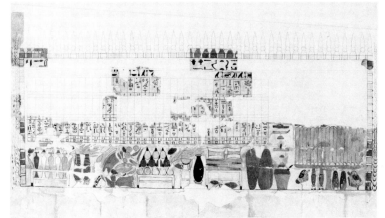

48.105.36

Tomb of Nofermaat and Itet, Meidum (Petrie 16B)
Dynasty 4, time of Snefru

Geese (now Cairo CG 1742)
Passage, PM IV 93
CKW (1920–21); 161.5 × 24.5; 1:1 31.6.8

Temple of Nebhepetra Mentuhotpe
Dynasty 11

Animal trampling foreigners
Ambulatory (?), cf. E. Naville, *The XIth Dynasty Temple at Deir el Bahri*, vol. 3, London, 1913, pl. 14
CKW (1920–21); 31.2 × 53.3; 1:2 48.105.28

Sarcophagus of Ashayt from Naville-Winlock 17 (now Cairo JdE 47267)
Dynasty 11, time of Nebhepetra Mentuhotpe

Provisions
Head end, interior
CKW (1926); 31 × 34; 1:2 48.105.29

Provisions
Foot end, interior
CKW (1926); 31 × 34.3; 1:2 48.105.30

Offering scene
Left side, interior
CKW (1926); 107.1 × 33.9; 1:2 48.105.32

Offering scene
Right side, interior
CKW (1926); 108.6 × 33.9; 1:2 48.105.31

Tomb of Khety (T 311)
Dynasty 11, time of Nebhepetra Mentuhotpe

Provisions (layout partially reconstructed)
Burial chamber, PM I²1 387 (4)–(5)
CKW (1923–24); 92.2 × 53.5; 1:4 48.105.33

Offering list and provisions (layout partially reconstructed)
387 (4)–(5)
CKW (1923–24); 98.5 × 55.4; 1:4 48.105.34

Provisions (layout partially reconstructed)
387 (4)–(5)
CKW (1923–24); 92.6 × 47.5; 1:4 48.105.35

Offering list and provisions (layout partially reconstructed)
387 (4)–(5)
CKW (1923–24); 97.6 × 47.6; 1:4 48.105.36

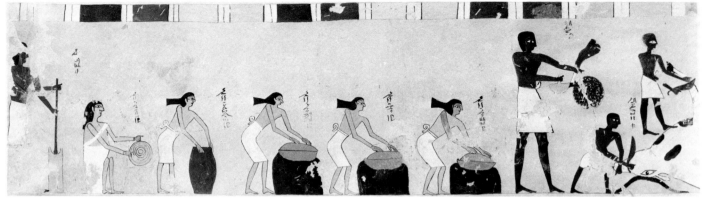

31.6.1

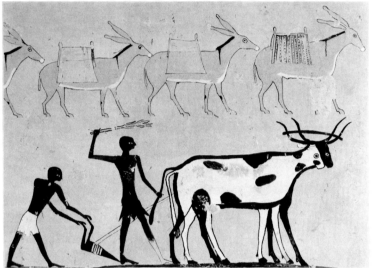

31.6.2

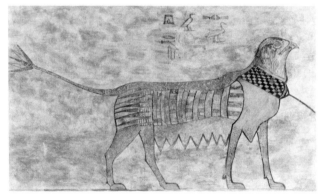

33.8.14

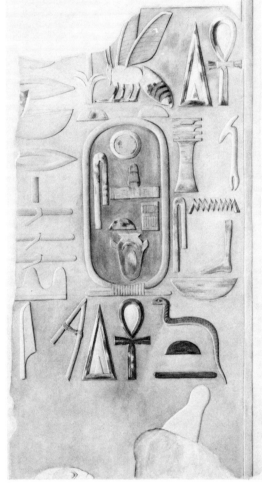

Inst. 1979.2.24

Inst. 1979.2.29

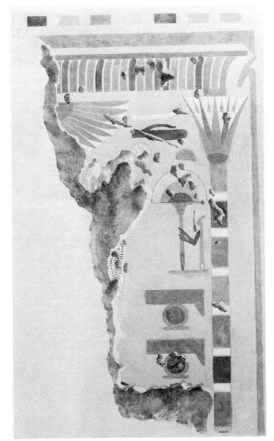

30.4.161

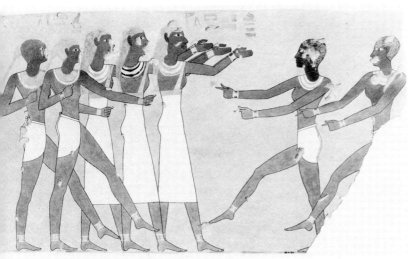

0.4.160

Tomb of Djar (T 366)
Dynasty 11, time of Nebhepetra Mentuhotpe

Preparation of food and drink
Hall, PM I²1 429 (2) II 2
Na.deGD (1930); 170 × 45; 1:1 31.6.1

Laden donkeys and ploughing
429 Pillar B(a) II–III
Na.deGD (1931); 118.5 × 81; 1:1 31.6.2

Tomb of Khety, Beni Hasan (Newberry-Griffith 17)
Dynasty 11

Griffin
Hall, PM IV 157 (15)–(16)
NdeGD (1931); 45.3 × 26.5; 1:1 33.8.14

Funerary Temple of Amenemhat I, Lisht
Dynasty 12

Inscription above king and god (now Cairo JdE 40483)
Probably EHJ (1907–8); 39.5 × 74.5; 1:1 Inst. 1979.2.24

Funerary Temple of Senwosret I, Lisht
Dynasty 12

Man carrying provisions
Sanctuary (?)
Copyist unknown; 57.2 × 29.7; 1:1 Inst. 1979.2.29

Tomb of Inyotefiker and Senet (T 60)
Dynasty 12, time of Senwosret I

Inscribed section of a kiosk
Passage, PM I²1 121 (3)
HRH (1914–15); 43 × 59; 1:2 30.4.161

Priestesses and dancers
121 (5)–(6) I
HRH (1914–15); 57 × 32; 1:3 30.4.160

Tomb of Khnumhotpe, Beni Hasan (Newberry-Griffith 3)
Dynasty 12, time of Senwosret II

Desert animal
PM IV 145 (7)–(10)
NdeGD (1931); 18.5 × 13.8; 1:1 33.8.11

Wild feline
145 (7)–(10)
NdeGD (1931); 36.5 × 21.5; 1:1 33.8.12

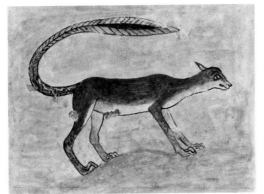

33.8.11

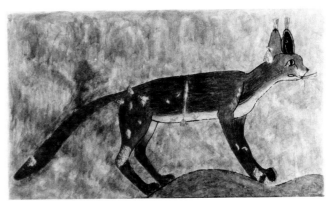

33.8.12

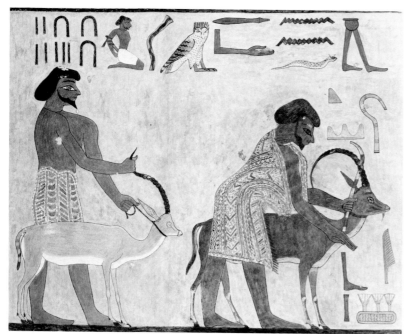

33.8.17

33.8.13

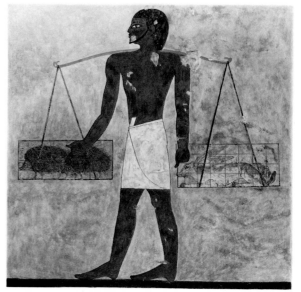

33.8.9

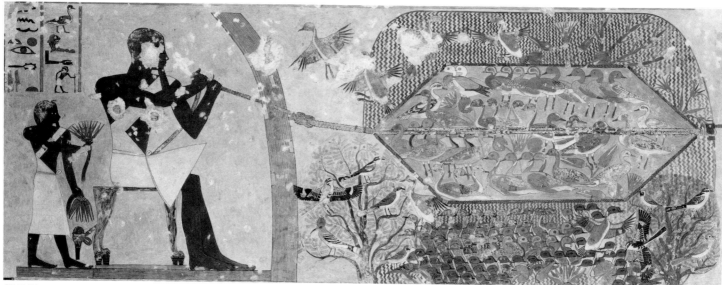

33.8.18

33.8.10

33.8.15

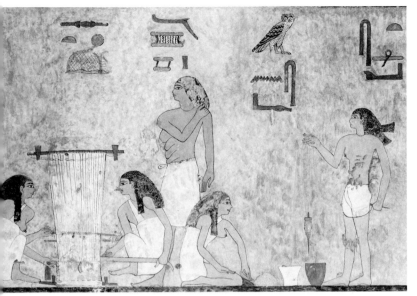

8.16

Tomb of Khnumhotpe, Beni Hasan, continued

Nomads with horned animals
145 (7)–(10)
No.deGD (1931); 81.5 × 63.5; 1:1 33.8.17

Nile perch
147 (12)
NdeGD (1931); 45.5 × 29.4; 1:1 33.8.13

Khnumhotpe netting fowl
147 (13)
Na.deGD (probably 1931); 260 × 101; 1:1 33.8.18

Ram hieroglyph
Probably 147 (12)–(14)
NdeGD (1931); 21 × 18; 1:1 33.8.9

Ba hieroglyph
Probably 147 (12)–(14)
NdeGD (1931); 19 × 18.5; 1:1 33.8.10

Man carrying hedgehogs and a hare
147 (15)–(19)
No.deGD (probably 1931); 54 × 51.5; 1:1 33.8.15

Women weaving
148 (20)
No.deGD (probably 1931); 103.5 × 66.5; 1:1 33.8.16

Tomb not known, in Asasif
Dynasty 17 or 18

Decorative borders of a doorway
Copyist unknown; 9.4 × 17; 1:4 48.105.25

Tomb not known, in Asasif
Dynasty 17 or 18

Moored boats (?)
Copyist unknown; 25.5 × 20.5; 1:2 48.105.26

Tomb not known, in Asasif
Dynasty 18

Seated woman
Na.deGD (1915–16); 13.1 × 13; scale unknown
 48.104.24

Tomb of Tetiky (T 15)
Early Dynasty 18, probably time of Ahmose I

Ceiling decoration imitating beam and matting
CKW (1924); 74 × 66; 1:1 30.4.4

.105.25

30.4.4

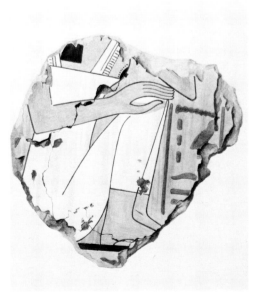

48.104.24

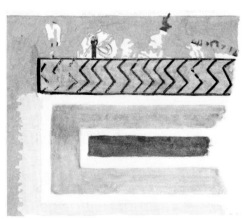

48.105.26

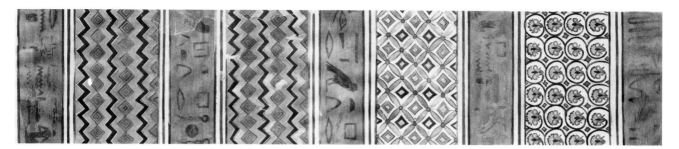

30.4.127a,b,c

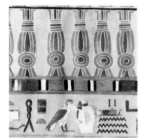

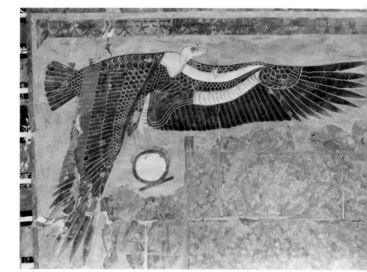

30.4.138

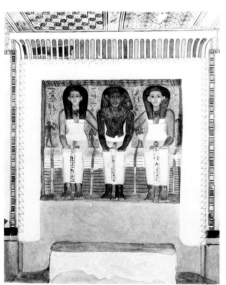

30.4.197

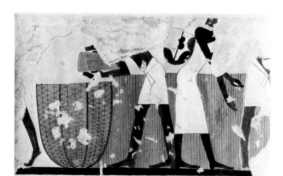

30.4.126

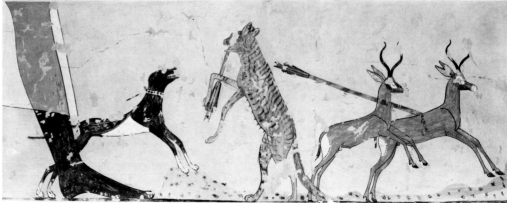

30.4.52

30.4.234

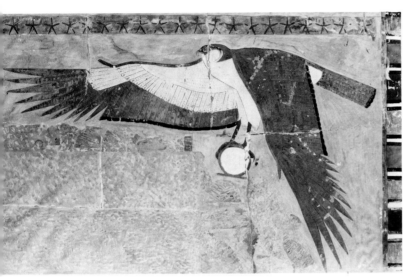

4.139

30.4.49

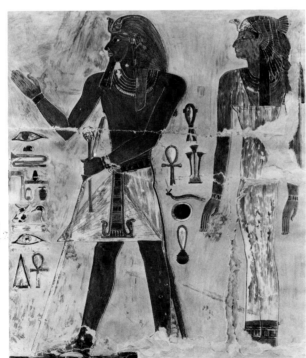

30.4.137

Tomb of Tjay (T 349)
Dynasty 18

Egyptians and Nubian woman reaping
Passage, PM I²1 415 (2)
Na.deGD (1897–98); 51 × 29.5; scale unknown

30.4.126

Rendering of statues of Tjay and his family in niche
Inner room, 417 (8)
CKW (1926–27); 41 × 33; scale unknown 30.4.197

Ceiling decoration and borders
CKW (1926–27); 31.5 × 228; 1:1 30.4.127a,b,c

Tomb of Ineni (T 81)
Dynasty 18, time of Amenhotpe I–Tuthmosis III

Hunting scene with hyena and gazelles
Portico, pillar, PM I²1 161 (10)
Na.deGD (1929); 108.5 × 41; 1:1 30.4.52

House with storehouses
161 (11) IV
Na.deGD (1925–26); 71 × 33.5; 1:2 30.4.234

Temple of Hatshepsut
Dynasty 18

The goddess Nekhbet of Elkab
Shrine of Anubis, hypostyle, PM II² 354 (59)
CKW; 106 × 75; 1:1 30.4.138

The god Horus of Behdet
354 (60)
CKW; 121 × 74; 1:1 30.4.139

Tuthmosis I and Seniseneb
Chapel of Anubis, niche, 363 (122) (f)
Na.deGD (1925); 69 × 80; 1:1 30.4.137

Tomb of Senenmut (T 71)
Dynasty 18, time of Hatshepsut

Cretans bringing gifts
Hall, PM I²1 140 (3)
Na.deGD; 70.5 × 42.5; 1:1 30.4.49

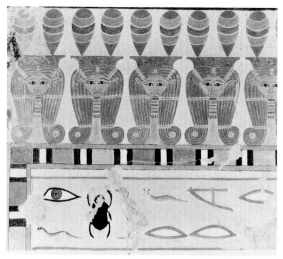

37.4.1

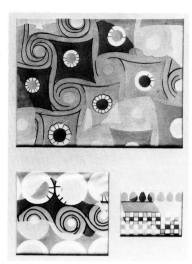

30.4.147

31.6.37

Tomb of Senenmut (T 71), continued

Hathor-head frieze (restored)
140 (2)–(3)
Na.deGD (probably 1936); 57.5 × 48.5; 1:1 37.4.1

Three fragments of ceiling patterns (restored)
No.deGD (?); 61.5 × 46; 1:1 30.4.147

Two fragments of ceiling patterns (left, now MMA
 23.3.463)
Na.deGD (1921); 53 × 18; 1:1 31.6.37

Tomb of Senenmut (T 353)
Dynasty 18, time of Hatshepsut

Astronomical scenes with twelve discs for months
Hall, PM I²1 418 ceiling
CKW; 56.5 × 73; approximately 1:5 48.105.52

Tomb of Amenhotpe (?) (T 73)
Dynasty 18, time of Hatshepsut

Ibex
Hall, PM I²1 143 (1) 1
Na.deGD (1926); 31 × 30; 1:1 30.4.51

Drying of fish and net making (restored)
143 (1) 1 subscene
NdeGD (1926); 92 × 55; 1:1 30.4.50

Tomb of Duauneheh (T 125)
Dynasty 18, time of Hatshepsut

Dog named Ebony below owner
Passage, PM I²1 240 (13) II
Na.deGD (1938); 18.5 × 24.2; scale unknown 39.4.1

Tomb of Nebamun (T 179)
Dynasty 18, time of Hatshepsut

Pet dog below owner's wife
Hall, PM I²1 285 (2)
CKW (1920–21); 46.5 × 38; 1:1 30.4.100

Food provisions
285 (2)
CKW (1921); 32 × 20; scale unknown 30.4.101

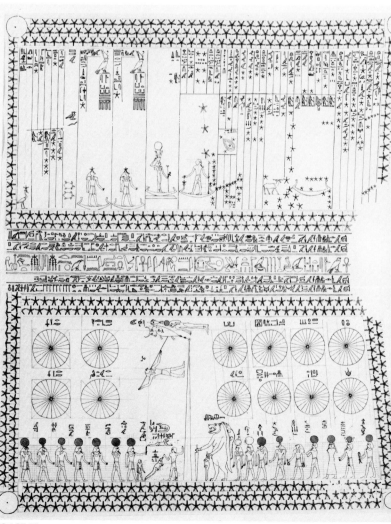

48.105.52

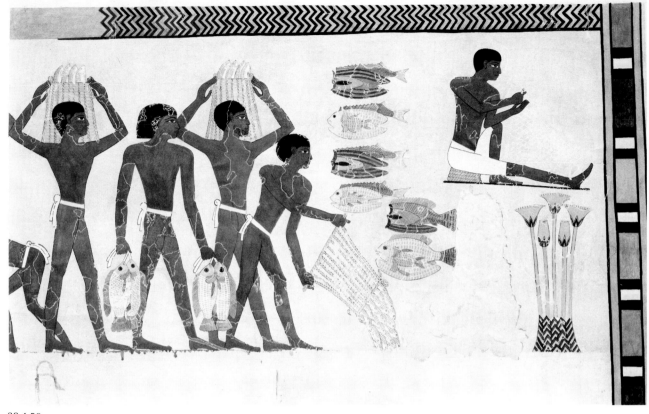

30.4.50

30.4.51

39.4.1

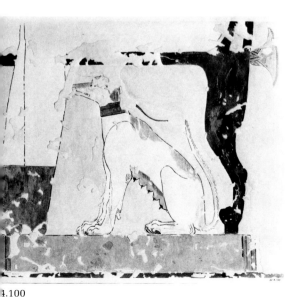

4.100

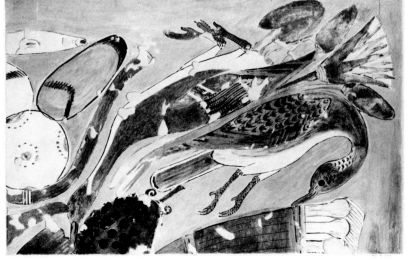

30.4.101

75

30.4.99

48.105.19

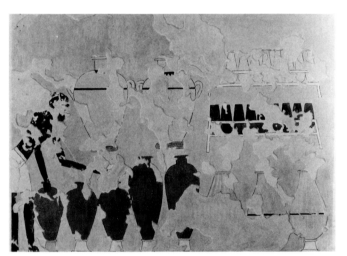

30.4.233

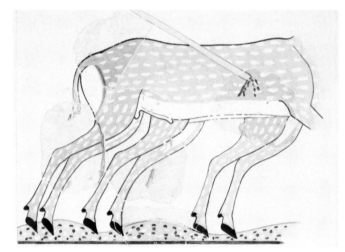

48.105.20

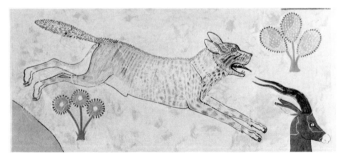

31.6.36

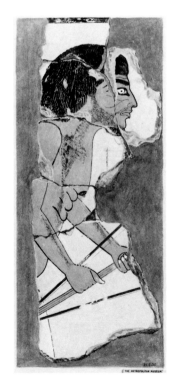

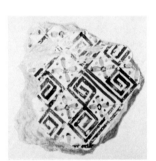

48.105.21

31.6.38

31.6.35

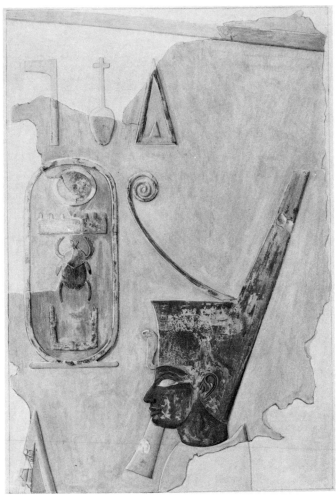

48.105.27

30.4.217

30.4.216

Tomb of Nebamun (T 179), continued

Man before false door
285 (2) II
CKW (1920–21); 29.5 × 27; scale unknown 30.4.99

Storage of wine and beer
286 (4) subscene
CKW (1921); 52.5 × 37; 1:1 30.4.233

Tomb of Inyotef (T 155)
Dynasty 18, time of Hatshepsut and Tuthmosis III

Portion of a hunting scene (restored; includes one of the
 heads from 31.6.38)
Passage, PM I²1 265 (10) II
Na.deGD (1931); 64 × 38; 1:1 31.6.36

Hyenas
265 (10) II
Na.deGD (1931); 43 × 20; 1:1 31.6.38

Nine fragments of a hunting scene
265 (10) I–II
Copyist unknown; 48 × 36.5; scale unknown 48.105.19

Two antelope, one wounded by weapon (restored)
265 (10) I–II
Na.deGD; 34 × 25.5; scale unknown 48.105.20

Old man
Na.deGD; 12.5 × 29; 1:1 31.6.35

Ceiling decoration
Na.deGD (1931); 20 × 20; 1:1 48.105.21

Temple of Hatshepsut or of Tuthmosis III (?)
Dynasty 18

Tuthmosis III (probably Edinburgh RSM 1951.132, cf.
 C. Aldred, New Kingdom Art in Ancient Egypt,
 1951, fig. 9)
CKW (1926); 28.4 × 41.7; 1:1 48.105.27

Tomb of Puimra (T 39)
Dynasty 18, time of Tuthmosis III

Palm trees in a garden scene (now Cairo JdE 43368)
Hall, PM I²1 71 (3) I–III
No.deGD (1909–10); 47 × 21.5; 1:1 30.4.217

Man with bow case and quiver
72 (8)–(9) I 1
HRH (1915); 18 × 28; 1:1 30.4.216

77

30.4.210

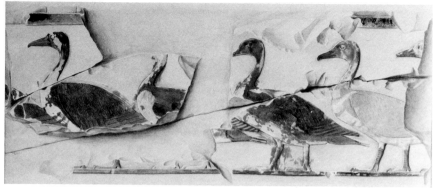

30.4.12

30.4.212

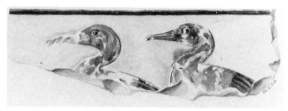

30.4.214

30.4.209

30.4.215

30.4.211

Tomb of Puimra (T 39), continued

Head of hippopotamus
72 (8)–(9) I 2
HRH (1915); 21 × 13.5; 1:1 30.4.210

Swamp scene with birds and butterflies
72 (8)–(9) I 3
HRH (1914–16); 37.5 × 19; 1:1 30.4.212

Waterweeds
72 (8)–(9) I 3
HRH (1915); 16.5 × 10.5; 1:1 30.4.209

Waterfowl
72 (8)–(9) I 3
HRH (1914–16); 19 × 17; 1:1 30.4.215

Seniseneb, wife of Puimra
72 (8)–(9) II
No.deGD (1916); 9.5 × 16.5; 1:1 30.4.211

Geese and ducks
72 (8)–(9) II
HRH (1914–16); 47 × 18; 1:1 30.4.12

Two ducks
72 (8)–(9) II
HRH (1914–16); 18.5 × 6; 1:1 30.4.214

Cleaning and curing fish
72 (8)–(9) II
HRH (1914–16); 60.5 × 39.5; 1:1 30.4.17

Boatmen gathering papyrus
72 (8)–(9) II
HRH (1914–16); 66 × 39.5; 1:1 30.4.11

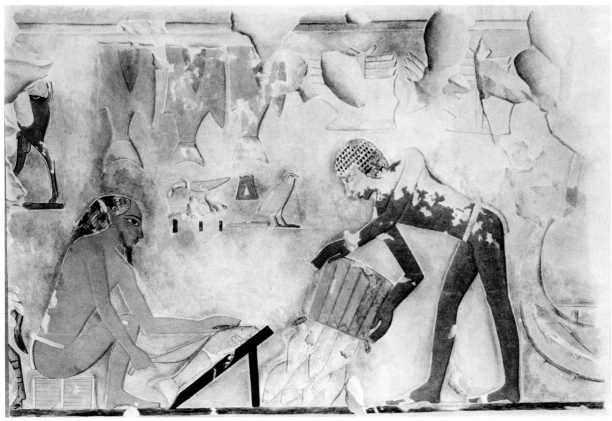

30.4.17

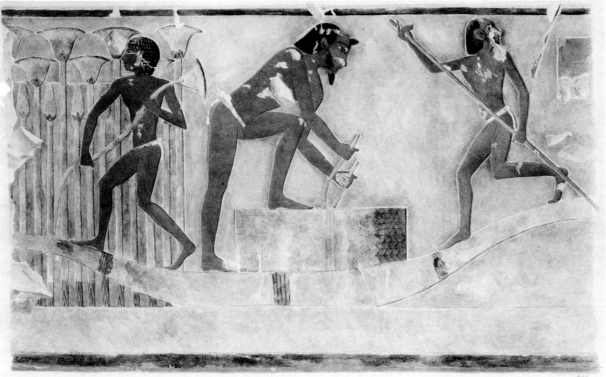

30.4.11

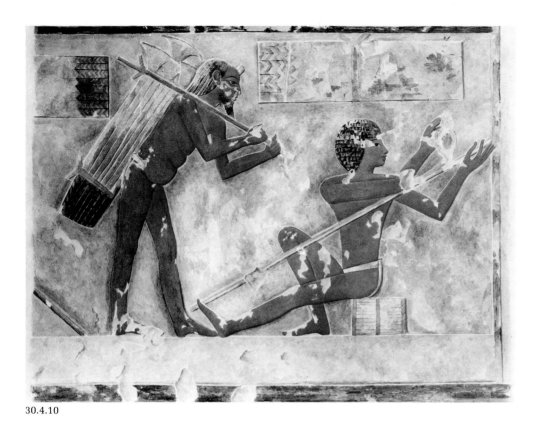

30.4.10

30.4.213

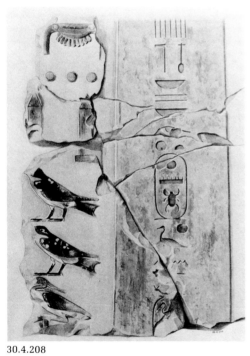

30.4.208

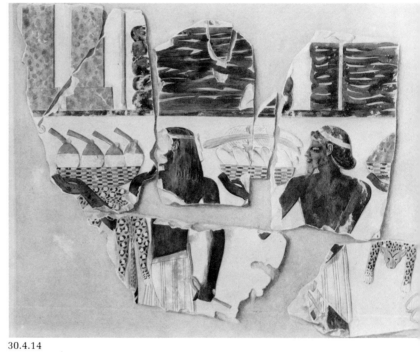

30.4.14

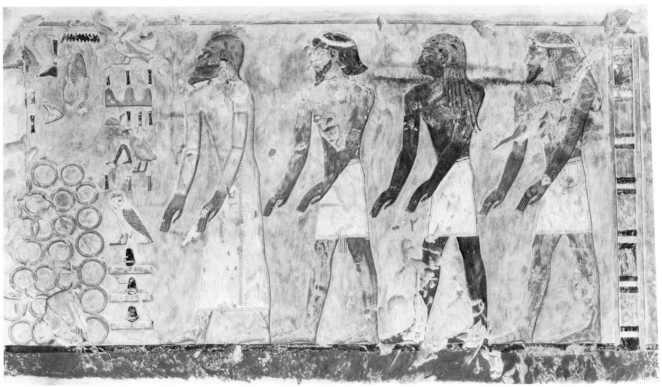

30.4.13

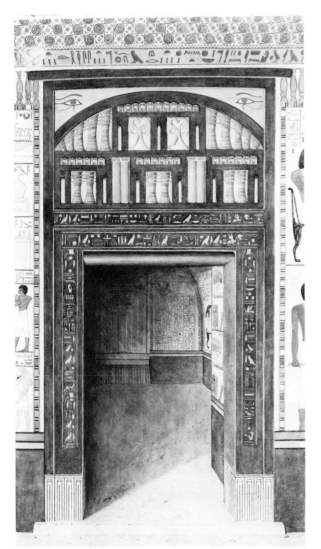

30.4.15

Tomb of Puimra (T 39), continued

Men splitting papyrus
72 (8)–(9) II
HRH (1914–16); 51.5 × 40; 1:1 30.4.10

Face of Puimra (?) (orientation uncertain)
72 (11) IV–VI
HRH (1915); 6 × 22.5; 1:1 30.4.213

Men of the East bringing gifts
72 (11) VI
HRH (1914–16); 49 × 41.5; 1:1 30.4.14

Fragment of an inscribed obelisk
72 (12) I
HRH (1914–16); 22 × 31; 1:1 30.4.208

Four foreign chieftains coming in peace
72 (12) II
No.deGD (1910); 95.5 × 52; 1:1 30.4.13

Rendering of a decorated doorway (substantially
 restored)
North chapel, 73 (17)
No.deGD (c. 1917); 34.5 × 61; 1:10 30.4.15

Tomb of Puimra (T 39), continued

Part of north half of a vaulted ceiling
Central chapel, shrine, 74 ceiling
HRH (1914–16); 27 × 71; 1:1 30.4.16

Tomb of Amenemhat (T 82)
Dynasty 18, time of Tuthmosis III

Hippopotamus at bay
Hall, PM I²1 164 (8)
CKW (1928); 31 × 47.5; 1:1 30.4.53

Tomb of Menkheperraseneb (T 86)
Dynasty 18, time of Tuthmosis III

Syrian with son and Cretan with rhyton
Hall, PM I²1 177 (8) I
Na.deGD (1925); 42 × 46; 1:1 30.4.55

Tomb of Minnakhte (T 87)
Dynasty 18, time of Tuthmosis III

Garden, pool, and funeral ceremony (restored)
Inner room, PM I²1 179 (8) II–IV
CKW (1921); 122 × 68; 1:1 30.4.56

Tomb of User (T 131)
Dynasty 18, time of Tuthmosis III

Delegation of foreigners
Hall, PM I²1 246 (11) III
NdeGD (1925); 64 × 40; 1:1 30.4.95

30.4.16

30.4.53

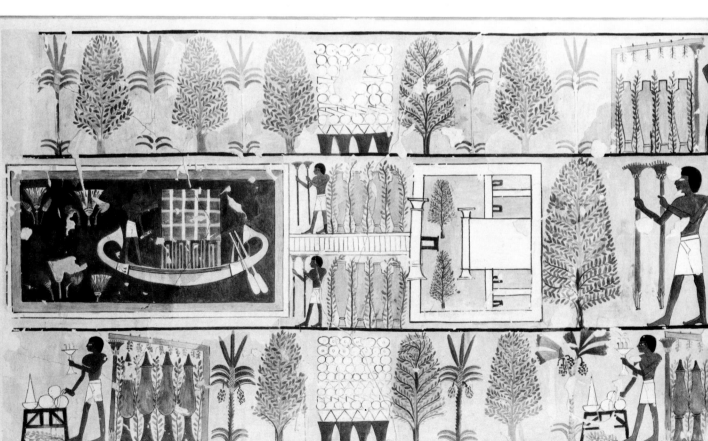

30.4.56

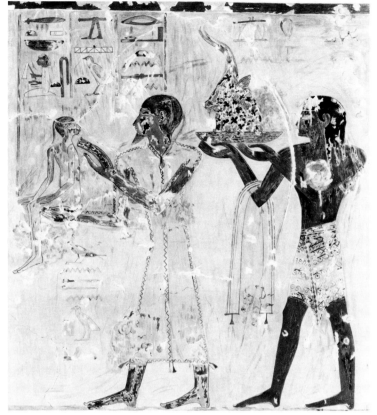

30.4.55

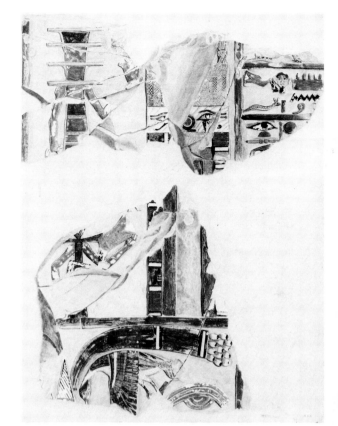

15.5.5

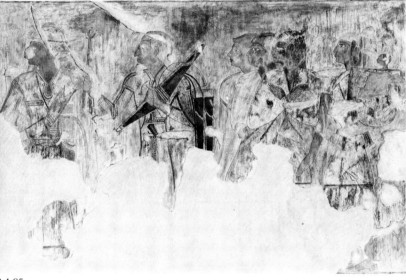

0.4.95

30.4.7

Tomb of Mentuherkhepeshef (T 20)
Dynasty 18, time of Tuthmosis III (?)

Fragments of a false door
Passage, PM I²1 35 (4)–(5)
No.deGD (1912); 36 × 46.7; 1:1 15.5.5

Stag in hunting scene (now Cairo JdE 43367a,b)
35 (7)
No.deGD (1912); 29.5 × 25; 1:1 30.4.7

Six fragments of ceiling patterns
35 ceiling
Copyist unknown; 40 × 14; scale unknown 48.105.9

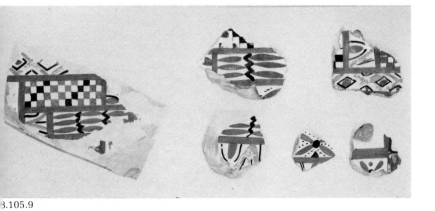

3.105.9

48.105.10

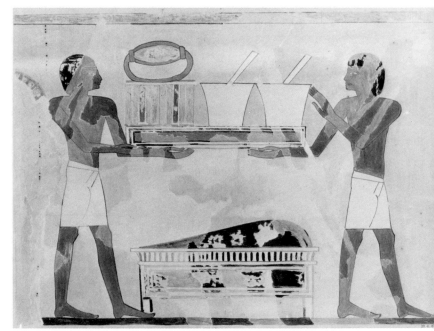

30.4.43

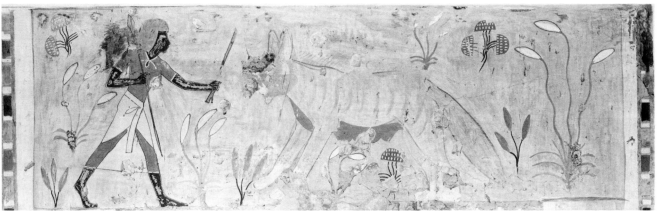

30.4.54

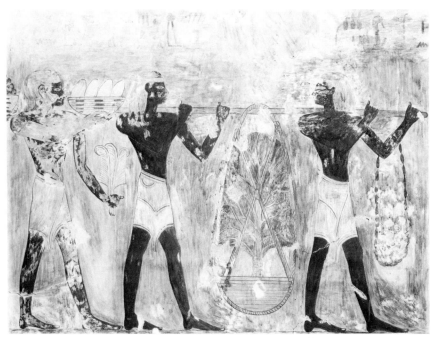

30.4.152

30.4.94

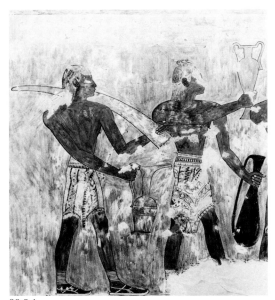

33.8.1

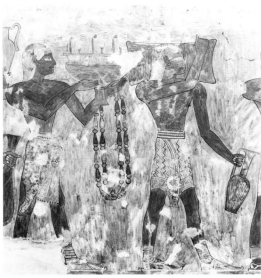

31.6.45

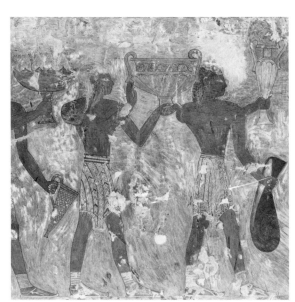

30.4.84

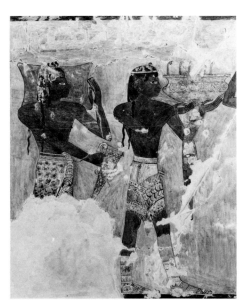

31.6.42

Tomb of Mentuherkhepeshef (T 20), continued

Five fragments of ceiling patterns
35 ceiling
Copyist unknown; 18.5 × 10; scale unknown 48.105.10

Tomb of Amenemweskhet (T 62)
Dynasty 18, time of Tuthmosis III (?)

Men carrying tray of provisions (restored)
Inner room, PM I²1 125 (4) III
Na.deGD (1925); 44 × 30.5; 1:1 30.4.43

Tomb of May (T 130)
Dynasty 18, time of Tuthmosis III (?)

Pet cat tied to chair
Inner room, PM I²1 245 (9) I
HRH (1916); 32 × 27; 1:1 30.4.94

Tomb of Amenemhab (T 85)
Dynasty 18, time of Tuthmosis III–Amenhotpe II

Encounter with a female hyena
Hall, PM I²1 173 (18) inner lintel
Na.deGD (1920); 93 × 28; 1:2 30.4.54

Tomb of Rekhmira (T 100)
Dynasty 18, time of Tuthmosis III–Amenhotpe II

Men from Punt carrying beads, tree, feathers, and eggs
Hall, PM I²1 207 (4) I
Na.deGD (1927); 61.5 × 46; 1:1 30.4.152

Men of Keftiu and the Isles in the Sea with vases, bag,
 and tusk
207 (4) II
Na.deGD (1926); 45.5 × 42; 1:1 33.8.1

Men of Keftiu and the Isles with vases, ingot, and beads
207 (4) II
Na.deGD (1926); 42 × 45; 1:1 31.6.45

Men of Keftiu and the Isles with gifts
207 (4) II
Na.deGD (1923–24); 46.5 × 45.5; 1:1 30.4.84

Men of Keftiu and the Isles with vessels, dagger, and
 copper ingot
207 (4) II
Na.deGD (1925–26); 37.5 × 45; 1:1 31.6.42

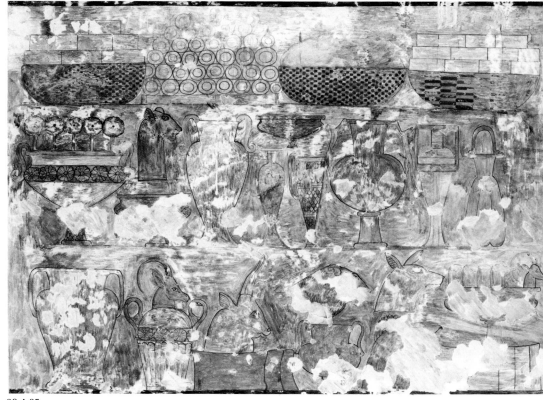

30.4.85

Tomb of Rekhmira (T 100), continued

Goldwork from Keftiu and the Isles
207 (4) II
Na.deGD (1924); 65 × 45; 1:1 30.4.85

A pack of hounds brought by the Nubians
207 (4) III
Na.deGD (1923–24); 50.5 × 15.5; 1:1 30.4.82

Nubians with giraffe and monkey
207 (4) III
Na.deGD (1925); 56 × 45; 1:1 31.6.40

Nubians bringing ebony, ivory, animals, and skins
207 (4) III
Na.deGD (1923–24); 72 × 45.5; 1:1 30.4.81

Syrians with ingot, ivory, and animals
207 (4) IV
Na.deGD (1926); 51 × 45; 1:1 31.6.43

Syrians with gifts; horses
207 (4) IV
Na.deGD (1926); 52 × 45; 1:1 31.6.41

Syrians with ingot and chariot
207 (4) IV
Na.deGD (1926); 55.5 × 42; 1:1 31.6.34

Syrians with vessels and weapons
207 (4) IV
Na.deGD (1922–23); 35 × 46; 1:1 30.4.83

30.4.82

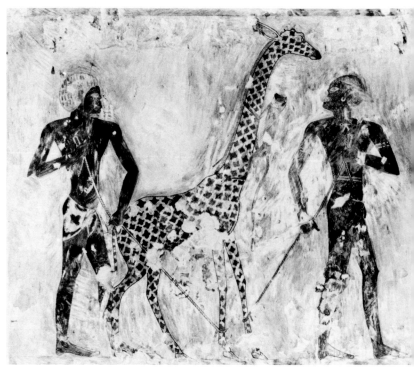

31.6.40

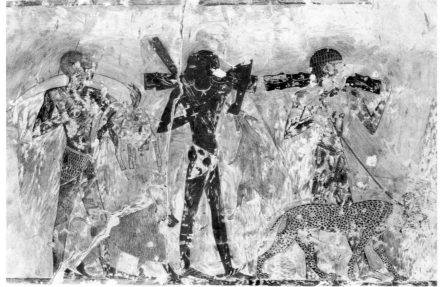

30.4.81

31.6.43

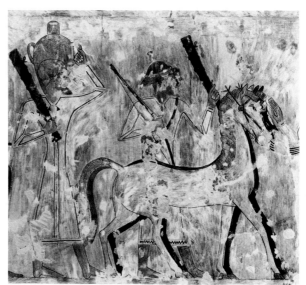

31.6.41

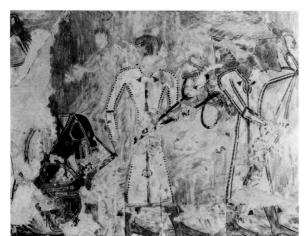

31.6.34

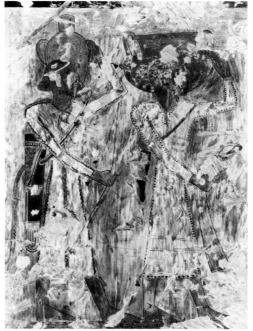

30.4.83

31.6.9

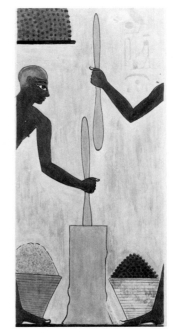

31.6.17

Tomb of Rekhmira (T 100), continued

Gifts from Retjenu and eastward
207 (4) IV
Na.deGD (1925); 60.5 × 23.5; 1:1 31.6.9

Pounding meal for offering-cakes
Passage, 210 (13) II
Na.deGD (1927); 20 × 43.5; 1:1 31.6.17

Sifting the pounded meal
210 (13) II
Na.deGD (1927); 44.5 × 20.5; 1:1 31.6.24

Adding hot fat to the dough
210 (13) II
Na.deGD (1927); 50 × 30.5; 1:1 31.6.16

Cooking cakes with fat
210 (13) II
Na.deGD (1927); 35.5 × 24; 1:1 31.6.15

Preparing and cooking cakes
210 (13) II
Na.deGD (1927); 32.5 × 43.5; 1:1 31.6.30

Carrying finished loaves in baskets
210 (13) II
Na.deGD (1927); 30.5 × 43; 1:1 31.6.31

Gathering honey
210 (13) II
Na.deGD (1926); 43.5 × 33; 1:1 30.4.88

Wine and papyrus brought to the treasuries of Amun
 (restored)
210 (13) III
CKW (1930); 130 × 52; 1:1 30.4.151

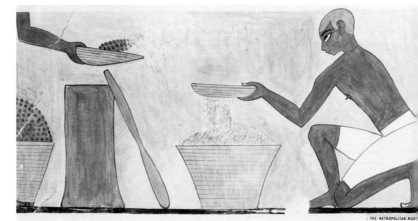

31.6.24

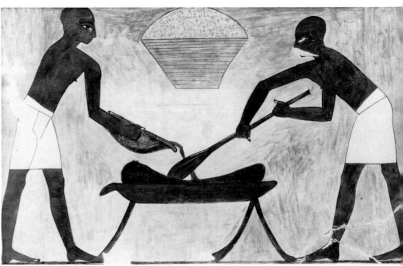

31.6.16

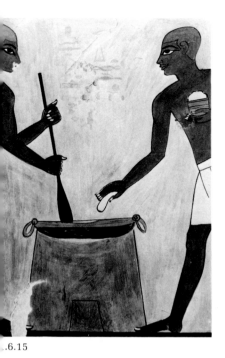

.6.15

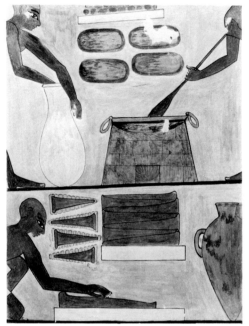

31.6.30

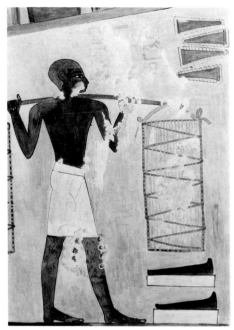

31.6.31

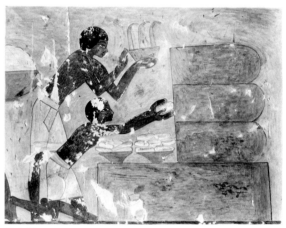

30.4.88

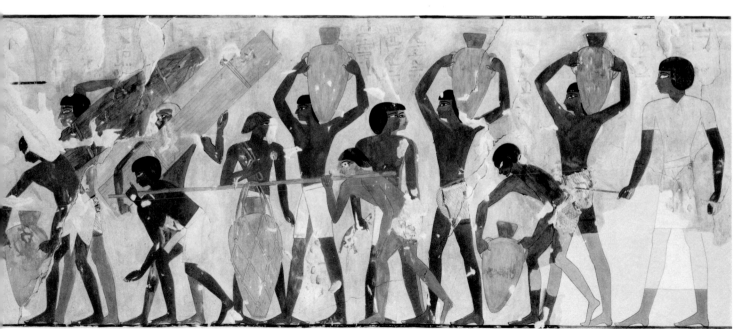

0.4.151

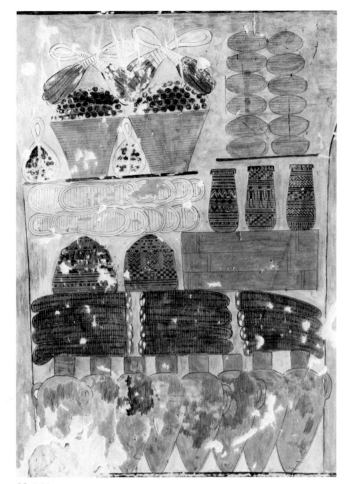

30.4.86

30.4.87

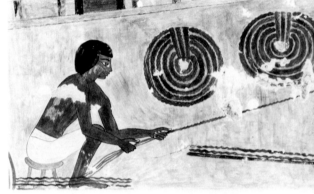

33.8.2

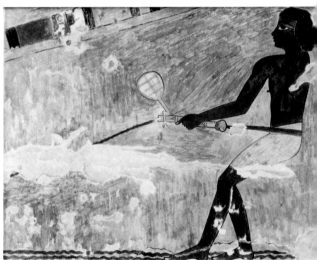

31.6.32

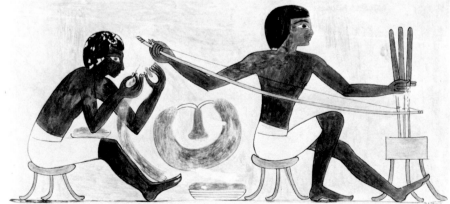

31.6.25

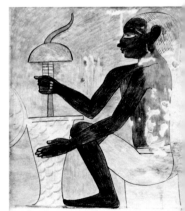

31.6.13

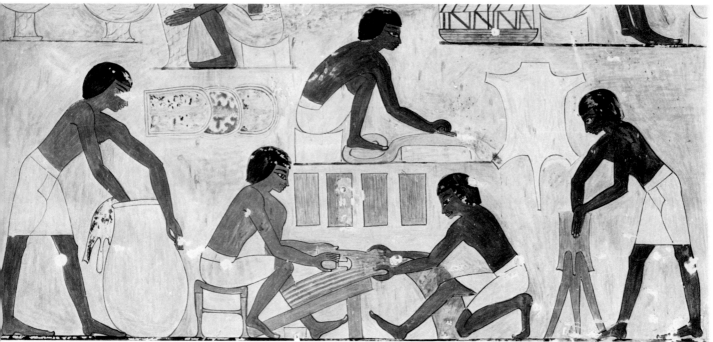

5.101.2

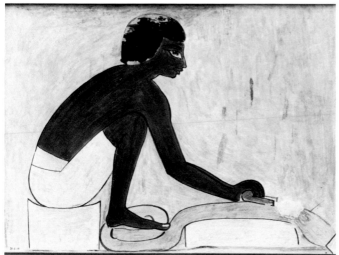

31.6.14

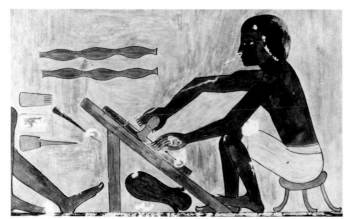

31.6.21

Tomb of Rekhmira (T 100), continued

Provisions stored in the temple magazines
210 (13) III
Na.deGD (1923); 37.5 × 52.5; 1:1 30.4.86

Provisions from Nubia stored in magazines
210 (13) III
Na.deGD (1924); 38 × 17.5; 1:1 30.4.87

Stringing beads and drilling holes with a bow drill
211 (14) I
Na.deGD (1929); 62.5 × 27.5; 1:1 31.6.25

Drilling a stone vase
211 (14) I
Na.deGD (1929); 23.5 × 26.5; 1:1 31.6.13

Making leather rope
211 (14) II
Na.deGD (1932); 50 × 28; 1:1 33.8.2

Making leather rope
211 (14) II
Na.deGD (1929); 45 × 31; 1:1 31.6.32

Soaking and scraping leather skins
211 (14) II
Na.deGD (1935); 106 × 48.5; 1:1 35.101.2

Softening a roll of leather with stone
211 (14) II
Na.deGD (1929); 33 × 24.5; 1:1 31.6.14

Cutting leather for sandals
211 (14) II
Na.deGD (1929); 45.5 × 28; 1:1 31.6.21

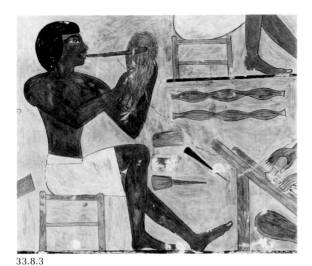

33.8.3

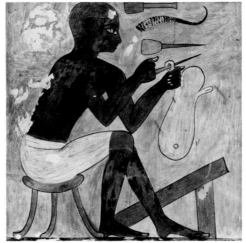

31.6.26

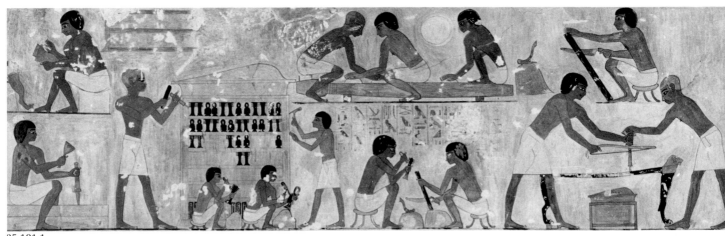

35.101.1

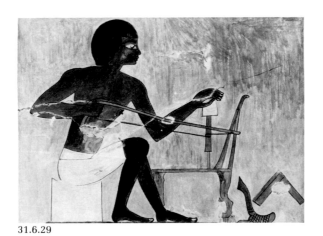

31.6.29

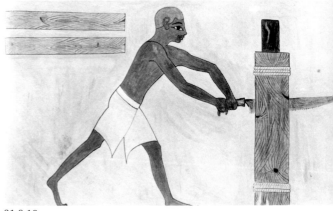

31.6.18

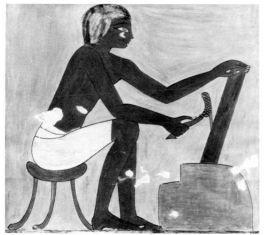
31.6.28

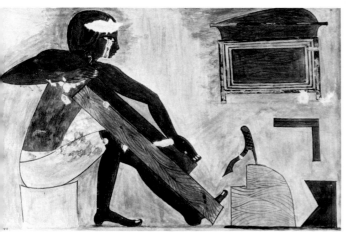
1.6.12

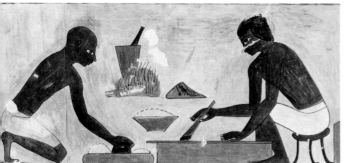
3.8.4

Tomb of Rekhmira (T 100), continued

Pulling thongs through leather soles
211 (14) II
Na.deGD (1932); 39.5 × 32; 1:1 33.8.3

Making sandals
211 (14) II
Na.deGD (1929); 30.5 × 31.5; 1:1 31.6.26

Making a shrine, bier, and column
211 (14) III
Na.deGD (1935); 197 × 58.5; 1:1 35.101.1

Using a bow drill on a chair
211 (14) III
Na.deGD (1929); 41 × 30; 1:1 31.6.29

Sawing a plank
211 (14) III
Na.deGD (1928); 53.5 × 32; 1:1 31.6.18

Trimming wood with an adze
211 (14) III
Na.deGD (1928); 34 × 31; 1:1 31.6.28

Carpenter with tools
211 (14) III
Na.deGD (1928); 41.5 × 26; 1:1 31.6.12

Preparing and applying stucco to a box
211 (14) III
Na.deGD (1928); 59.5 × 27.3; 1:1 33.8.4

Pouring molten metal and working bellows
211 (14) IV
Na.deGD (1927); 54 × 57.5; 1:1 31.6.11

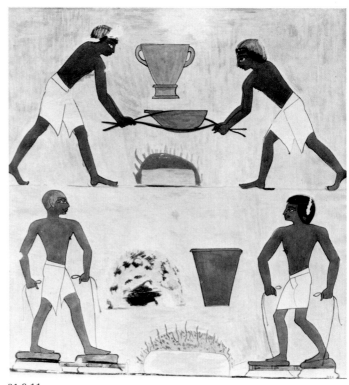
31.6.11

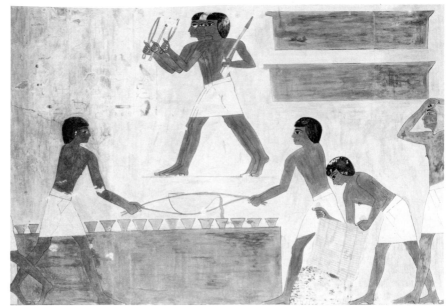

33.8.5

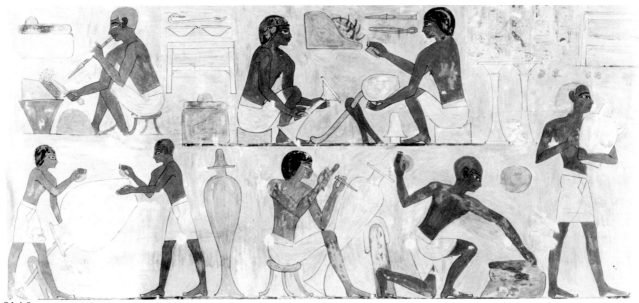

34.4.2

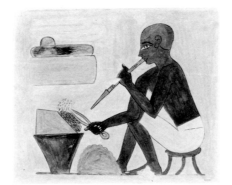

31.6.22

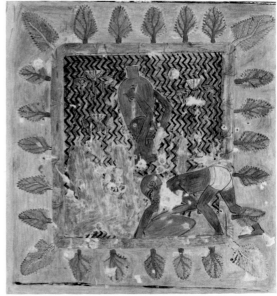

30.4.89

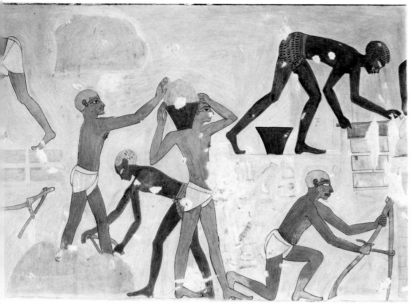

30.4.77

48.105.17

31.6.33

31.6.20

Tomb of Rekhmira (T 100), continued

Casting a bronze door
211 (14) IV
Na.deGD (1927); 90.5 × 59; 1:1 ... 33.8.5

Making metal vases
211 (14) IV
Na.deGD (1933–34); 126 × 58.5; 1:1 ... 34.4.2

Using a blowpipe to heat tongs
211 (14) IV
Na.deGD (1928); 34.5 × 27.5; 1:1 ... 31.6.22

Drawing water from a pond for brickmaking
211 (14) V
Na.deGD (1925); 45.5 × 48.5; 1:1 ... 30.4.89

Making bricks
211 (14) V
Na.deGD (1926); 68.5 × 48; 1:1 ... 30.4.77

Platform in process of construction
211 (14) V
Na.deGD (1927); 53 × 49.5; 1:1 ... 48.105.17

Pushing a block with levers
211 (14) VI
Na.deGD (1927); 47 × 27; 1:1 ... 31.6.33

Measuring a block's flatness with pegs
211 (14) VI
Na.deGD (1927); 39.5 × 25; 1:1 ... 31.6.20

31.6.27

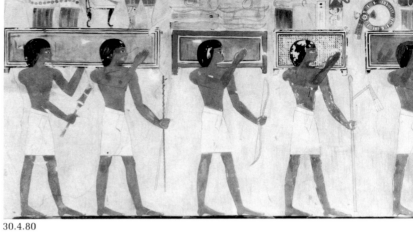

30.4.80

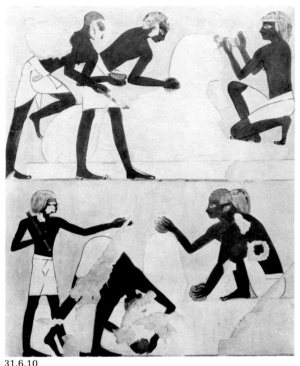

31.6.10

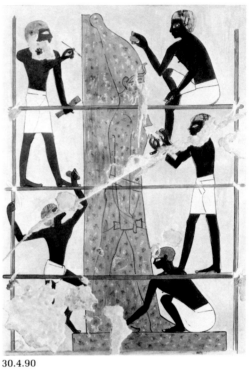

30.4.90

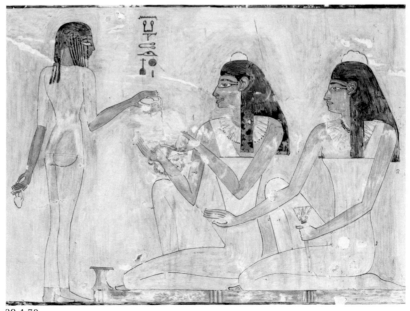

30.4.78

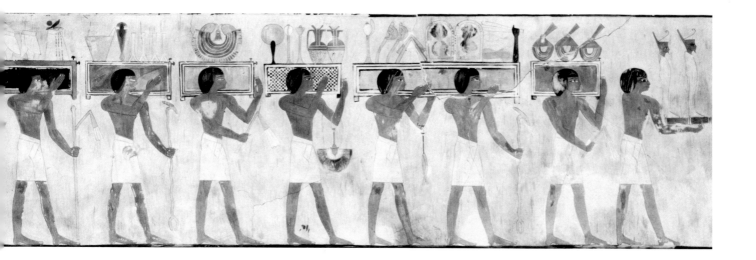

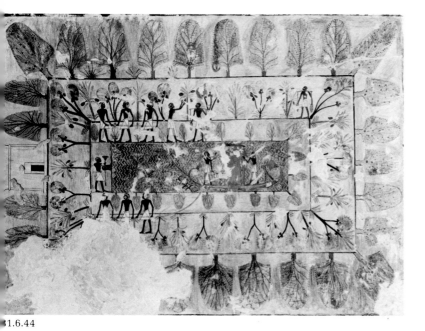

31.6.44

Tomb of Rekhmira (T 100), continued

Masons squaring block of limestone (legs slightly
 restored)
211 (14) VI
Na.deGD (1927); 38.5 × 29; 1:1 31.6.27

Polishing a sphinx and an offering table
211 (14) VI
Na.deGD (1927); 45 × 53.5; 1:1 31.6.10

Polishing and inscribing a statue
211 (14) VI
Na.deGD (1927); 54 × 38.5; 1:1 30.4.90

Procession with funerary furniture
212 (15) VI
CKW (1928–29); 304 × 58; 1:1 30.4.80

Funerary banquet with ladies and servant
213 (18) III
Na.deGD (1925); 66.5 × 47.5; 1:1 30.4.78

Pool with statue of deceased being towed in a boat
214 (19) VIII–IX
Na.deGD (1928); 66 × 48; 1:1 31.6.44

Rekhmira and his mother receiving offerings (restored)
214 (20) I
CKW (1928–29); 87.5 × 57.5; 1:4 30.4.79

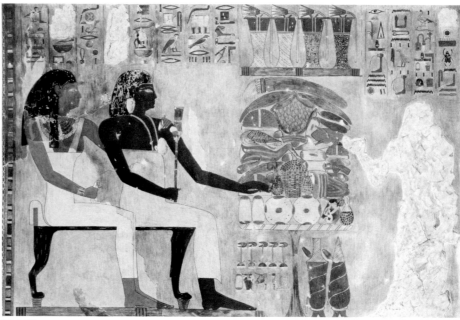

30.4.79

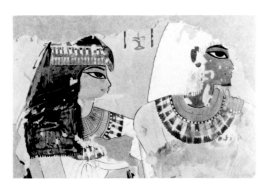

30.4.192

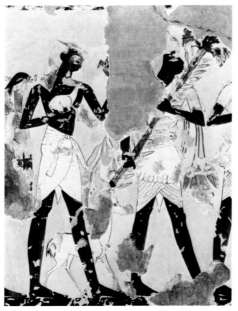

30.4.193

30.4.98

33.8.6

30.4.97

30.4.200

0.4.201

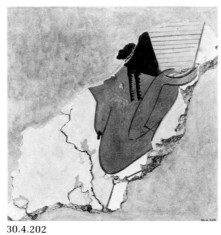

30.4.202

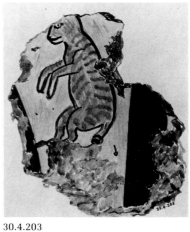

30.4.203

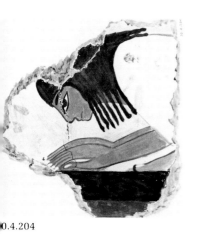

0.4.204

48.105.22

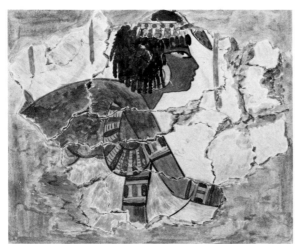

30.4.205

Tomb of Menkheperraseneb (T 79)
Dynasty 18, time of Tuthmosis III–Amenhotpe II (?)

Burial equipment from the king
Hall, PM I²1 157 (7) I–VI
Na.deGD (1932); 54 × 62; 1:2 33.8.6

Tomb of Kenamun (T 162)
Dynasty 18, time of Tuthmosis III–Amenhotpe II (?)

The aged Kenamun and his wife
Passage, PM I²1 276 (8)
CKW (1922–23); 54 × 36; 1:1 30.4.192

Offering-bearers
276 (8)
CKW (1922–23); 35.5 × 45; 1:1 30.4.193

Geometric ceiling pattern (restored)
CKW (1922); 39.5 × 53; 1:1 30.4.97

Shell-like ceiling pattern (restored)
Na.deGD (1922); 45 × 68; 1:1 30.4.98

Man carrying basket of figs (restored)
Na.deGD (1922); 31.5 × 37; 1:1 30.4.200

Baskets of fruits and vegetables
Na.deGD (1922); 25.5 × 35; 1:1 30.4.201

Woman with basket on her shoulder
 (found stored in T 16)
CKW (1921–22); 18 × 17; 1:1 30.4.202

Hare being carried
Na.deGD (1922); 10 × 11; 1:1 30.4.203

Man praying
Na.deGD (1922); 11.5 × 12.5; 1:1 30.4.204

Servant girl bending over
 (found stored in T 16)
Na.deGD (1922); 20.5 × 16.5; 1:1 30.4.205

Provisions
CKW (1922–23); 12.6 × 14.4; 1:1 48.105.22

Tomb of Mentuiwy (T 172)
Dynasty 18, time of Tuthmosis III–Amenhotpe II (?)

Jars with fiber handles
Hall, PM I²1 280 (4) II
CKW (1921); 18 × 19; 1:1 30.4.231

Tomb of Khaemwaset (T 261)
Dynasty 18, time of Tuthmosis III–Amenhotpe II (?)

Khaemwaset inspects produce from his estates
Hall, PM I²1 344 (1) I–III
CKW (1922); 220 × 77; 1:1 30.4.121

Tomb of Djehuty (T 45)
Dynasty 18, time of Amenhotpe II

Djehuty and woman worshiping
Hall, PM I²1 85 (5)
No.deGD (1907–8); 65 × 51; 4:7 15.5.9

30.4.231

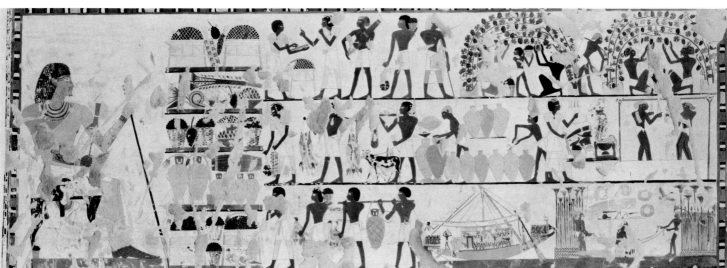

30.4.121

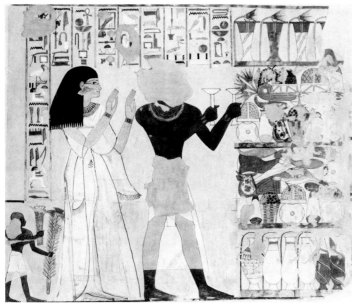

15.5.9

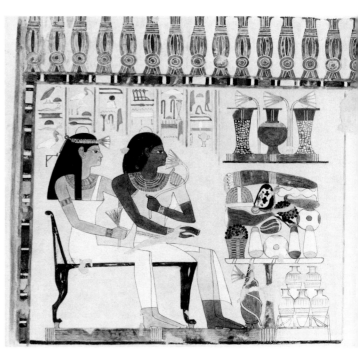

15.5.8

100

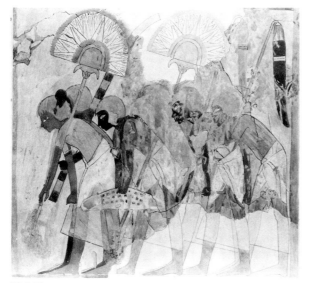

30.4.38

30.4.41

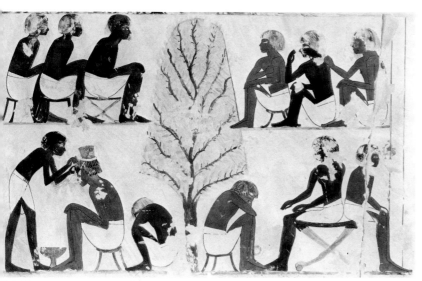

0.4.40

Djehuty and mother before offerings
85 (6)
No.deGD (1907–8); 49 × 44; 4:7 15.5.8

Tomb of Userhat (T 56)
Dynasty 18, time of Amenhotpe II

Ensign-bearers and soldier (restored)
Hall, PM I²1 112 (8) III, belonging to (9)
CKW (1925); 62 × 56; 1:1 30.4.38

A barber at work and men waiting their turn
112 (11) IV
Na.deGD (1925–26); 73 × 45; 1:1 30.4.40

Hunting from a chariot
Inner room, 113 (14) I
CKW (1922); 127 × 74; 1:1 30.4.42

Wounded hyena (?) from hunting scene
113 (14) I
CKW (1922); 18 × 16.5; 1:1 30.4.41

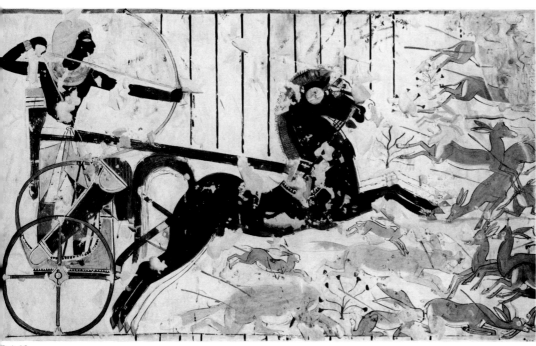

0.4.42

30.4.221

30.4.220

Tomb of Userhat (T 56), continued

Coptic horse graffito on fowling scene
113 (15) I
CKW (1922); 33 × 30.5; 1:1 30.4.220

Coptic horse graffito on fishing scene
113 (15) I
CKW (1922); 23 × 16.5; 1:1 30.4.222

Coptic animal graffito on fishing scene
113 (15) I
CKW (1922); 22 × 19.5; 1:1 30.4.221

Bearers with chariot and horse
113 (17)–(18) II
CKW (1922); 40.5 × 33; 1:1 30.4.39

Tomb of Djehutynofer (T 80)
Dynasty 18, time of Amenhotpe II

House with tree
Inner room, PM I²1 159 (10) III
CKW (1922); 15.5 × 36; 1:1 30.4.225

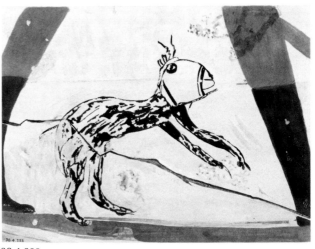

30.4.222

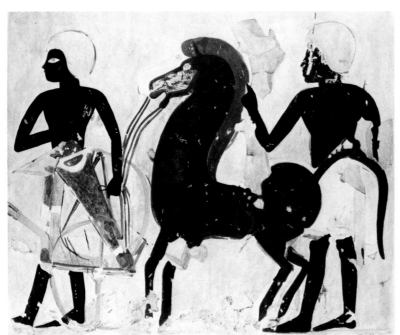

30.4.39

30.4.225

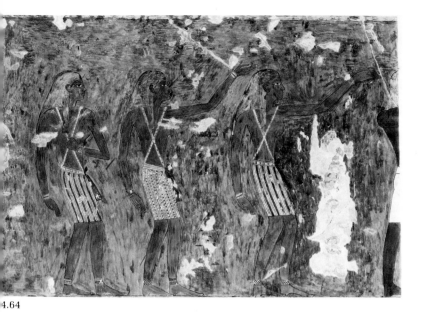

30.4.64

Tomb of Kenamun (T 93)
Dynasty 18, time of Amenhotpe II

Women chanting in the funeral procession
Outer hall, PM I²1 190 (3) I
Na.deGD (1926–27); 65 × 43; 1:1 30.4.64

Female celebrants in funeral procession (girl on right
 restored)
190 (3) III
NdeGD (1911); 71 × 42.5; 1:1 30.4.63

Osiris and the Western Goddess in kiosk
190 (4)
HRH (1914–16); 50 × 43; 1:2 30.4.65

Lunette over doorway
190 (8)
NdeGD, HRH; 56.6 × 40; 1:3 30.4.62

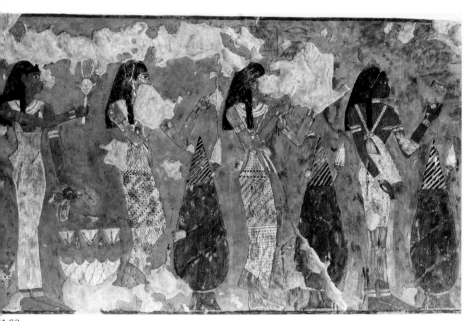

30.4.63

30.4.65

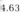
30.4.62

Tomb of Kenamun (T 93), continued

Amenhotpe II with Maat receiving New Year's gifts
191 (9)
HRH (1915); 42 × 65.5; approximately 2:7 30.4.168

Subject nations beneath throne (detail of 30.4.168)
191 (9)
NdeGD; 115.5 × 31.5; 1:1 30.4.69

A masterpiece of goldwork for the king
191 (9)
Na.deGD (1913); 36.5 × 40; 1:1 30.4.61

New Year's gifts for the king
191 (9) I–IV
Na.deGD (1929); 102 × 50.5; 2:9 30.4.73

A bearer of gifts (detail of 30.4.73)
191 (9) I
HRH (1914–16); 39 × 53; 1:1 30.4.66

Bow, whip, dagger; quivers; coat of mail
 (details of 30.4.73)
191 (9) II, IV
No.deGD (1913); 41.5 × 52; 1:1 30.4.75

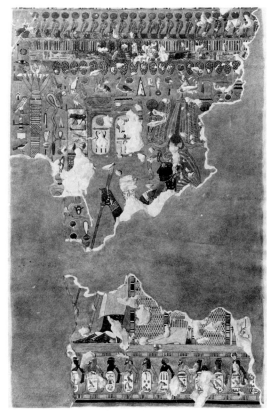

30.4.168

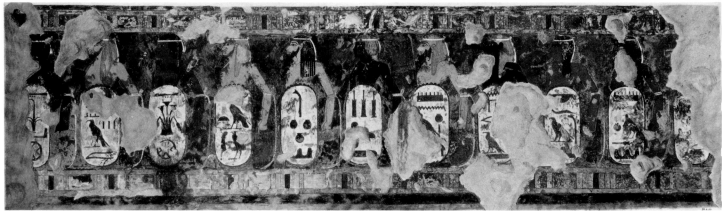

30.4.69 (detail of 30.4.168)

30.4.61

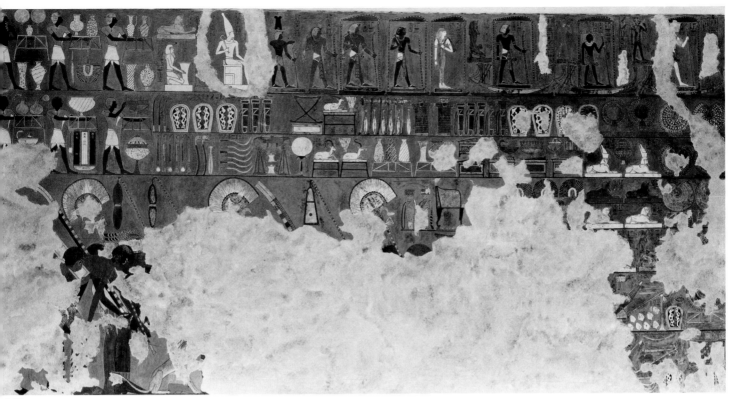

4.73

30.4.75 (details of 30.4.73)

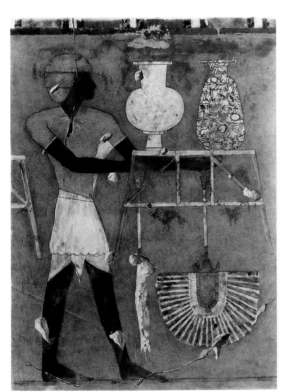

30.4.66 (detail of 30.4.73)

30.4.174 (detail of 30.4.73)

30.4.176 (detail of 30.4.73)

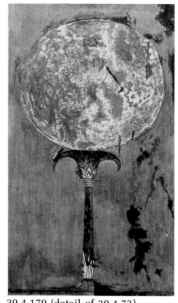

30.4.179 (detail of 30.4.73)

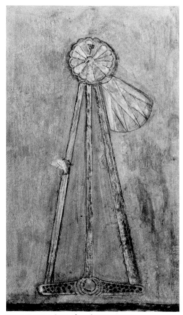

30.4.175 (detail of 30.4.73)

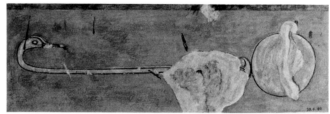

30.4.180 (detail of 30.4.73)

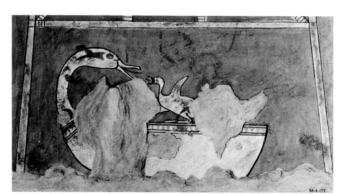

30.4.177 (detail of 30.4.73)

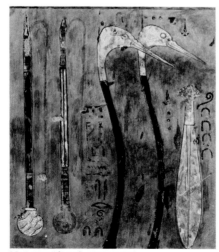

30.4.173 (detail of 30.4.73)

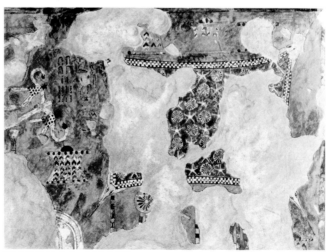

30.4.178 (detail of 30.4.73)

30.4.74 (detail of 30.4.73)

30.4.181 (detail of 30.4.73)

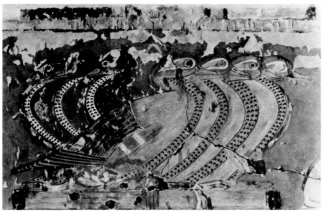
30.4.172

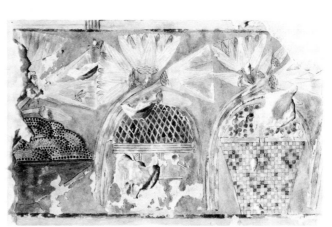
30.4.71

Tomb of Kenamun (T 93), continued

Products of the Delta: Nile fish
191 (11)
No.deGD (1913); 48.5 × 44; almost 1:1 15.5.3

Cattle from an inspection scene
191 (12)
CKW (1920); 58 × 40; 1:1 30.4.196

Attendants with equipment for a hunting expedition
191 (12)
HRH (1914–16); 47.5 × 53.5; 1:1 30.4.68

Amenhotpe II as a child with his nurse, Kenamun's
 mother
192 (16)
CKW (1925); 47 × 64.5; 1:3 30.4.72

Lute-player and bearer before Amenhotpe II and nurse
192 (16)
HRH (1915–16); 38 × 61.5; 1:3 30.4.170

The goddess Renenutet
193 Pillar D (b) I
CKW (1920); 31.5 × 76.5; 1:1 30.4.171

Desert hunting scene: ibex with hound
Passage, 193 (19)
Na.deGD (1928); 57 × 49; 1:1 30.4.59

Desert hunting scene: fauna
193 (19)
HRH (1914–16); 79 × 126.5; 1:1 30.4.58

Detail of swamp scene: a papyrus thicket
193 (20)
HRH (1914–16); 68 × 79; 1:1 30.4.60

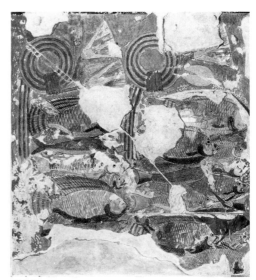

15.5.3

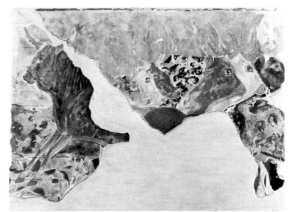

30.4.196

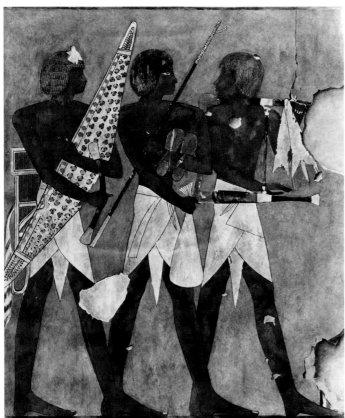

30.4.68

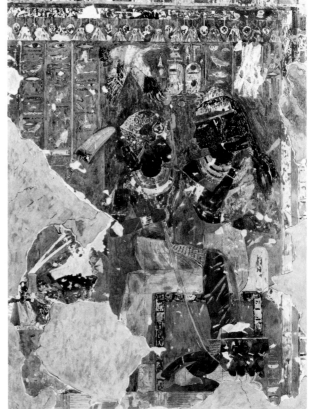

30.4.72

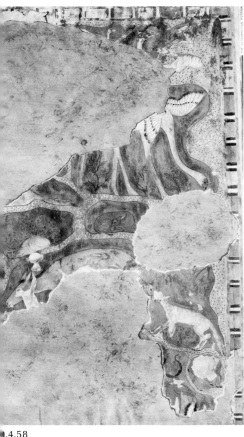

30.4.58

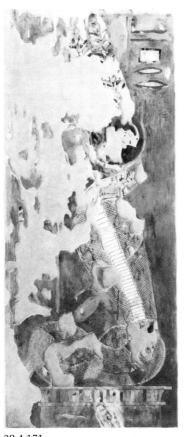

30.4.171

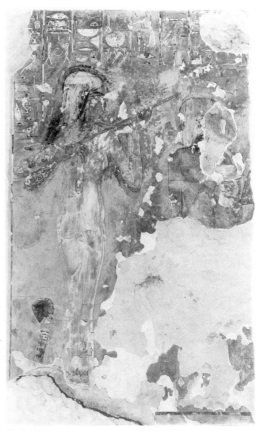

30.4.170

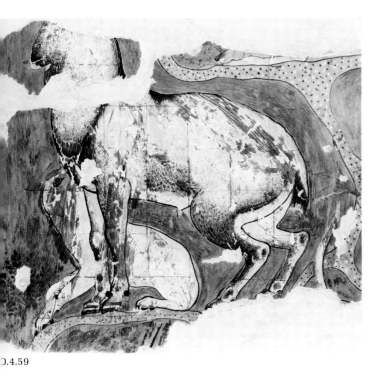

30.4.59

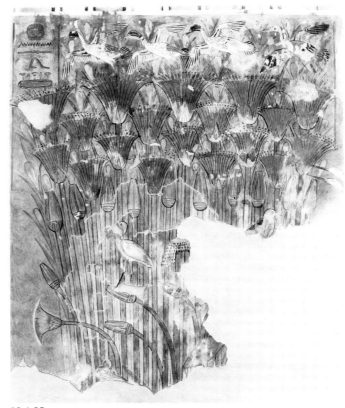

30.4.60

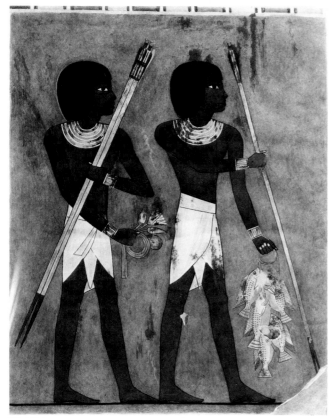

30.4.67

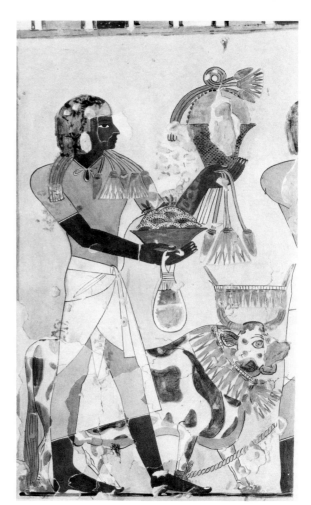

30.4.91

30.4.76

Tomb of Kenamun (T 93), continued

Fishing scene: attendants with harpoons and string
 of fish
193 (20)
HRH (1914–16); 43.5 × 53; 1:1 30.4.67

Tomb of Sennofer (T 96)
Dynasty 18, time of Amenhotpe II

Cat sitting below mistress's chair
Hall, PM I²1 198 (8) I
Na.deGD; 65 × 37.5; 1:1 30.4.76

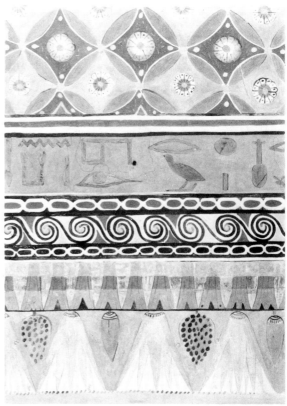

30.4.3

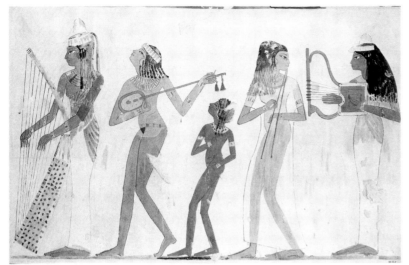

30.4.9

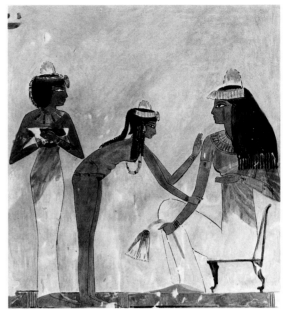

30.4.8

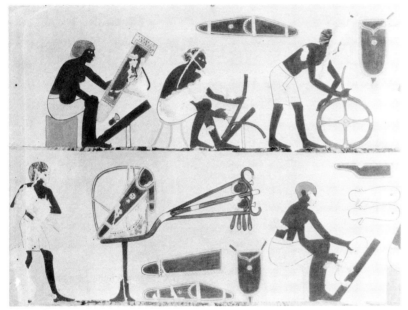

30.4.150

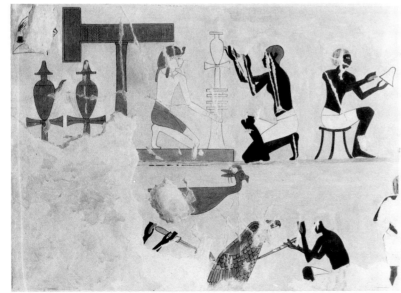

30.4.149

Tomb of Tjener (T 101)
Dynasty 18, time of Amenhotpe II

Bearers with honeycombs and bees; bull with decorated
 horns (restored)
Hall, PM I²1 215 (5) I
CKW (1926); 45 × 76; 1:1 30.4.91

Tomb of Kha (T 8)
Dynasty 18, time of Amenhotpe II–Amenhotpe III

Motif at spring of vault (restored)
Chapel, PM I²1 17 (3) ceiling
CKW (1922); 35.5 × 50; 1:1 30.4.3

Tomb of Djeserkaraseneb (T 38)
Dynasty 18, time of Tuthmosis IV

Musicians with harp, lute, double-pipe, and lyre (body of
 lutist restored)
Hall, PM I²1 70 (6) II
CKW (1921–22); 63.5 × 39.5; 1:1 30.4.9

Banquet guest with serving maids
70 (6) II
CKW (1921–22); 36 × 39; 1:1 30.4.8

Tomb of Hapu (T 66)
Dynasty 18, time of Tuthmosis IV

Wood and leather craftsmen
Hall, PM I²1 132 (2) I–II
Na.deGD (1927); 69 × 50; 1:1 30.4.150

Metal craftsmen
132 (2) I–II
Na.deGD (1927); 65.5 × 46; 1:1 30.4.149

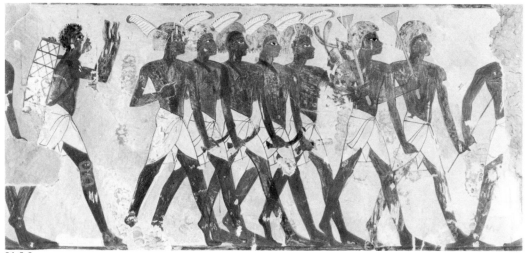

31.6.3

Tomb of Tjeneny (T 74)
Dynasty 18, time of Tuthmosis IV

Nubian soldiers with trumpeters and drummer
Hall, PM I²1 145 (5) IV
Na.deGD (1930–31); 91.5 × 42; 1:1 31.6.3

Tomb of Amenhotpesise (T 75)
Dynasty 18, time of Tuthmosis IV

Deceased offering bouquet to king
Hall, PM I²1 147 (3)
HRH (1914–15); 50 × 55; 1:3 30.4.232

Gifts for the Temple of Amun
147 (3)
HRH (1914–15); 70.5 × 36; 2:7 30.4.224

Tomb of Haty (T 151)
Dynasty 18, time of Tuthmosis IV

Haty supervising fodder preparation and cattle feeding
 (restored)
Hall, PM I²1 261 (2) III–IV
Na.deGD (1934); 120.5 × 64.5; 1:1 34.4.1

Tomb of Nakht (T 52)
Dynasty 18, time of Tuthmosis IV (?)

Nakht pouring libation and inspecting estate activities
Hall, PM I²1 99 (1)
No.deGD, LC; 2.26 × 1.69 meters; 1:1 15.5.19b

30.4.232

30.4.224

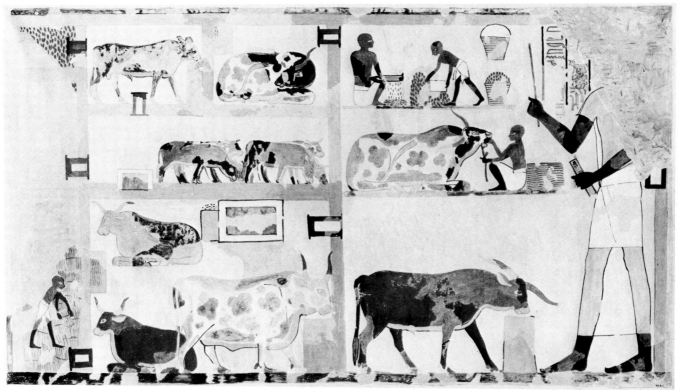

34.4.1

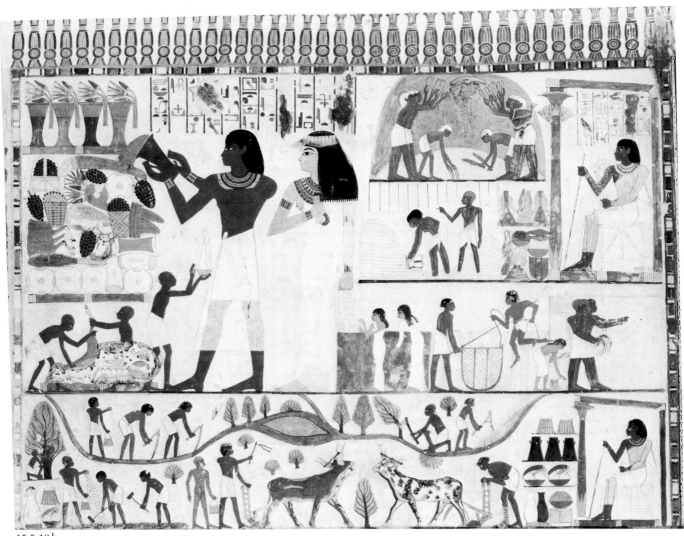

15.5.19 b

113

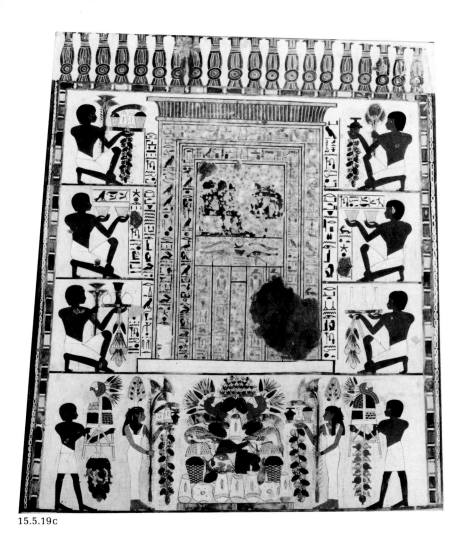

15.5.19c

15.5.19j

15.5.19k

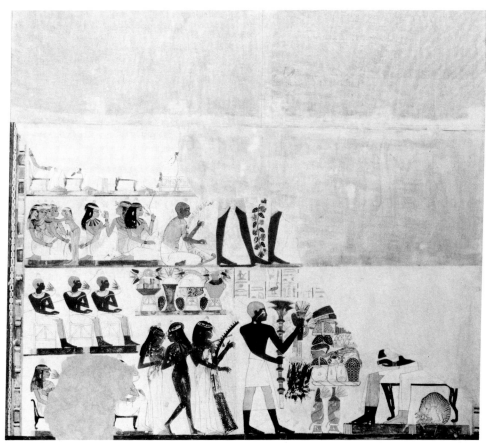

15.5.19d

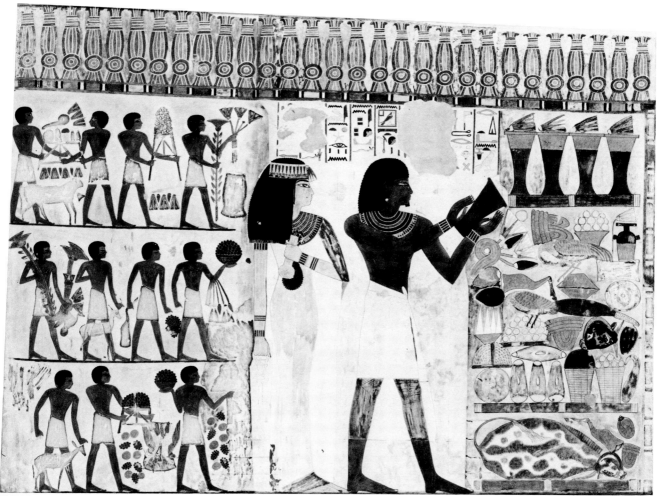

15.5.19 a

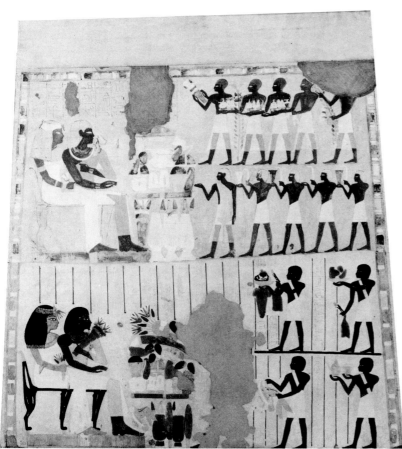

15.5.19 f

Tomb of Nakht (T 52), continued

False door stela surrounded by bearers and provisions
100 (2)
No.deGD, LC, FU; 1.54 × 1.69 meters; 1:1 15.5.19 c

Nakht and wife receiving offerings at the funerary
 banquet
100 (3)
No.deGD, LC; 1.82 × 1.65 meters; 1:1 15.5.19 d

Base line
100 (3)
Copyist unknown; 1 × .45 meters; 1:1 15.5.19 j

Base line
100 (3)
Copyist unknown; 1 × .44 meters; 1:1 15.5.19 k

Nakht and wife libating, followed by offering-bearers
101 (4)
No.deGD; 1.73 × 1.24 meters; 1:1 15.5.19 a

Nakht and wife receiving offerings
101 (5)
LC (1909–10); 1.48 × 1.58 meters; 1:1 15.5.19 f

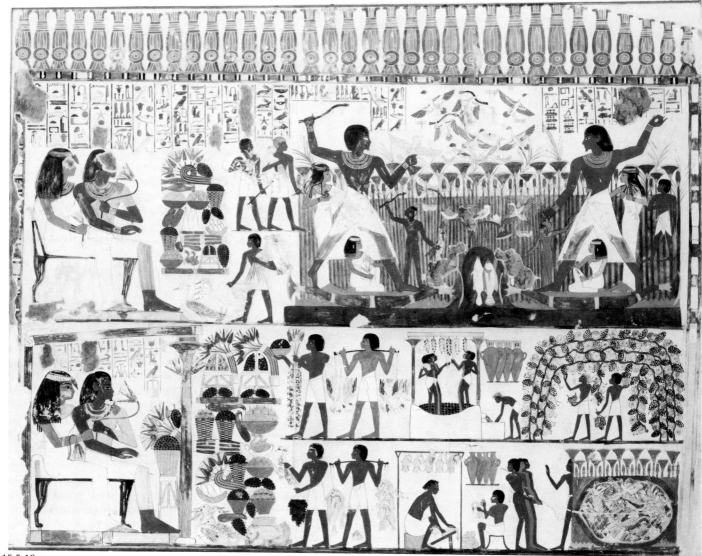

15.5.19 e

Tomb of Nakht (T 52), continued

Nakht and wife fishing and fowling, and watching estate
 activities
101 (6)
No.deGD, LC, FU; 2 × 1.53 meters; 1:1 15.5.19e

Base line
101 (6)
Copyist unknown; 1.01 × .45 meters; 1:1 15.5.19 l

Base line
101 (6)
Copyist unknown; 1 × .45 meters; 1:1 15.5.19 m

Ceiling pattern
Hall
No.deGD; 1.76 × 1.34 meters; 1:1 15.5.19 g

Ceiling pattern
Hall
LC (1909–10); 1.27 × 1.40 meters; 1:1 15.5.19h

Ceiling pattern
Hall
LC (1909–10); 1.96 × 1.49 meters; 1:1 15.5.19 i

15.5.19 l

15.5.19 m

15.5.19h

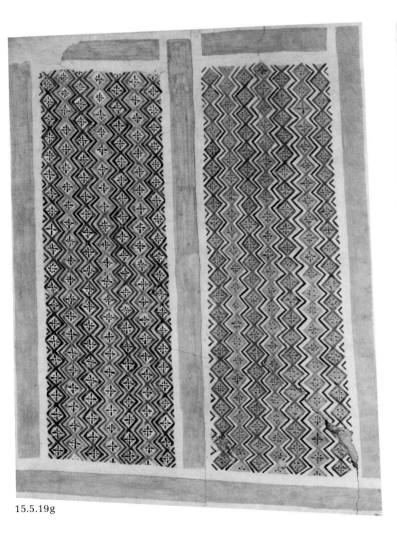

15.5.19g

15.5.19i

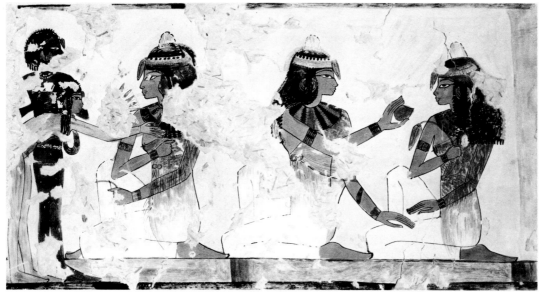

30.4.92

30.4.199

Tomb of Nebseny (T 108)
Dynasty 18, time of Tuthmosis IV (?)

Ladies and serving girls at banquet
Hall, PM I²1 225 (3)
Na.deGD (1922); 58 × 29.5; 1:1 30.4.92

Tomb of Amenemope (T 276)
Dynasty 18, time of Tuthmosis IV (?)

Wooden box stool
Hall, PM I²1 352 (2) II
CKW (1920); 16.5 × 10; 1:1 30.4.198

Lamp on a stand
Inner room, 353 (10) IV
CKW (1920); 9 × 39; 1:1 30.4.199

Animals of the desert
353 (11)
CKW (1920); 44.5 × 30; 1:1 30.4.122

Animal of the desert
353 (11)
CKW (1920–21); 18.5 × 32.5; 1:1 30.4.123

Tomb not known
Dynasty 18, time of Tuthmosis IV (?)

Portion of a threshing scene
Copyist unknown; 44 × 48.5; scale unknown
 48.105.23

Tomb of Horemhab (T 78)
Dynasty 18, time of Tuthmosis IV–Amenhotpe III

Trapping birds in a papyrus swamp
Passage, PM I²1 155 (13)
Na.deGD (1931); 107 × 47; 1:1 31.6.4

Tomb of Nebamun (T 90)
Dynasty 18, time of Tuthmosis IV–Amenhotpe III

Nebamun supervising estate activities and making
 offerings before a temple (restored)
Hall, PM I²1 184 (8) I–IV
CKW (1928); 130 × 99; 1:2 30.4.57

30.4.198

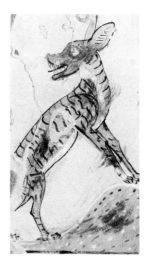

30.4.123

30.4.122

48.105.23

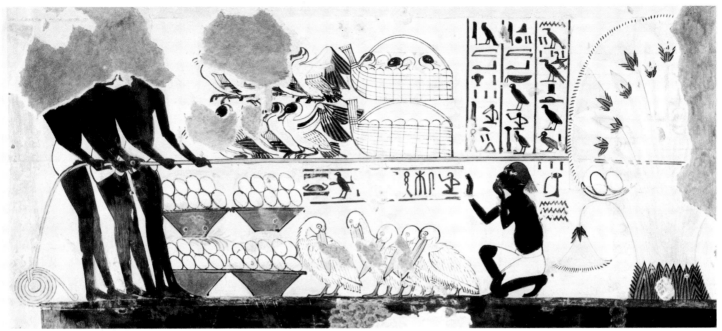

31.6.4

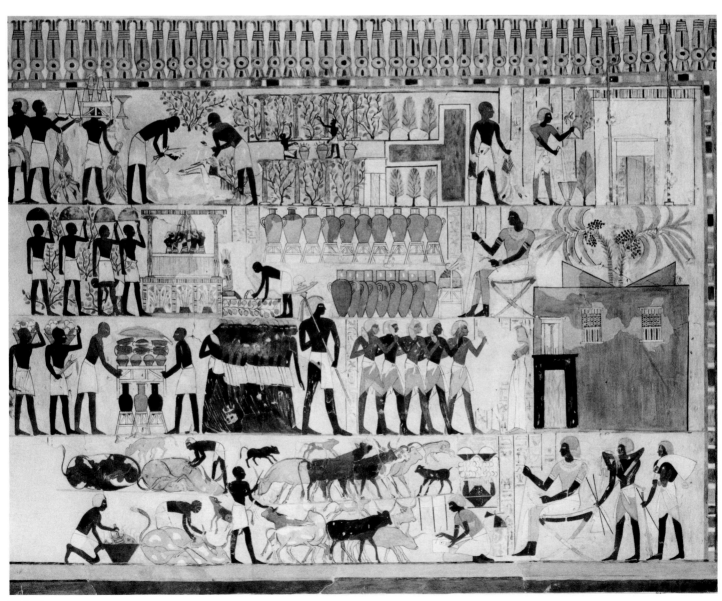

30.4.57

119

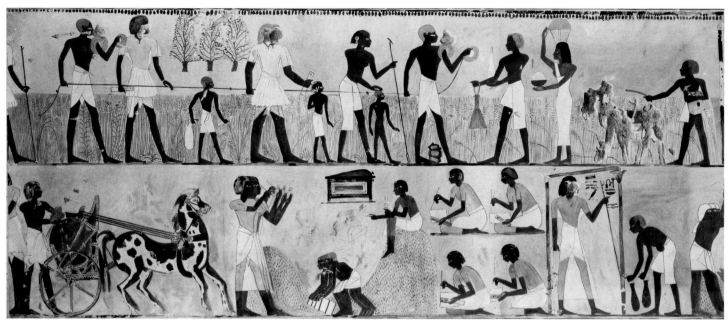

30.4.44

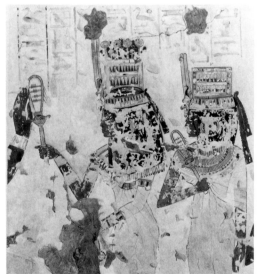

30.4.194

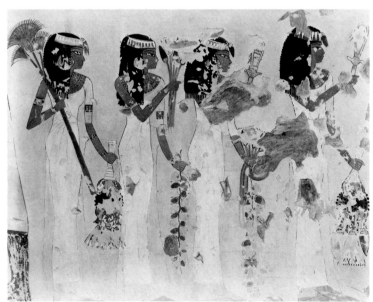

30.4.45

30.4.46

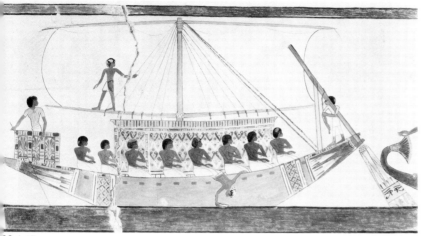

30.4.47

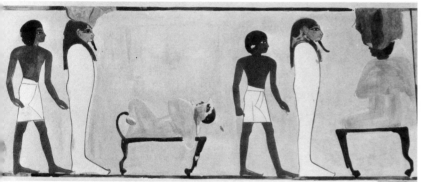

30.4.195

Tomb of Menna (T 69)
Dynasty 18, time of Tuthmosis IV–Amenhotpe III (?)

Detail of harvest scene
Hall, PM I²1 134 (2) I–II
CKW; 186 × 76; 1:1 30.4.44

Daughters of Menna holding sistra
134 (2) III–IV
CKW (1921–22); 45 × 49.5; 1:1 30.4.194

Daughters with offerings and sistra
137 (5) 1
CKW (1922); 67 × 52; 1:1 30.4.45

Woman presenting table of offerings
137 (6) right side, lower register
Na.deGD (1922); 41 × 77.5; 1:1 30.4.46

Nile ship used for the voyage to Abydos
138 (11) I
Na.deGD (1922); 72.5 × 38; 1:1 30.4.47

Priest enacting rituals before mummy of the deceased
138 (11) III
CKW (1922); 78 × 31; 1:1 30.4.195

Menna with family fishing and fowling
138 (12)
Na.deGD (1924); 189 × 101; 1:1 30.4.48

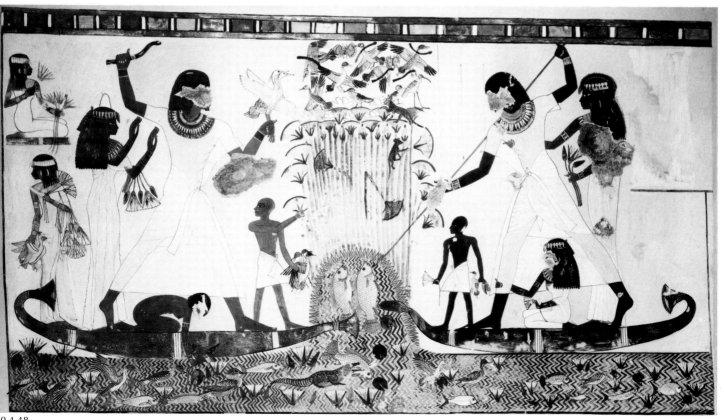

30.4.48

30.4.133

48.105.7

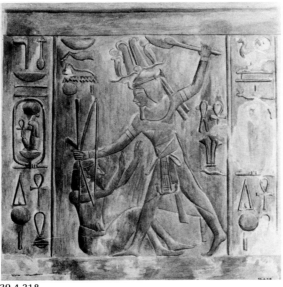

30.4.218

30.4.132

48.105.15

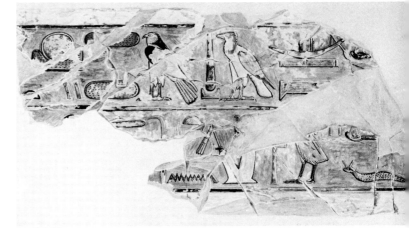

48.105.16

30.4.22

30.4.26

30.4.23

30.4.24

30.4.25

Palace of Amenhotpe III, Malkata
Dynasty 18, time of Amenhotpe III

Bull in a papyrus swamp
Palace, PM I²2 780 north waiting room M (c)
WJPJ (1910–12); 96.5 × 63.5; 1:1 30.4.133

Syrian kneeling, facing left
Great Banquet Hall H, 780 south wall (?)
WJPJ (?); 93.4 × 49.7; scale unknown 48.105.7

A clump of papyrus
Palace, west side, second harem suite from north (?)
WJPJ (1910–12); 35.5 × 63.5; 1:1 30.4.132

Tomb of Amenemhat Surer (T 48)
Dynasty 18, time of Amenhotpe III

Panel from throne: king slaying Asiatic enemy
Portico, PM I²1 88 (4)
CKW (1923); 23 × 22.5; 1:1 30.4.218

Two architrave fragments
89 fragments of architraves and of capital
Na.deGD; 42 × 17; 1:4 48.105.15

Fragment of inscribed architrave
89 fragments of architraves and of capital
Na.deGD (1934); 35.4 × 16; 1:4 48.105.16

Section of ceiling pattern (restored)
Location unknown, probably portico or passage
HRH (1914–15); 34 × 36.5; 1:1 30.4.22

Section of ceiling pattern (restored)
Location unknown, probably portico or passage
HRH (1914–15); 48.5 × 43; 1:1 30.4.23

Section of ceiling pattern (restored)
Location unknown, probably portico or passage
HRH (1914–15); 48.5 × 23.5; 1:1 30.4.24

Section of ceiling pattern (restored)
Location unknown, probably portico or passage
HRH (1914–15); 35 × 35; 1:1 30.4.25

Section of ceiling pattern (restored)
Location unknown, probably portico or passage
HRH (1914–15); 34 × 37; 1:1 30.4.26

30.4.27

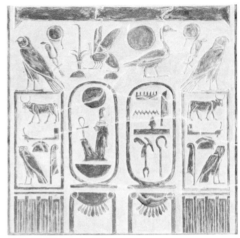

48.105.11

48.105.12

48.105.13

Tomb of Amenemhat Surer (T 48), continued

Section of ceiling pattern (restored)
Location unknown, probably portico or passage
HRH (1914–15); 57 × 29; 1:1 30.4.27

Fragment of inscribed lintel (restored)
89 finds
Na.deGD (1934); 54 × 45.5; probably 1:1 48.105.11

Fragment of inscribed architrave
Na.deGD (1933); 48 × 62.5; 1:1 48.105.12

Fragment of inscribed architrave
Na.deGD (1934); 33.4 × 35.6; 1:2 48.105.13

Fragment of inscribed architrave
Na.deGD (1933); 52 × 16.1; 1:2 48.105.14

48.105.14

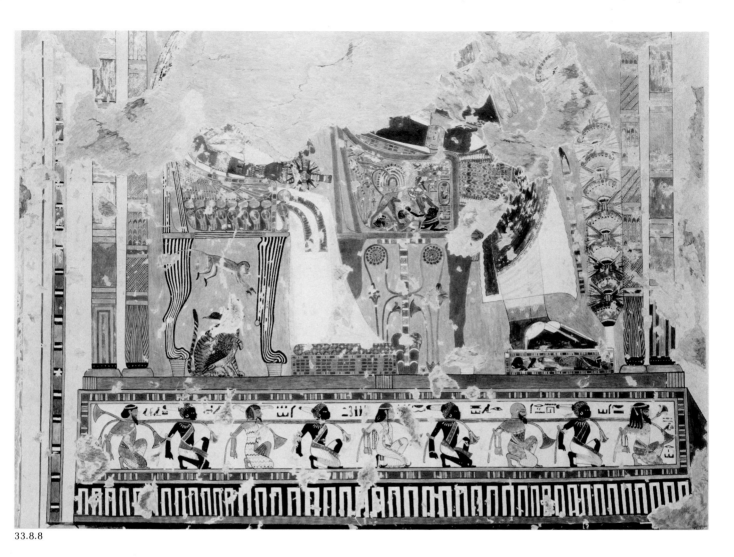

33.8.8

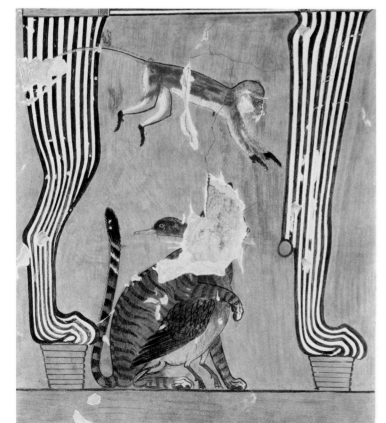

30.4.93 (detail of 33.8.8)

Tomb of Anen (T 120)
Dynasty 18, time of Amenhotpe III

Amenhotpe III and Queen Tiye enthroned
Hall, PM I²1 234 (3)
Na.deGD (1931); 101.5 × 70.5; 1:2 33.8.8

Pets under the queen's throne (detail of 33.8.8)
234 (3)
No.deGD (1929); 38 × 44; 1:1 30.4.93

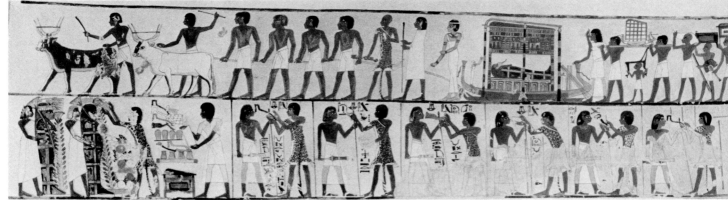

35.101.3

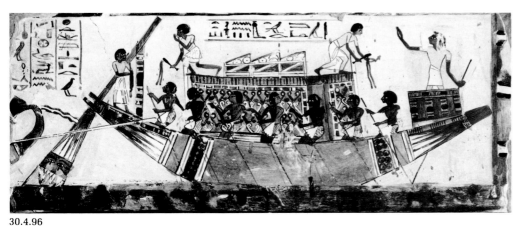

30.4.96

30.4.166

Tomb of Pairy (T 139)
Dynasty 18, time of Amenhotpe III

Funeral procession and rites (restored)
Hall, PM I²1 253 (4) II–III
Na.deGD (1935); 192 × 48.5; approximately 1:1

35.101.3

Journey to Abydos
253 (4) IV
CKW (1926); 71.5 × 28; 1:1

30.4.96

Tomb, name lost (T 226)
Dynasty 18, time of Amenhotpe III

Detail of offering procession: man carrying wheat and two
quail
Hall, PM I²1 327 (3)
Na.deGD (1925); 25.5 × 44; 1:1

30.4.166

Detail of offering procession: bull (position of fragments
restored)
327 (3)
Na.deGD (1914); 39 × 44.5; 1:1

15.5.2

Amenhotpe III and his mother in a kiosk (substantially
restored; original now Luxor Museum J 134)
327 (4)
Na.deGD (1914); 226 × 162; 1:1

15.5.1

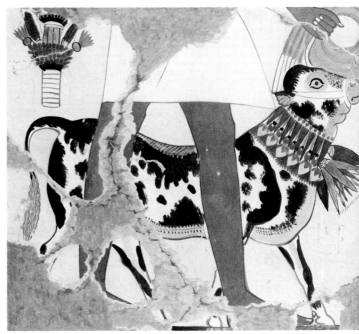

15.5.2

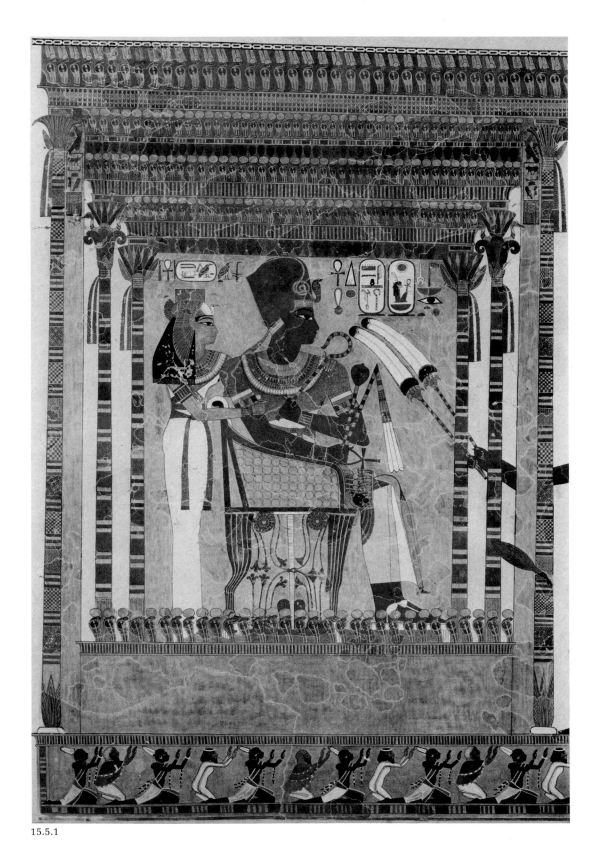

15.5.1

30.4.230

Tomb of Nakht (T 161)
Dynasty 18, time of Amenhotpe III (?)

Vase on stand (restored from R. Hay tracings, British
 Library, London)
Hall, PM I²1 274 (3) I
CKW (1921–22); 11.5 × 35; 1:1 30.4.230

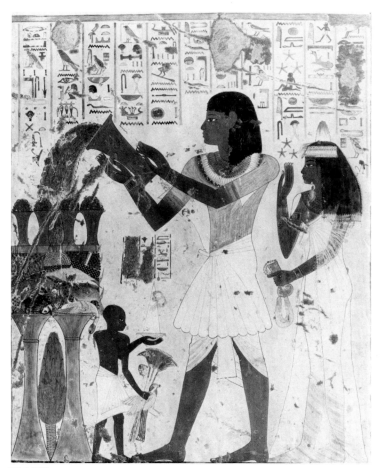

30.4.104

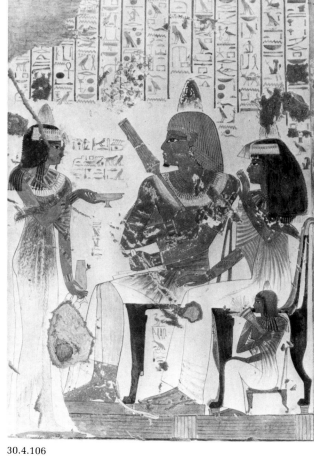

30.4.106

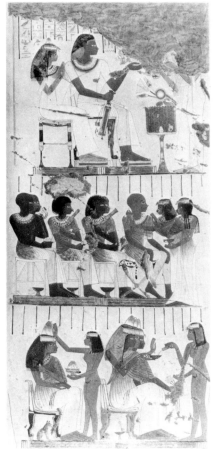

30.4.105

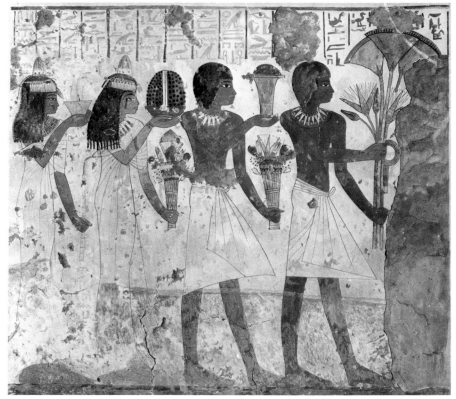

30.4.107

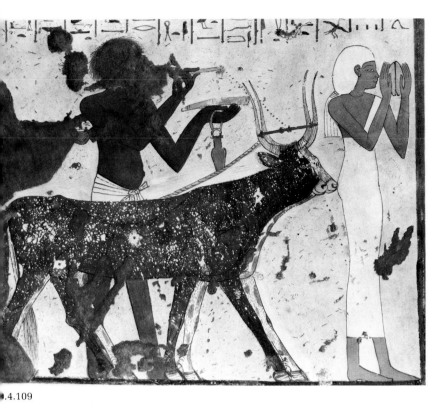

.4.109

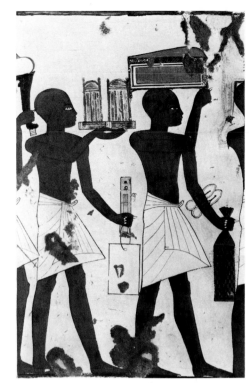

30.4.110

30.4.159

Tomb of Nebamun and Ipuky (T 181)
Dynasty 18, time of Amenhotpe III–IV

Deceased and mother pouring incense
Hall, PM I²1 286 (2)
Na.deGD (1920–21); 74 × 91; 1:1 30.4.104

Presentation of wine to Nebamun and family
287 (3)
Na.deGD (1916); 64.5 × 92; 1:1 30.4.106

Banquet scene
287 (3) I–III
Na.deGD (1920–21); 42.5 × 91.5; 1:1 30.4.105

Relatives bringing offerings
287 (3) subscene
Na.deGD (1919); 58 × 49; 1:1 30.4.107

Calf in the funeral procession
287 (4) I
No.deGD (1920); 11 × 9; 1:1 30.4.159

Man sprinkling milk before cows
287 (4) II
Na.deGD; 43 × 34; 1:1 30.4.109

Bearers with funerary provisions
287 (4) III
No.deGD (1920); 23 × 36; 1:1 30.4.110

Funeral barge being towed to West Bank by vessel
 containing mourners
287 (4) IV
HRH (1914–16); 57 × 36; 1:1 30.4.111

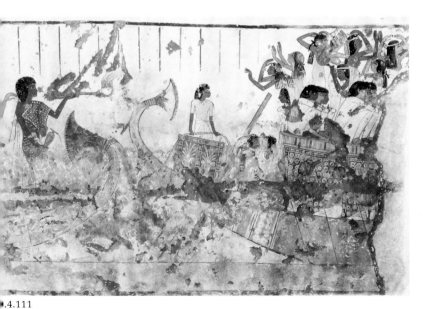

.4.111

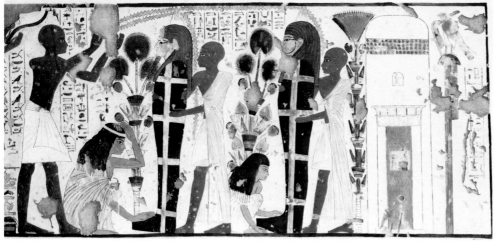

30.4.108

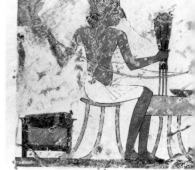

30.4.156

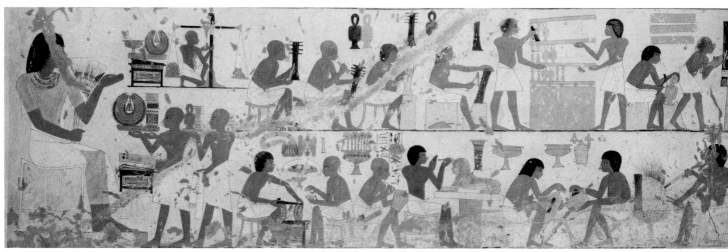

30.4.103

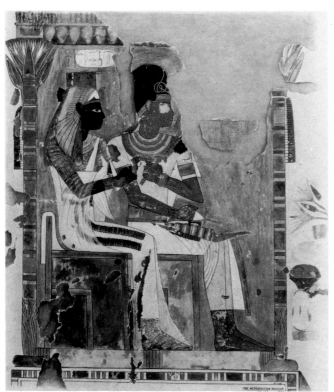

30.4.158

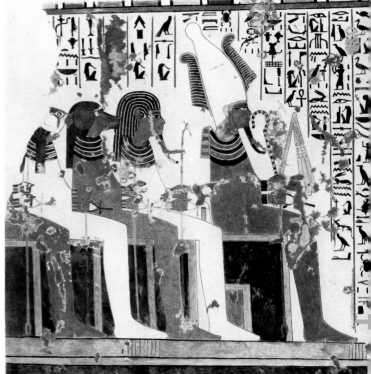

30.4.157

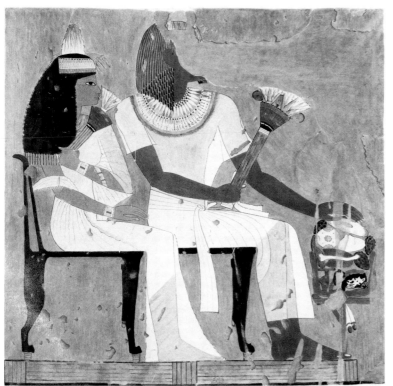

30.4.112

Tomb of Nebamun and Ipuky (T 181), continued

Performing funerary ceremonies before mummies at the
 tomb
287 (5)
CKW (1920–21); 81 × 37; 1:1 30.4.108

Deified Amenhotpe I and Ahmose-Nofretari in kiosk
288 (6) I 1
HRH (1914–16); 53 × 60; 1:1 30.4.158

Metal and wood artisans at work
288 (6) II
No.deGD (1921–22); 159.5 × 50; 1:1 30.4.103

Craftsman using bow drill
288 (6) II
NdeGD (1920); 23 × 22; 1:1 30.4.156

Osiris and the Sons of Horus
288 (7) I
HRH and (?)Na.deGD (1915); 79 × 77; 1:1 30.4.157

Deceased pair before table of offerings
Inner room 288 (9)
CKW (1921–22); 74.5 × 72.5; 1:1 30.4.112

Ceiling patterns (restored)
Na.deGD (1921); 79.5 × 53.5; 1:1 30.4.102

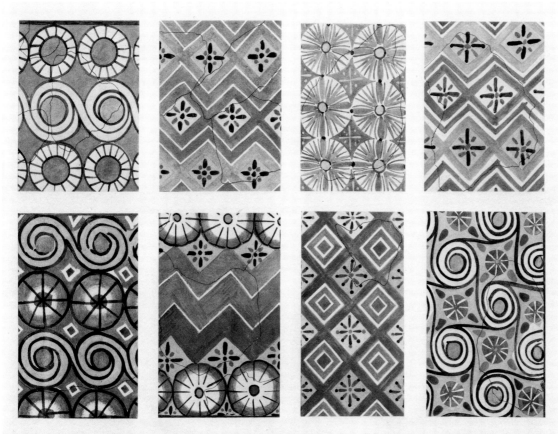

30.4.102

Tomb of Ramose (T 55)
Dynasty 18, time of Amenhotpe IV

Part of the funeral procession
Hall, PM I²1 108 (5) II
Na.deGD; 574.5 × 81; 1:1 30.4.37

North Palace of Akhenaton, Tell el Amarna
Dynasty 18, time of Akhenaton

A papyrus swamp scene (restored)
Northeast court, PM IV 195 "Green Room" Cubicle W,
 west wall
No. and Na.deGD (1926); 425 × 105.5; 1:1 30.4.136

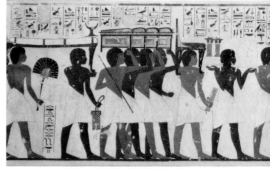

30.4.37

33.8.19

30.4.136

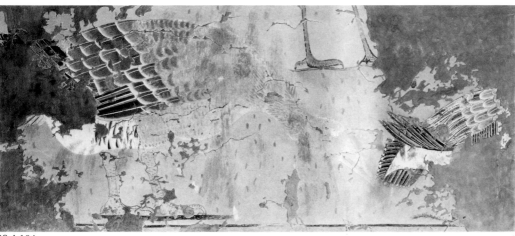

30.4.134

30.4.223

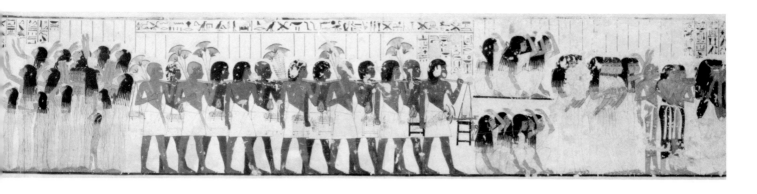

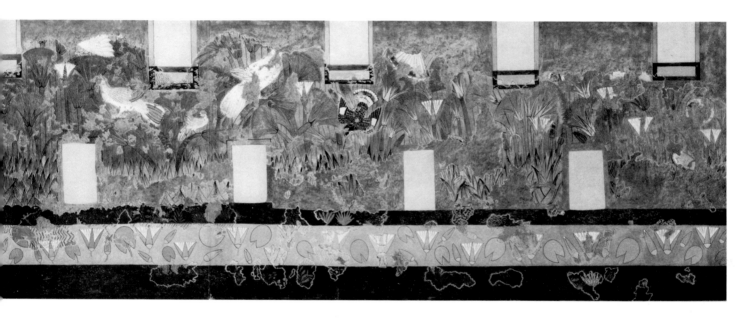

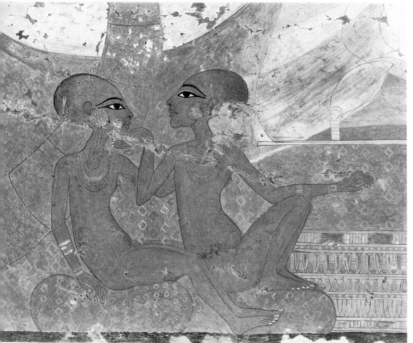

0.4.135

Geese feeding
195 other cubicles (west rooms)
No.deGD (1926–27); 97 × 40.5; 1:1 30.4.134

Scene with fowl
195 other cubicles (west rooms)
N deGD (probably 1926–27); 78 × 95.5; 1:1 33.8.19

Fragments of an olive tree (preliminary grouping for
 H. Frankfort, *The Mural Painting of El'Amarneh*,
 London, 1929, pl. 9C)
Various, 195
Na.deGD (1926–27); 13 × 18; 1:1 30.4.223

Private Palace, Tell el Amarna
Dynasty 18, time of Akhenaton

Two daughters of Akhenaton (detail of original, now
 Oxford 1893.1)
PM IV 199 palace
Na.deGD (1928); 38 × 30; 1:1 30.4.135

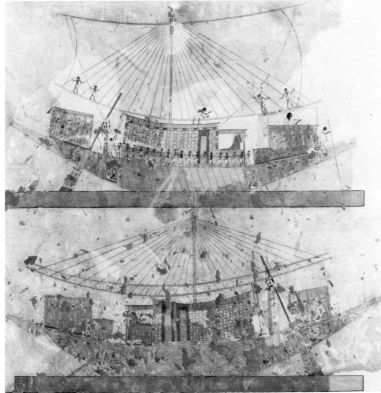

30.4.19

Tomb of Amenhotpe Huy (T 40)
Dynasty 18, time of Akhenaton-Tutankhamun

Viceregal dahabeah represented twice (restored)
Hall, PM I²1 75 (1) I
CKW (1926–27); 111.3 × 111.3; 1:1 30.4.19

Freight boats transported over mud flat (?) (restored)
75 (3) II
CKW (1926); 103 × 32; 1:1 30.4.18

Presentation of Nubian tribute to Tutankhamun (restored
 from J. Gardner Wilkinson notebooks, Hay and Dupuy
 tracings, and R. Lepsius, *Denkmaler aus Aegypten und
 Aethiopien*, Berlin, 1849–59, part 3, pls. 116–18)
75–76 (5)–(7)
CKW (1923–27); 524 × 182; 1:1 30.4.21

Mooring of boat carrying captive Nubians (detail of
 30.4.21)
75 (5) II
CKW (1922–23); 70 × 30; 1:1 30.4.20

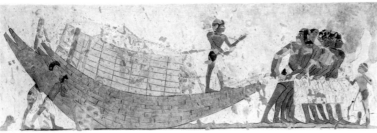

30.4.18

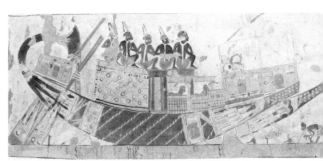

30.4.20 (detail of 30.4.21)

30.4.21

Tomb of Noferhotep (T 49)
Dynasty 18, time of Aye

Boats with mourners and provisions
Hall, PM I²1 92 (8) I
Na.deGD (1930?); 163 × 58; 1:1 31.6.6

Noferhotep greeted by wife before temple
Pillared hall, 93 (15)–(16) I 2
Na.deGD (1930); 81.5 × 72; 1:1 31.6.7

31.6.6

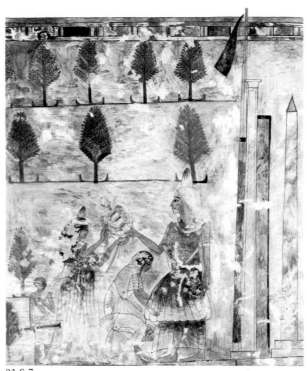

31.6.7

Tomb of Noferhotep (T 49), continued

Noferhotep and wife offering to deified Amenhotpe I and
 Ahmose-Nofretari
94 Pillar C (a)
Na.deGD (1930); 60 × 77; 2:3 31.6.39

Tomb of Horemhab (Valley of the Kings 57)
Dynasty 18, time of Horemhab

Horemhab before Horsiese (restored)
Antechamber I, PM I²2 568 (3) 4
LC (c. 1910–11); 35 × 63.5; scale unknown 23.2.86

Horemhab offering wine to Anubis (restored)
568 (4) 2
LC (c. 1910–11); 35.5 × 63; scale unknown 23.2.84

Horemhab before Isis (restored)
568 (4) 3
LC (c. 1910–11); 33 × 62.5; scale unknown 23.2.85

Book of Gates: boat of the sun god
Sarcophagus chamber, 568 (8) II
LC (c. 1910–11); 62.5 × 35.5; scale unknown 23.2.83

Book of Gates: text from fourth hour
568 (8) III
LC (c. 1910–11); 41.5 × 36; scale unknown 23.2.80

Book of Gates: boat with monkey driving swine
568 (12)
LC (c. 1910–11); 42 × 45; scale unknown 23.2.82

Boat with monkey driving swine (detail of 23.2.82)
568 (12)
LC (c. 1910–11); 60 × 46; scale unknown 23.2.81

Tomb of Noferhotep (T 50)
Dynasty 18, time of Horemhab

Ceiling pattern with bucrania and grasshoppers
Hall, PM I²1 96 ceiling
CKW (1922); 41 × 38.5; 1:1 30.4.167

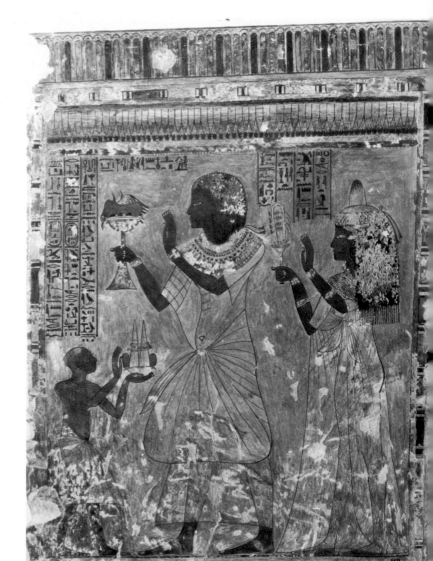

31.6.39

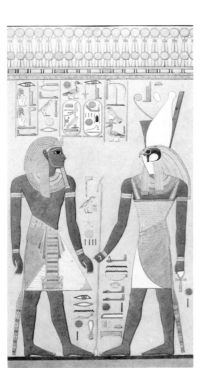

23.2.86

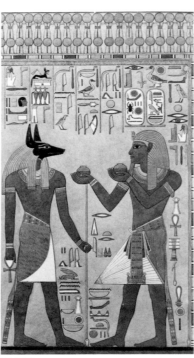

23.2.84

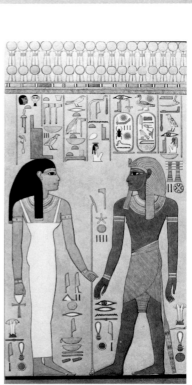

23.2.85

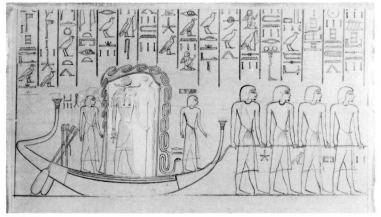

23.2.83

23.2.80

23.2.82

23.2.81 (detail of 23.2.82)

30.4.167

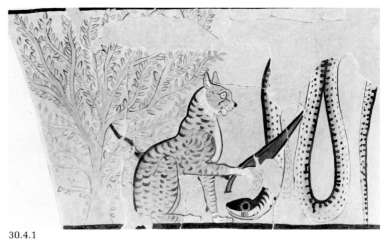

30.4.1

30.4.2

Tomb of Sennedjem (T 1)

Dynasty 19

Cat slaying serpent in scene from the Book of the Dead
Burial chambers, innermost, PM I²1 1 (5)
CKW (1920–21); 84.5 × 47; 1:1 30.4.1

Deceased and wife in fields of Iaru; adoring deities
3 (9) I–IV
CKW (1922); 84.5 × 54; 1:2 30.4.2

Tomb of Kener, usurped from Huy (T 54)

Early Dynasty 19

Deceased before deified Amenhotpe I and Ahmose-
 Nofretari
Hall, PM I²1 105 (5) I
CKW (1922); 63.5 × 39.5; probably 1:1 30.4.36

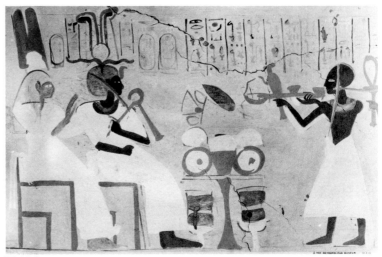

30.4.36

138

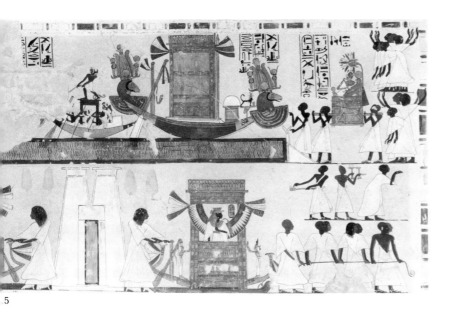

5

.1

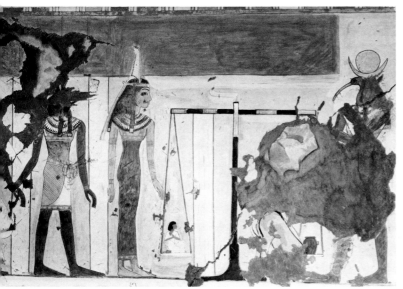

18

Tomb of Amenmose (T 19)
Dynasty 19, time of Ramesses I–early Ramesses II

Bark of Amun greeted by statues of deified Amenhotpe I
 and Ahmose-Nofretari
Hall, PM I²1 33 (3) I–II
CKW (1930–31); 130 × 74.5; 1:1 31.6.5

Festival of deified Amenhotpe I (restored from R. Hay
 tracings, British Library, London)
33 (4) I–II
CKW (1931–32); 196 × 75; 1:1 32.6.1

Tomb of Userhat (T 51)
Dynasty 19, time of Sety I

Weighing of Userhat's heart
Hall, PM I²1 97 (3) I 1–2
No.deGD (1911); 102 × 66; 1:1 15.5.18

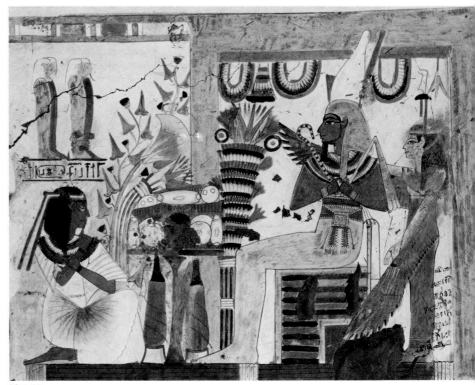

30.4.32

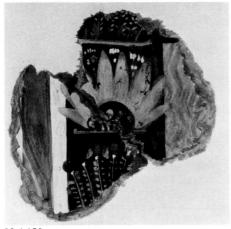

30.4.153

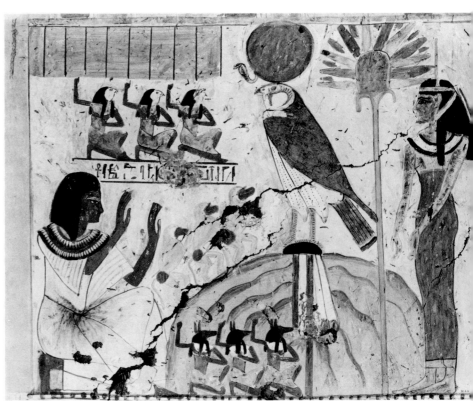

30.4.31

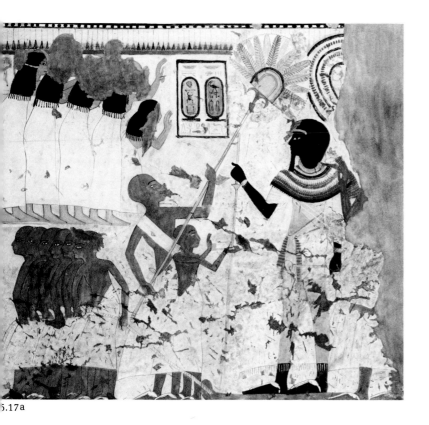

15.17a

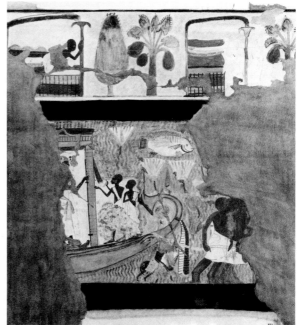

15.5.16

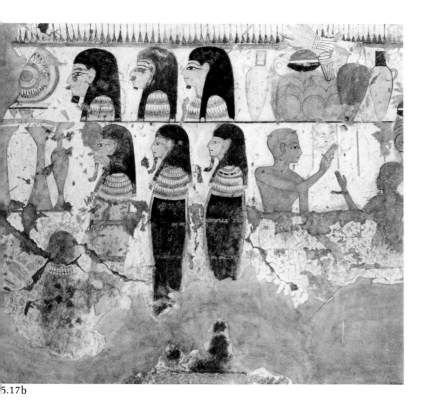

5.17b

Tomb of Userhat (T 51), continued

Userhat kneeling before Osiris and Western Goddess
97 (3) I 3
No.deGD (1909–10); 67 × 91; 1:1 30.4.32

Userhat adoring deities of the west
97 (3) I 4
No.deGD; 94.5 × 68; 1:1 30.4.31

Flora bordering a pool
97 (4) II
Na.deGD (1909); 17 × 16; 1:1 30.4.153

Dragging statue of Tuthmosis I
97 (5) II
No.deGD (1911); 75 × 64; 1:1 15.5.17a

Royal statue in bark on lake
97 (5) II
No.deGD (1911); 54 × 54; 1:1 15.5.16

Funerary equipment: masks, coffins
97 (5) III
No.deGD (1911); 75 × 64; 1:1 15.5.17b

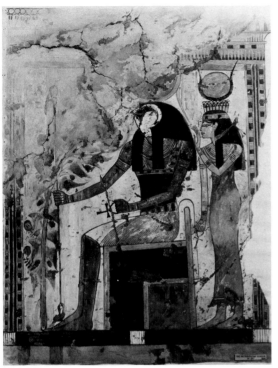

30.4.163

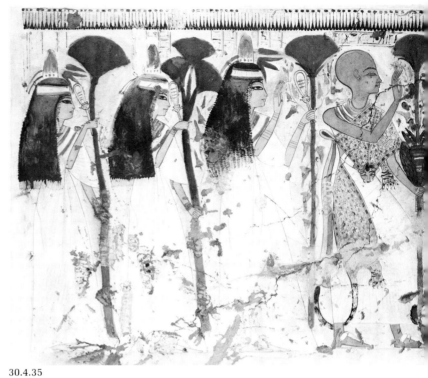

30.4.35

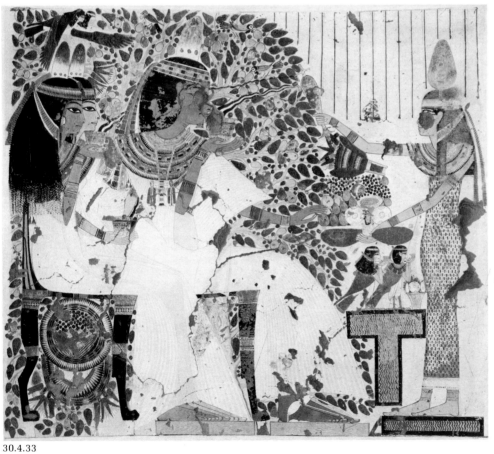

30.4.33

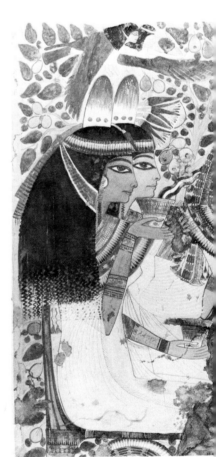

30.4.162 (detail of 30.4.33)

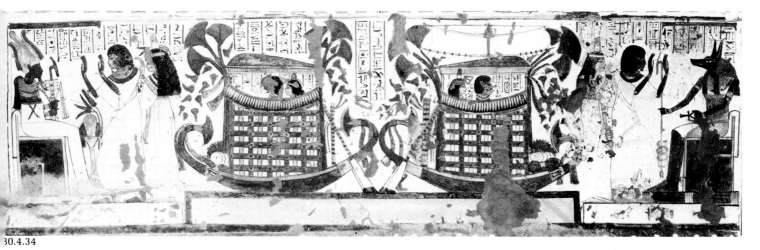

30.4.34

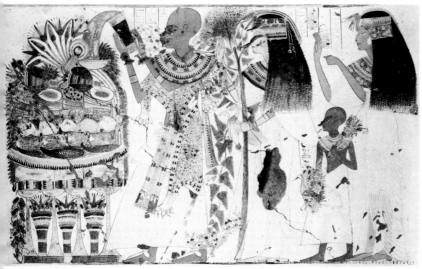

30.4.29

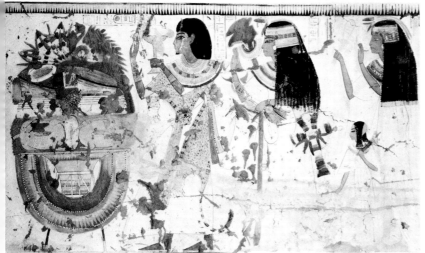

30.4.30

Tomb of Userhat (T 51), continued

Montu and Mertseger in kiosk
98 (6)
CKW (1924–25); 66 × 85; 1:1 30.4.163

Priests and priestesses with offerings for Montu
98 (6)
NH (1910–11); 123 × 97.5; 1:1 30.4.35

Userhat, family, and *bas* receiving sustenance from
 goddess
98 (7)
No.deGD; 162.5 × 138; 1:1 30.4.33

Wife and mother with their *bas* (detail of 30.4.33)
98 (7)
Copyist unknown; 24 × 47; 1:2 30.4.162

Pilgrimage to Abydos of Userhat and wife
98 (7) subscene
No.deGD (1909–10); 168 × 47; 1:1 30.4.34

Userhat and family offering to Osiris
98 (9) I
No.deGD; 149.5 × 88.5; 1:1 30.4.29

Userhat and family offering to Tuthmosis I and Ahmose-
 Nofretari
98 (9) II
NH (1910–11); 155 × 89; 1:1 30.4.30

30.4.164

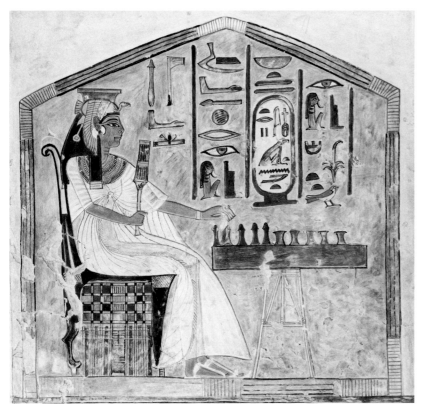

30.4.145

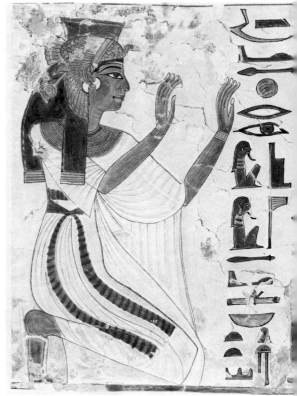

30.4.144

30.4.143

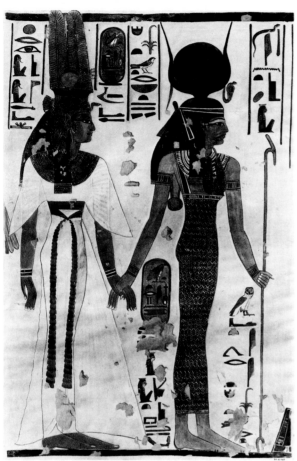

30.4.142

Tomb of Userhat (T 51), continued

Frieze of Hathor heads and Anubis jackals
99 frieze
No.deGD; 150.5 × 24; 1:1 30.4.164

Tomb of Nofretari (Valley of the Queens 66)
Dynasty 19, time of Ramesses II

Nofretari playing draughts
Outer hall, PM I²2 762 (2) I
Na.deGD (1921–22); 46 × 43; approximately 1:2

 30.4.145

Nofretari kneeling in adoration
762 (2) I
Na.deGD (1922); 34 × 46; approximately 1:2 30.4.144

Beings of the Underworld
762 (2) I
Na.deGD (1922); 68 × 41; approximately 4:7 30.4.143

Nofretari led by Isis
763 (10)
CKW (1922–23); 46 × 70; approximately 1:3 30.4.142

Tomb of Panehsy (T 16)
Dynasty 19, time of Ramesses II

Procession from Temple of Amun
Hall, PM I²1 28 (5) II
CKW (1923–24); 192 × 67.5; 1:1 30.4.6

30.4.6

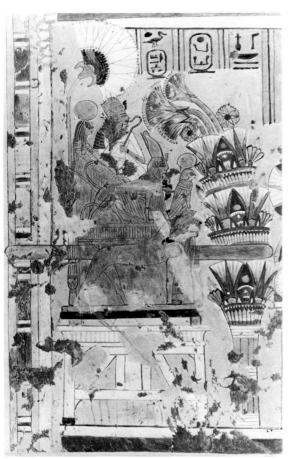

30.4.5

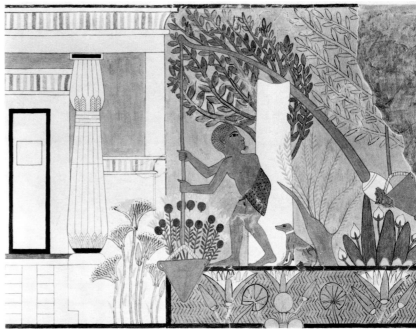

30.4.115

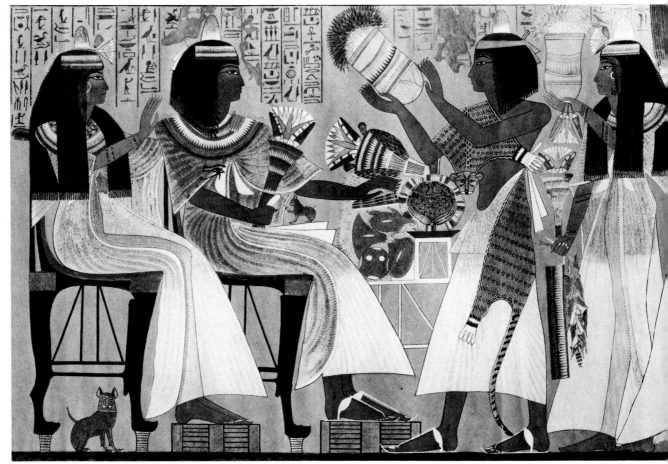

30.4.114

146

30.4.190

Tomb of Panehsy (T 16), continued

Statue of deified Amenhotpe I on palanquin
28 (6) I 2
Na.deGD (1922); 41.5 × 65.5; 1:1 30.4.5

Tomb of Ipuy (T 217)
Dynasty 19, time of Ramesses II

Servant near garden chapel with shadoof (restored from
 Georges Legrain copy, *Mémoires publiés par les
 membres de la Mission archéologique française au
 Caire*, vol. 5, fasc. 2, Paris, 1891, pl. after p. 612)
Hall, PM I²1 315 (2) III
No.deGD (1924); 48 × 35; 1:1 30.4.115

Ipuy and wife receiving offerings from their children
 (substantially restored)
316 (3) II
No.deGD (1920–21); 74 × 47.5; 1:3 30.4.114

Cat under chair (detail of 30.4.114)
316 (3) II
No.deGD (1919); 19.5 × 25; 1:1 30.4.183

Kitten on Ipuy's lap (detail of 30.4.114)
316 (3) II
No.deGD (1912); 17 × 13; 1:1 30.4.184

Ipuy and family offering to deities
316 (4)
HRH (1914); 64 × 45; 1:4 30.4.188

Sacrifice of goat; measuring grain
316 (5) II
No.deGD (1920–21); 20 × 19; 1:1 30.4.190

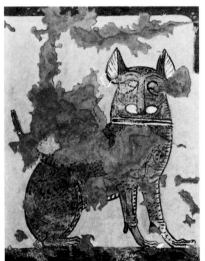

30.4.183 (detail of 30.4.114)

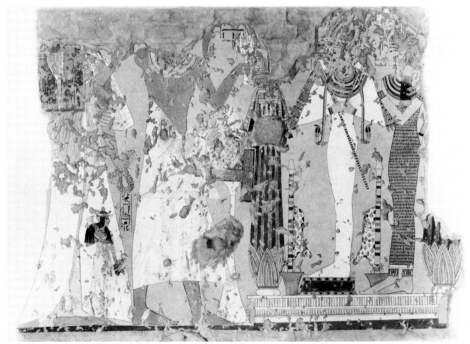

30.4.188

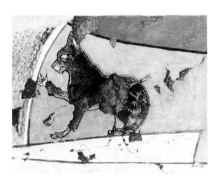

30.4.184 (detail of 30.4.114)

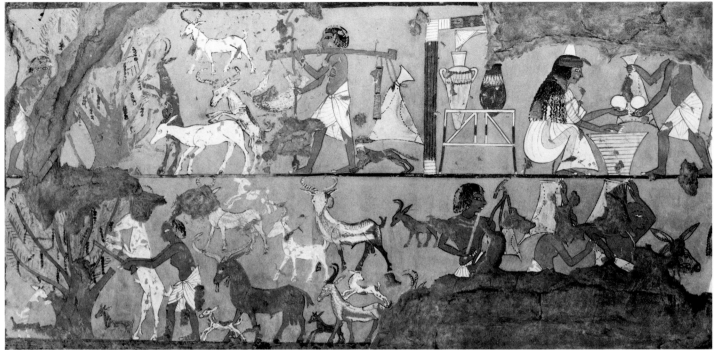

30.4.117

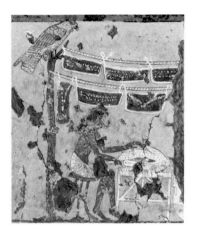

30.4.191

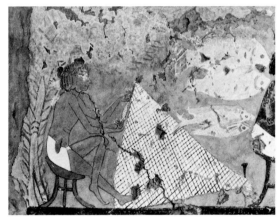

30.4.155

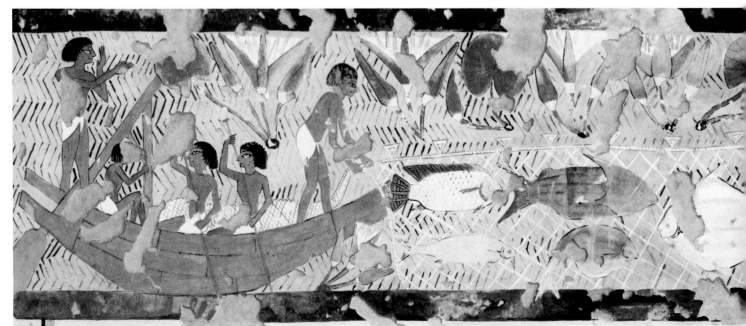

30.4.120

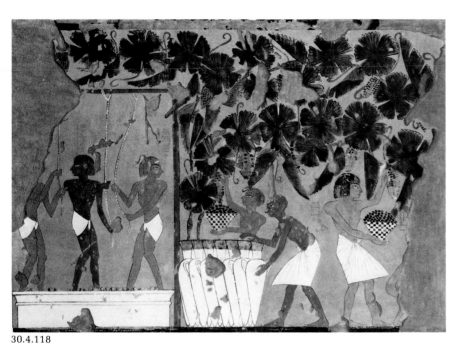

30.4.118

30.4.119

Tomb of Ipuy (T 217), continued

Goats, herdsmen, dogs: market scene		
316 (5) III		
No.deGD (1920); 72.5 × 34; 1:1	30.4.117	

Butcher with meat hanging above		
316 (5) IV		
No.deGD (1919); 20.5 × 24; 1:1	30.4.191	

Making (mending?) a net		
316 (5) IV		
No.deGD (1919); 27 × 20; 1:1	30.4.155	

Vineyard work
316 (5) IV
CKW; 65 × 45; 1:1 30.4.118

Fishing and fowling scenes
316 (5) IV–V
NdeGD (1919–20); 42 × 49.5; 1:1 30.4.119

Fishing with net; netting fowl
316 (5) V
CKW; 139 × 28; 1:1 30.4.120

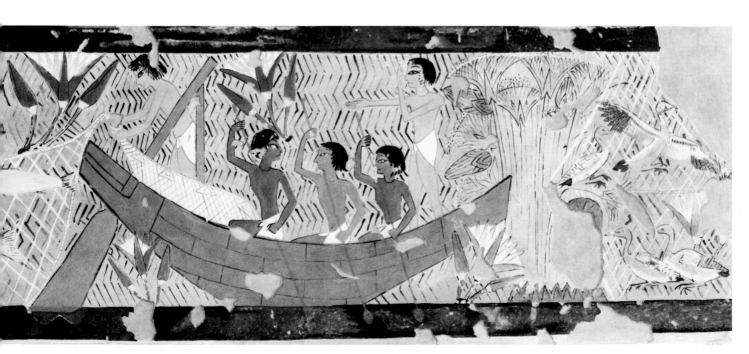

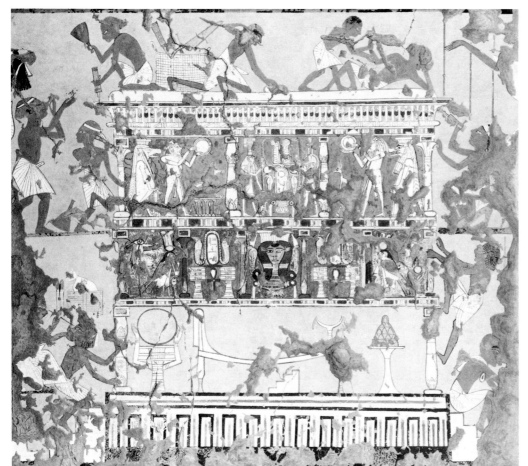

30.4.116

30.4.189

30.4.187

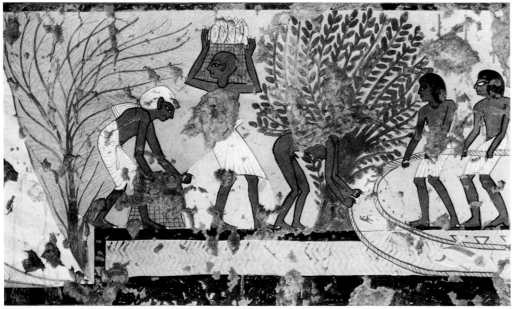

15.5.6

30.4.185

30.4.186

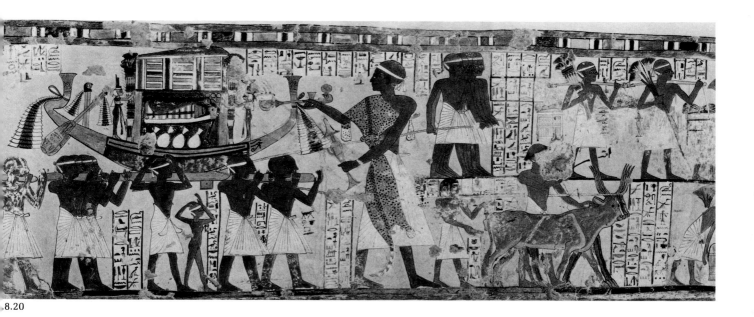

8.20

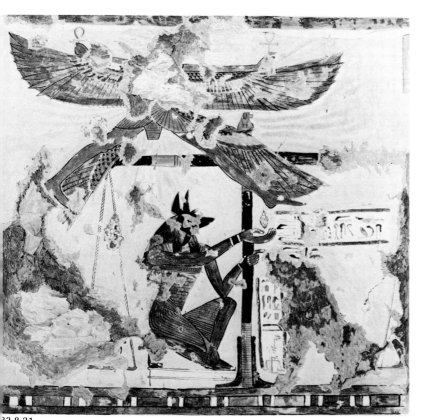

33.8.21

Tomb of Ipuy (T 217), continued

Carpenters making catafalque for the deified
 Amenhotpe I
316 (6) III
No.deGD; 81 × 69.5; 1:1 30.4.116

Fishing and gathering up fish
316 (6) IV
No. and Na.deGD (1913); 64 × 35; 1:1 15.5.6

A goose on the prow of a boat
317 (10)
Na.deGD (1922); 13.5 × 17; 1:1 30.4.189

Parts of leaves and flowers
CKW (1923); 7 × 14; 1:1 30.4.187

Fragments of a palm tree (placement uncertain)
Na.deGD (1922); 11 × 18.5; 1:1 30.4.185

Parts of a fig tree
CKW (1922); 8.5 × 11.5; 1:1 30.4.186

Tomb of Nakhtamun (T 341)
Dynasty 19, time of Ramesses II

Boat with Nakhtamun's mummy preceded by his son
Hall, PM I²1 408 (2) II
Na.deGD (1933); 159 × 58.5; 1:1 33.8.20

Anubis weighing the heart with winged deity above
408 (3) I
Na.deGD; 68 × 65.5; 1:1 33.8.21

151

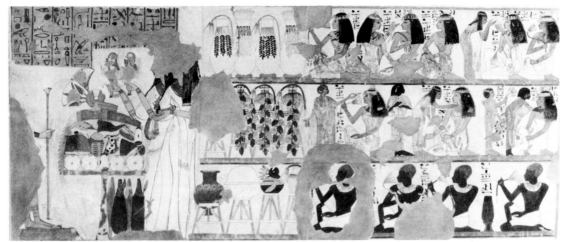

15.5.14

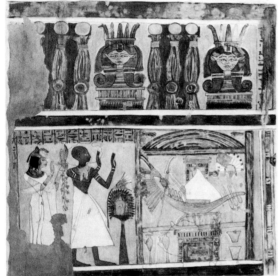

15.5.11

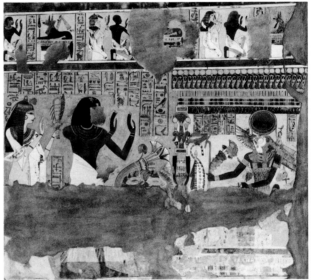

15.5.12

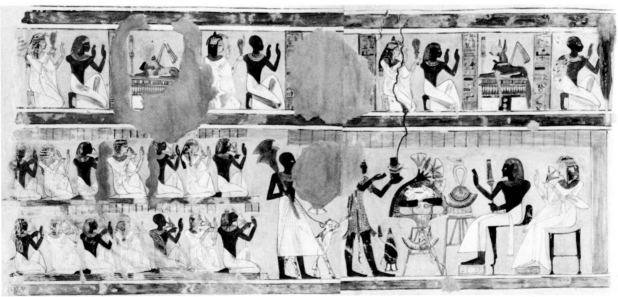

15.5.13

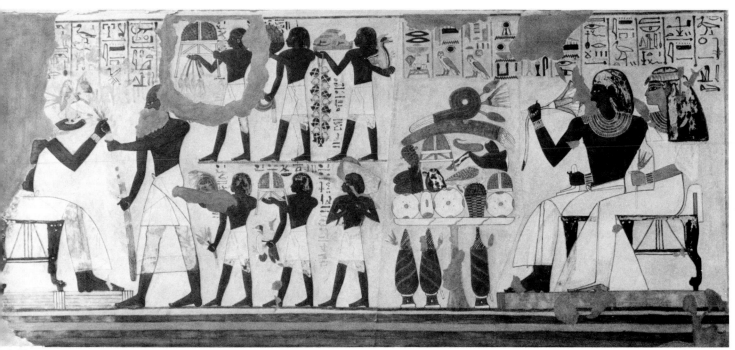

15.5.15

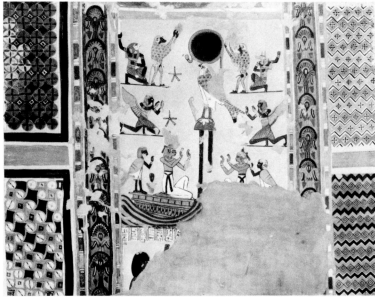

15.5.10

Tomb of Djehutyemhab, usurped from Djehuty (T 45)
Dynasty 19, time of Ramesses II (?)

Adoration of Anubis jackal; funeral banquet
Hall, PM I²1 85 (2) I
No.deGD (1908); 117 × 51; approximately 5:8 15.5.13

Deceased and wife adoring Sokar
85 (3) I
Na.deGD (1908); 49 × 48; 4:7 15.5.11

Frieze showing adoration of Anubis; deceased and wife
 adoring deities
85 (4)
No.deGD and FU (1908); 60 × 54; 1:3 15.5.12

Wife and daughter of deceased, offering to goddess;
 banquet guests
86 (8) I
Na.deGD (1908); 162 × 65; 1:1 15.5.14

Presentation of offerings to deceased; deceased and wife
 before offerings
86 (8) II 1–2
No.deGD (1908); 171 × 74; 1:1 15.5.15

Western Sun on a standard adored by various deities
86 ceiling
No.deGD (1908); 69.5 × 53; approximately 2:5 15.5.10

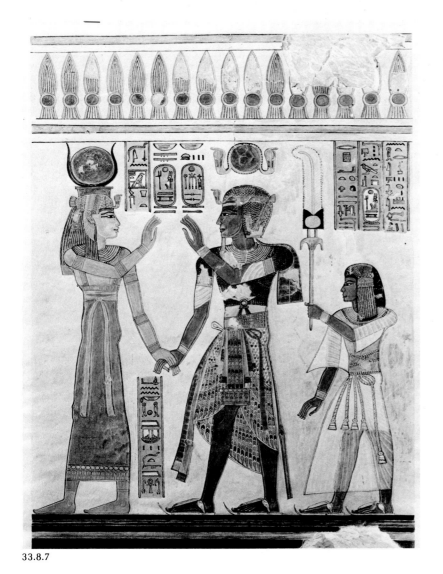

33.8.7

48.105.8

30.4.207

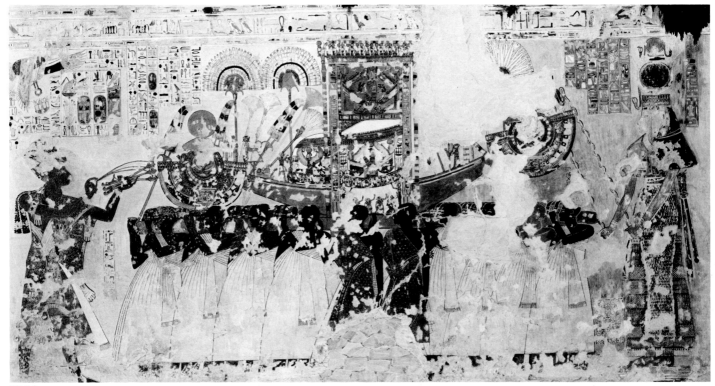

36.4.2

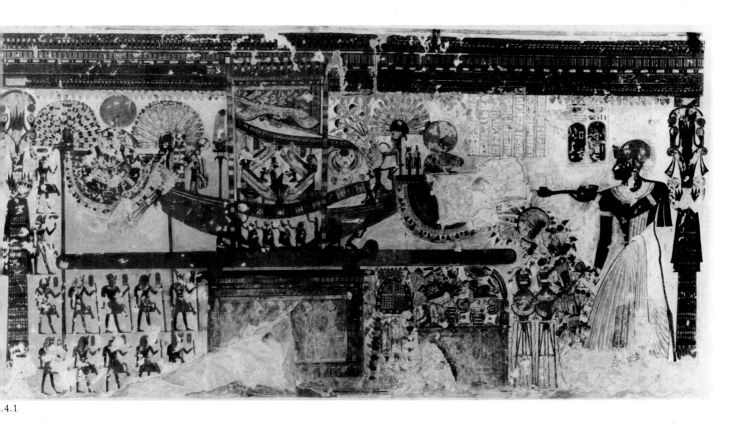

.4.1

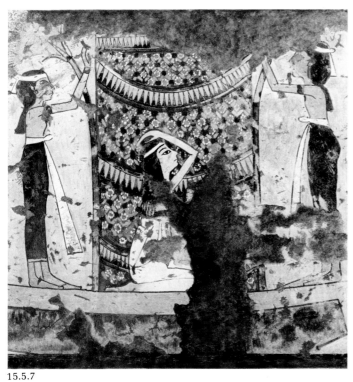

15.5.7

Tomb not known (found in T 16)
Dynasty 19, time of Ramesses II (?)

Papyrus and royal statue (in procession?)
Na.deGD (1922); 23 × 16.6; 1:1 48.105.8

Tomb of Amenherkhepeshef (Valley of the Queens 55)
Dynasty 20, time of Ramesses III

Prince and his father with Hathor
Hall, PM I²2 759 (8) 6
Na.deGD (1933); 64.5 × 94.5; about 2:5 33.8.7

Tomb of Hekamaatranakhte (T 222)
Dynasty 20, time of Ramesses III–Ramesses IV

Ceiling pattern
CKW (1924); 19.5 × 18; 1:1 30.4.207

Tomb of Imiseba, usurped from Nebamun (T 65)
Dynasty 20, time of Ramesses IX

King censing bark followed by Hathor
Hall, PM I²1 130 (3)
Na.deGD (1936); 152 × 77.5; 2:9 36.4.2

King before bark; statues of kings below
130 (4)
Na.deGD (1936); 131 × 65.5; 1:4 36.4.1

Tomb of Horemhab (T 207)
Ramesside

Mourner and goddesses on a funeral bark
South side of east wall
No.deGD (1912); 45 × 45; 1:1 15.5.7

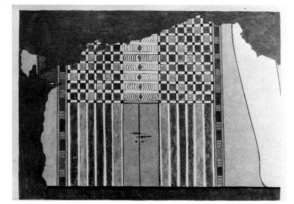

30.4.206

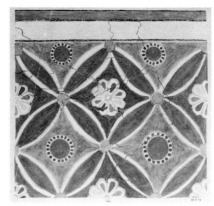

30.4.113

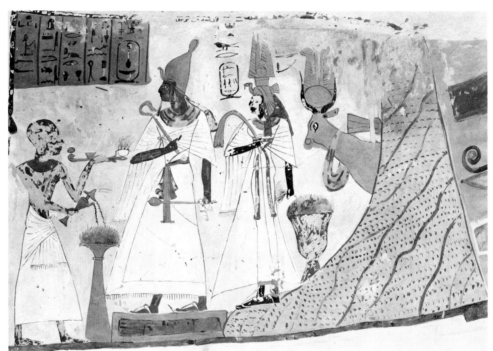

30.4.124

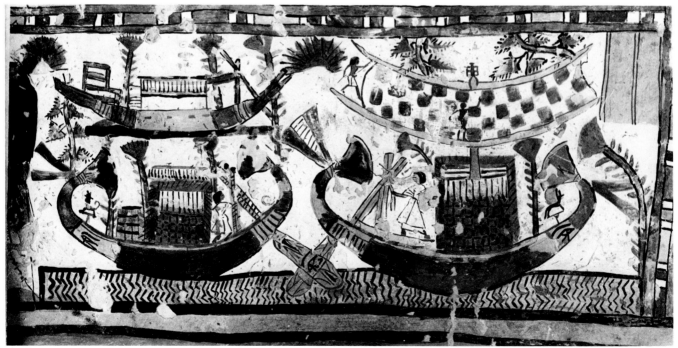

30.4.125

.4.148

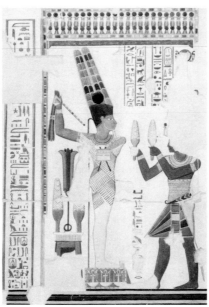

48.105.6

Tomb of Horemhab (T 207), continued

Throne of a deity
Northwest wall
No.deGD (1912); 37.5 × 26; 1:1 30.4.206

Ceiling of shrine (restored)
NdeGD (1913); 27 × 26; 1:1 30.4.113

Tomb of Ameneminet (T 277)
Ramesside

Deceased before deified Mentuhotpe and "Noferys," and
 Hathor-cow
Hall, PM I²1 354 (3) I 3 (actually between 3 and 4 over
 doorway to burial chamber)
CKW (1924–25); 87.5 × 60; 1:1 30.4.124

Tomb of Amenemhab (T 278)
Ramesside

Pilgrimage to Abydos
Hall, PM I²1 355 (7) II
CKW (1924–25); 112.5 × 55; 1:1 30.4.125

Tomb of Nofersekheru (T 296)
Ramesside

Nofersekheru and wife drinking from garden pool
Hall, PM I²1 378 (2) II 1
Na.deGD (1930); 78 × 67; 1:1 30.4.148

Temple of Amun at Hibis, Kharga Oasis
Dynasty 27, time of Darius I

King offering lettuce to god (color restored)
Inner gateway, PM VII 278 (7)
CKW (1929); 37.4 × 52; approximately 1:8 48.105.6

Seth with lion slaying serpent (color restored)
Second hypostyle, facade 280 (38)
CKW (1929); 36 × 45; 1:5 48.105.5

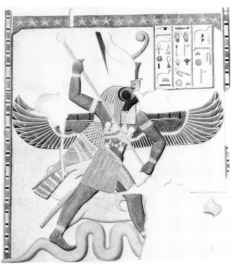

48.105.5

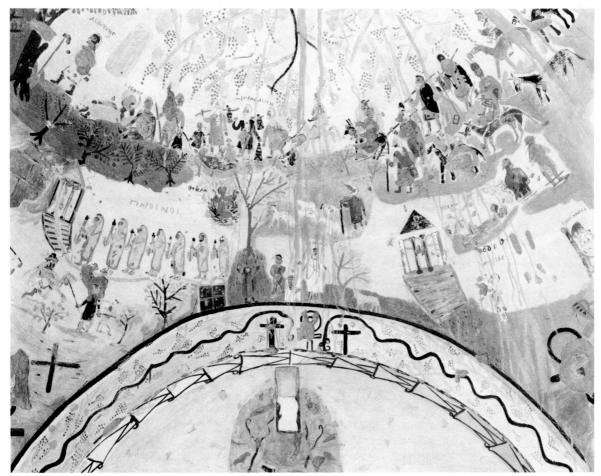

30.4.140

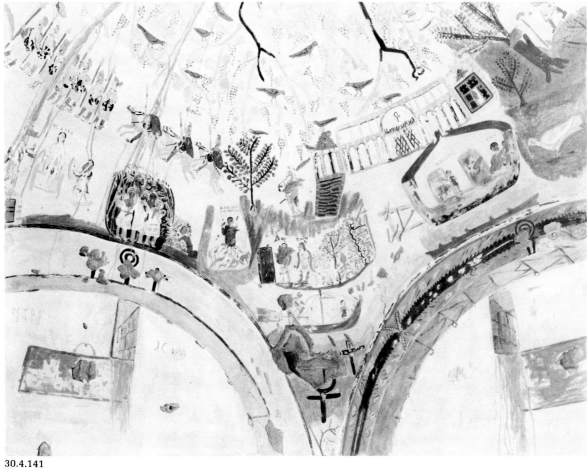

30.4.141

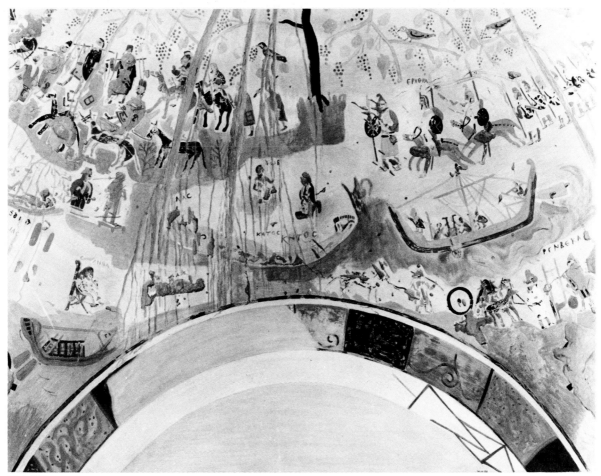

30.4.226

30.4.227

MMA Tomb 20, Kharga Oasis, Bagawat
Coptic period

Moses and the Burning Bush; Parthenoi and Sacrifice of
 Isaac (graffiti omitted)
Chapel, dome
CKW (1928–29); 65.6 × 50.5; scale unknown 30.4.140

Various Old Testament scenes (graffiti omitted)
Chapel, dome
CKW (1928–29); 70.5 × 52; scale unknown 30.4.141

Flight of Israelites from Host of Pharaoh (line of arch
 restored; graffiti omitted)
Chapel, dome
CKW (1928–29); 66.5 × 50.5; scale unknown 30.4.226

MMA Tomb 25, Kharga Oasis, Bagawat
Coptic period

Apse decoration (restored)
Chapel, apse
CKW (1927); 48 × 68; scale unknown 30.4.227

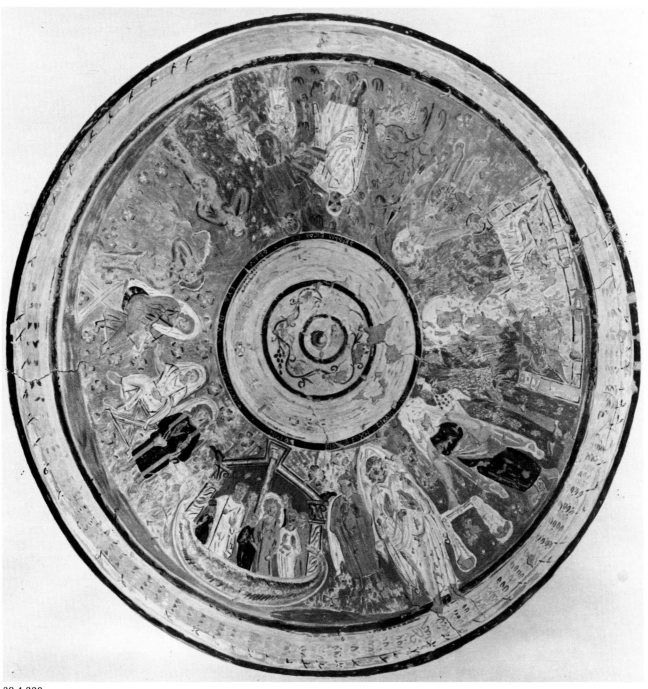

30.4.228

30.4.229

48.105.4

MMA Tomb 238, Kharga Oasis, Bagawat
Coptic period

Peacock in pendentive
Chapel, pendentive
CKW (1927); 35 × 56; 1:4 30.4.229

Allegorical and biblical scenes
Chapel, dome
CKW; diameter 81; 1:4 30.4.228

Monastery of Abu Makar, Wadi Natrun
Coptic period

Saint Michael
Chapel of Saint Michael, north wall
WJPJ (1911); 18.1 × 43.4; 1:5 48.105.4

Index of Theban Tomb Owners

Index of
Theban Tomb Numbers

Index of Monuments
Other Than Theban Tombs